ANATOMY
FOR THE
ARTIST

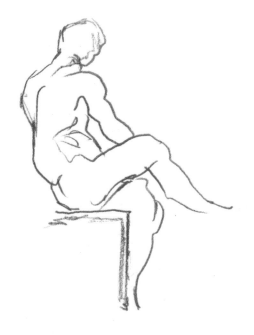

ANATOMY FOR THE ARTIST

A COMPLETE GUIDE TO DRAWING THE HUMAN BODY

JENNIFER CROUCH

SIRIUS

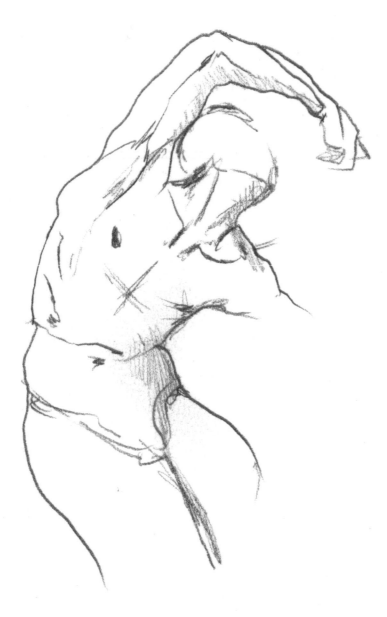

Jennifer Crouch is an artist and teacher with a background in physics and medical illustration. She worked as an anatomical artist from 2011 to 2013, and teaches on the short courses in Anatomical Drawing at Central Saint Martins. She is a current PhD candidate at the University of Portsmouth where her practice-based research explores physical phenomena, corporeality, and the ways in which bodies and machines interface with each other (both actually and notionally). Her research makes use of MRI, sculpture and weaving, and her collaborators include MRI scientists at The Francis Crick Institute and the Centre for Advanced Biomedical Imaging at UCL. She is co-founder of art-science collective Jiggling Atoms, has authored books on popular science, and enjoys gardening.

SIRIUS

This edition published in 2022 by Sirius Publishing, a division of Arcturus Publishing Limited,
26/27 Bickels Yard, 151–153 Bermondsey Street,
London SE1 3HA

ISBN: 978-1-83940-681-2
AD007304UK

Printed in China

CONTENTS

INTRODUCTION

We all move, breathe, grow, get sick and change – and we are all different. These aspects of anatomy and of being (or becoming) a person with a body are the ideas that are at the heart of this book. As the CERN's Particles for Justice website states:

'The humanity of any person, regardless of ascribed identities such as race, ethnicity, gender identity, religion, disability, gender presentation, or sexual identity is not up for debate.'

Source: particlesforjustice.org

People are diverse, and art can be used to celebrate that. Many anatomical drawing books seem to focus purely on a Western anatomical ideal, with Leonardo da Vinci's *Vitruvian Man* and 'realistic' drawing at their core. Some books frame anatomy as something where ideal proportions exist as truths about the nature of reality, restricting any notion of proportion, sex, gender, age and body type to tiny, simplistic categories where there is only one kind of woman, man and child, and nothing else. But we are more than this!

The drawing of the *Vitruvian Man* (and the symbolism attributed to it) was Leonardo's attempt to capture the different proportions of the body. By using circles and squares, he illustrated how the stretched-out arm's length relates to height and other body proportions, and this image came to represent art, knowledge and science in a very specific way. For Leonardo, this drawing was a scientific study of body mechanics and proportions; the use of squares and circles to interpret and draw people's proportions is a very useful technique in anatomical drawing. However, it's important to acknowledge that this figure does not represent all bodies, and much of the expansive range of human morphology and anatomy is excluded from it. While there are some measurable patterns and commonalities in how humans grow and change, anatomical ideals and archetypes don't even begin to capture the complexity, diversity, unexpectedness and wonders of anatomy (let alone biology). There is so much more to anatomical drawing (and the science of anatomy) than form, function and ideal proportions.

In this book, I have tried to showcase anatomy in some of its expansive wonderfulness and to provide descriptions of techniques that might support artists who want to draw the human form. Just as there is no

right or wrong kind of anatomy, there is no right or wrong way to draw or paint it. Realism most certainly is not the best way to draw anything either: an abstract scribble, minimal collection of dashes or expressive child-like sketches can capture the gesture and nuances of personality just as well. The kind of guidance detailed in this book will support the development of what some call 'technical' drawing and others might refer to as 'realistic' or even 'academic' drawing.

As children, we are experimental with our drawing and representation. But somehow, as we learn more about ourselves and the world, many tend to become more self-critical and claim that they can't draw because the works they create do not look realistic. We are conditioned and even encouraged to believe that 'realism' is somehow superior to other styles, but it's not; it's simply a style, and we use different styles to say different things about the world in different ways. Whatever style you happen to prefer, be it ancient or contemporary, abstract, symbolic, minimalist, maximalist, comic or realistic, bear in mind that observational drawing needn't be the ultimate measure of your skills as an artist. Capturing things exactly as they are is not the measure of you as an artistic human. If you happen to wish to improve or practise the specific skills used in observational (or 'realistic') drawing, then just try practising, because like most things, that is all that is required.

One thing to remember about practice is that it is not a case of 'practice makes perfect', but rather 'practice makes progress', and doing art is always a journey – you can decide where you want to go with it. Don't be too hard on yourself, and don't be ashamed of the things you love to do creatively, as each drawing you create is all part of the process of exploration. We are all artists and creative in our own way, and we all have a style that we prefer to use, which we eventually personalise and evolve as we move through life and develop our own creative practice.

I personally don't usually draw things realistically; I actually tend to be more into abstract forms, bright colours, otherworldly landscapes, absurdities, fantasy and lumpy weird textures, but in this book I use a 'realistic' style (or observational drawing) as a way to celebrate how wide-ranging, expansive and diverse anatomy can be. I use observational drawing to attend to the small details that make people special and make me love them. In my role as a teacher and researcher, I like to think of careful observational drawing as an activity that is about love, being present, relaxed and watching the world, rather than about ability, impressing people or being adept at drawing. Try to use it as a tool for understanding and reflection.

I encourage you not to be too critical, nor judge your own drawings or those of artists around you as simply 'good' or bad'. Explore what kind of drawings you enjoy most, then practise the skills that will help you to say what you want to say in the way that you want to say it.

1 ANATOMICAL KNOWLEDGE

Anatomists, healthcare providers and medical professionals of all kinds use terminology to help to describe specific parts of the body and specific spaces within the body. It can seem bewildering, but it is useful to remember that these are just words that refer to the names given to muscles, bones and organs, and the system of naming in anatomy helps us to understand where in the body each structure is located. There are many ways of talking about the body, different medical traditions, terminologies and conceptual frameworks. Anatomical terminology can be understood as a language that enables us to talk about anatomical structures with precision, and it reduces medical errors by eliminating ambiguity.

Anatomical terms and medical language provide precision by using composite words that describe what anatomical structures look like and where they are found. They have a very logical structure and contain roots, prefixes and suffixes that help us name and identify different structures. The root often refers to a specific organ, tissue or condition. The prefix or suffix often describes the state of that organ, tissue or condition.

You can imagine that in surgical procedures and for diagnostic purposes it is very important to understand and communicate among members of a medical team exactly what is happening to a body. 'Hypertension', for instance, contains the prefix *hyper* which means 'high' or 'over', while the root word *tension* means 'pressure'. Hypertension, therefore, refers to high blood pressure. Some names will have two parts, such as the latissimus dorsi, where *latissimus* literally means 'to the side of,' and *dorsi* means 'back'. Not surprisingly, the latissimus dorsi is found on either side of the back (this is the muscle that is very pronounced in professional swimming champions). Anatomical terms derive from ancient Greek and Latin, and some modern languages such as Romanian, Greek, Italian, French and Spanish share many words with these ancient languages. You may hear similar words or part of words being spoken on a casual basis by speakers of these languages.

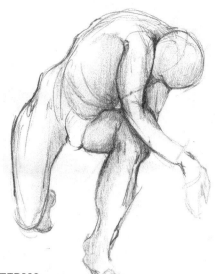

THE ANATOMICAL VOCABULARY

Anatomy is the study of the body in terms of organ systems, areas of the body, different tissues and how they interrelate. There are different approaches to the study of anatomy: the *systemic approach*, which is the study of systems; or the *regional approach*, the study of areas. The following terms are needed in the construction of medical vocabulary:

◆ Directional terms
◆ Anatomical planes
◆ Body cavities
◆ Body regions

DIRECTIONAL TERMS

Directional anatomical terms are essential for describing specific and relative locations of any anatomical structures.

Anterior (or ventral): the front direction, or towards the front of the body. Toes are anterior to the foot, and the nose is anterior to the ears.

Posterior (or dorsal): the back direction, or towards the back of the body. The scapula is posterior to the clavicle.

Superior (or cranial): above or higher than another part of the body.

Inferior (or caudal): below or lower than another part of the body.

Inter: found between, for example intervertebral cartilage is cartilage found between the vertebrae.

Lateral: to the side of, or towards the side of a structure or the body. The thumb is lateral to the digits.

Medial: to the middle of, or in the direction towards the middle of the body.

Proximal: nearer to a point of attachment such as a joint or socket, or near the trunk of the body.

Distal: regarding limbs and in discussing any area of them that is further away from the point of attachment or the trunk.

Prone: of the arm or hand, with the palm facing down.

Supine: of the arm or hand, with the palm facing up.

Ulnar: the finger side of the arm or hand.

Fibular: on the little toe side of the leg or foot.

Tibial: on the big toe side the leg or foot.

Superficial: closer to the surface.

Deep: further from the surface.

Thoracic: of the chest.

Abdominal: the area where the stomach and middle of the back are found.

Lumbar: the area from the hips down, including the lower back and buttocks.

Orbital: the area around the eye.

Occipital: the back of the head.

Temporal: near the temples.

LATIN PREFIXES

These are used to name parts of the body. If you see the following Latin words (usually as prefixes), then you can use these definitions to interpret what they are and where they can be found in or on the body.

Abdominis: abdominal area
Anguli oris: corner of the mouth
Auricularis: ear
Brachii: concerning the arm
Capitis: head
Carpi: wrist
Cervicis: neck
Digiti: finger or toe
Dorsi: back
Fascia: connective tissue
Femoris: femur
Fossa: a pit or hollow area

Frontalis: forehead
Hallucis: big toe
Indicis: finger
Labii: lips
Lumborum: lower back and buttocks, or the groin area
Mentalis: chin
Naris: nostril
Nasalis: nose
Nucha: back of the neck or nape
Oculus: eye
Oris: mouth

Palmaris: palm
Patella: kneecap
Plantar: sole of the foot
Pectoralis: breast or chest area
Pollicis: thumb
Radialis: radius
Scapula: shoulder blade
Thoracis: chest area, or of the chest
Tibialis: of the tibia
Ulnaris: of the ulna
Vertebral: of the vertebrae

ANATOMICAL PLANES

To further increase precision, anatomists use sections or **planes** – two-dimensional surfaces within a three-dimensional structure. These imagined two-dimensional surfaces passing through a body help anatomists and medical professionals to talk about specific sites in the body. There are three planes used in medicine and anatomy: sagittal, transverse and frontal.

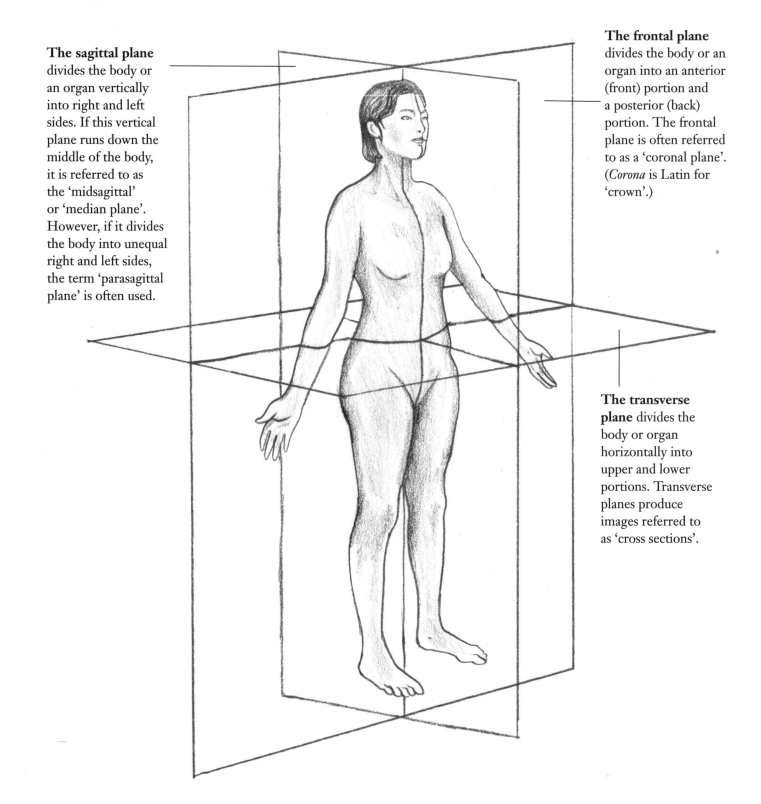

The sagittal plane divides the body or an organ vertically into right and left sides. If this vertical plane runs down the middle of the body, it is referred to as the 'midsagittal' or 'median plane'. However, if it divides the body into unequal right and left sides, the term 'parasagittal plane' is often used.

The frontal plane divides the body or an organ into an anterior (front) portion and a posterior (back) portion. The frontal plane is often referred to as a 'coronal plane'. (*Corona* is Latin for 'crown'.)

The transverse plane divides the body or organ horizontally into upper and lower portions. Transverse planes produce images referred to as 'cross sections'.

THE ANATOMICAL POSITION

Anatomists discuss anatomical structures in terms of their **orientation**. The idea of the body as an environment is a commonly used metaphor in the arts, but indeed, in all respects we can consider bodies as environments and even as ecosystems. Maps are oriented with north and south; similarly, a body can be orientated in the 'anatomical position', which is standing with feet shoulder width apart and parallel, and the upper limbs held straight out on each side with palms facing forward.

This standard position is used to help identify and name structures unambiguously and in the simplest way possible. Not all bodies have the same posture, but we understand the purpose of the anatomical position if we imagine someone recovering from surgery on their wrist – a surgeon can discuss the anterior (front) carpal (wrist) region as named according to the anatomical position, and other medical professionals will know what that means, regardless of the position of the recovering patient.

A body lying down is said to be **prone** or **supine**. Prone means face-down, and supine refers to face-up, and these terms are useful in describing the position of a body during physical examinations, surgical procedures or after accidents.

ANTERIOR VIEW

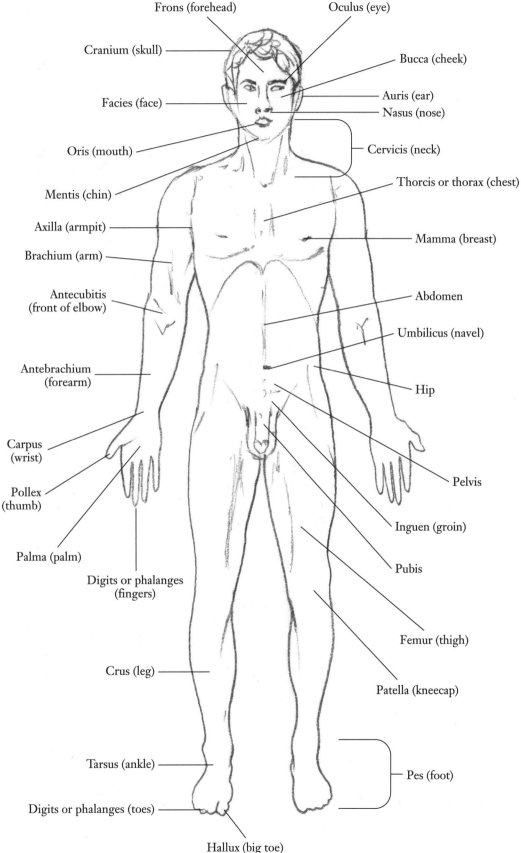

Frons (forehead)

Oculus (eye)

Cranium (skull)

Bucca (cheek)

Facies (face)

Auris (ear)

Nasus (nose)

Oris (mouth)

Cervicis (neck)

Thorcis or thorax (chest)

Mentis (chin)

Axilla (armpit)

Mamma (breast)

Brachium (arm)

Antecubitis (front of elbow)

Abdomen

Umbilicus (navel)

Antebrachium (forearm)

Hip

Carpus (wrist)

Pelvis

Pollex (thumb)

Inguen (groin)

Palma (palm)

Pubis

Digits or phalanges (fingers)

Femur (thigh)

Crus (leg)

Patella (kneecap)

Tarsus (ankle)

Pes (foot)

Digits or phalanges (toes)

Hallux (big toe)

POSTERIOR VIEW

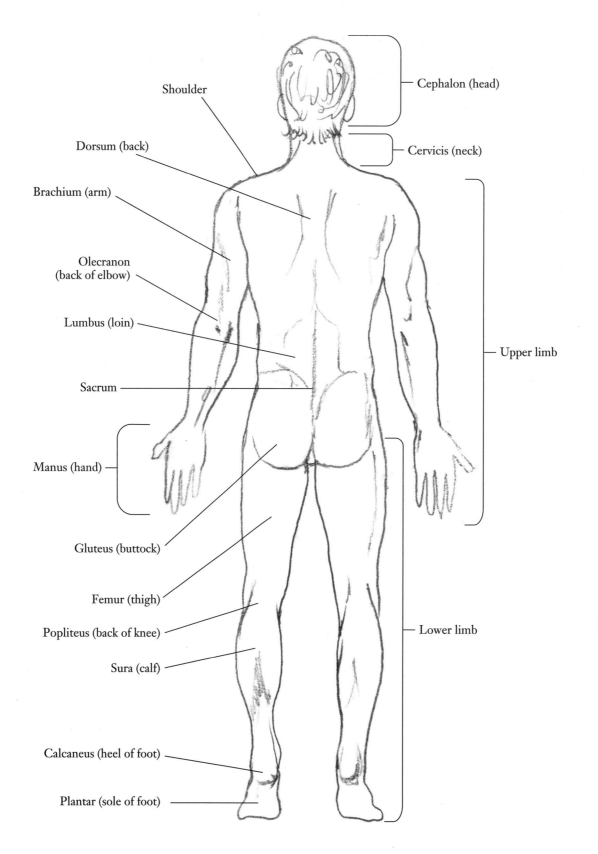

Shoulder

Dorsum (back)

Brachium (arm)

Olecranon
(back of elbow)

Lumbus (loin)

Sacrum

Manus (hand)

Gluteus (buttock)

Femur (thigh)

Popliteus (back of knee)

Sura (calf)

Calcaneus (heel of foot)

Plantar (sole of foot)

Cephalon (head)

Cervicis (neck)

Upper limb

Lower limb

BODY CAVITIES AND SEROUS MEMBRANES

Membranes, sheaths and other structures separate the body's organs into different compartments and sections, keeping different organs and functions in specific and/or separate places within the body. The dorsal (posterior) cavity and ventral (anterior) cavity are large body compartments that protect and contain delicate and vital organ systems. Subdivisions of these dorsal and ventral cavities is necessary in medical practice to further precisely describe and locate organs and structures. To improve communication, particularly when identifying a suspicious mass, discussing surgical procedures such as removing a tumour or in understanding a patient's pain, health care providers divide up the cavity further. Regions and quadrants may be used. The body can be further divided into nine regions or four quadrants, depending on the level of precision necessary. More on this can be explored in a medical anatomy textbook.

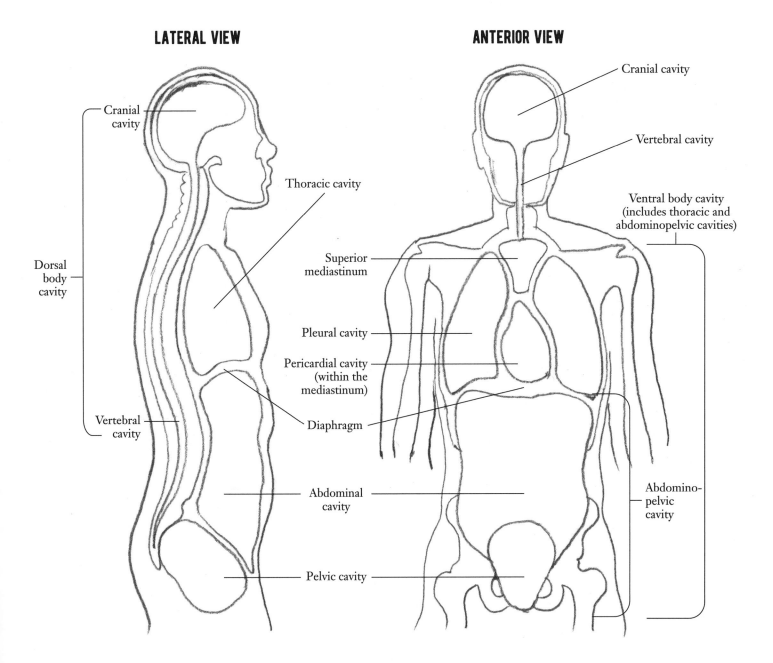

LATERAL VIEW

Cranial cavity

Dorsal body cavity

Vertebral cavity

Thoracic cavity

Superior mediastinum

Pleural cavity

Pericardial cavity (within the mediastinum)

Diaphragm

Abdominal cavity

Pelvic cavity

ANTERIOR VIEW

Cranial cavity

Vertebral cavity

Ventral body cavity (includes thoracic and abdominopelvic cavities)

Abdomino-pelvic cavity

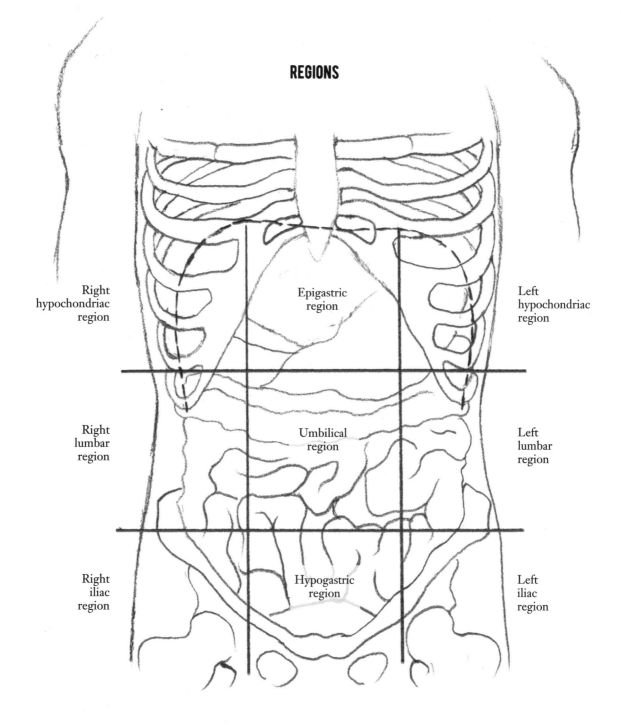

Right
hypochondriac
region

Epigastric
region

Left
hypochondriac
region

Right
lumbar
region

Umbilical
region

Left
lumbar
region

Right
iliac
region

Hypogastric
region

Left
iliac
region

REGIONAL TERMS

Regional terms are more useful for a medical textbook. A detailed regional approach will further subdivide the cavity horizontally inferior to the ribs and superior to the pelvis, then divide further with vertical lines from the midpoint of both clavicles (collarbones); this results in nine regions. The use of quadrants is simpler and more commonly used in medicine – the cavity is subdivided into one horizontal and one vertical line that cross at the umbilicus (belly button or navel). Quadrants may be referred to during some of our drawing tutorials.

QUADRANTS

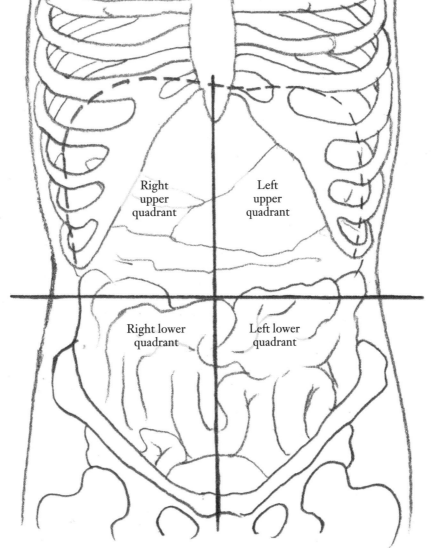

Right
upper
quadrant

Left
upper
quadrant

Right lower
quadrant

Left lower
quadrant

Ventral cavity: includes the thoracic and abdominopelvic cavities and their subdivisions. The thoracic cavity includes the lungs and heart, while the abdominopelvic cavity contains the digestive and reproductive systems.
Dorsal cavity: contains the cranial and spinal cavities.

NAMING ANATOMICAL STRUCTURES: MAJOR MUSCLES

The names of muscles may sound very complicated, but naming rules are applied to accurately describe position and orientation. Muscles are named in terms of the following descriptive categories:

◆ Size
◆ Shape
◆ Location
◆ Orientation of muscle fibres
◆ Actions of muscles
◆ Points of origin of a muscle
◆ Points of origin and insertion
◆ Muscle function
◆ Movements possible

SIZE

◆ Maximus: largest
◆ Major: larger
◆ Magnis: large
◆ Medius: middle
◆ Minor: small
◆ Minimus: smallest
◆ Longus: longest
◆ Bravis: shortest
◆ Latissimus: widest

Example: latissimus dorsi – the back muscles at the side of the body.

POSITION/LOCATION

◆ Interossei: between
◆ Lateralis: to the side
◆ Medialis: to the middle
◆ Orbicularis: around an opening or orifice
◆ Profundus: deep within
◆ Superficialis: near the surface

Example: vastus medialis or vastus lateralis – two sets of muscles, one on the inner and one on the outer part of the leg on either side of the knee.

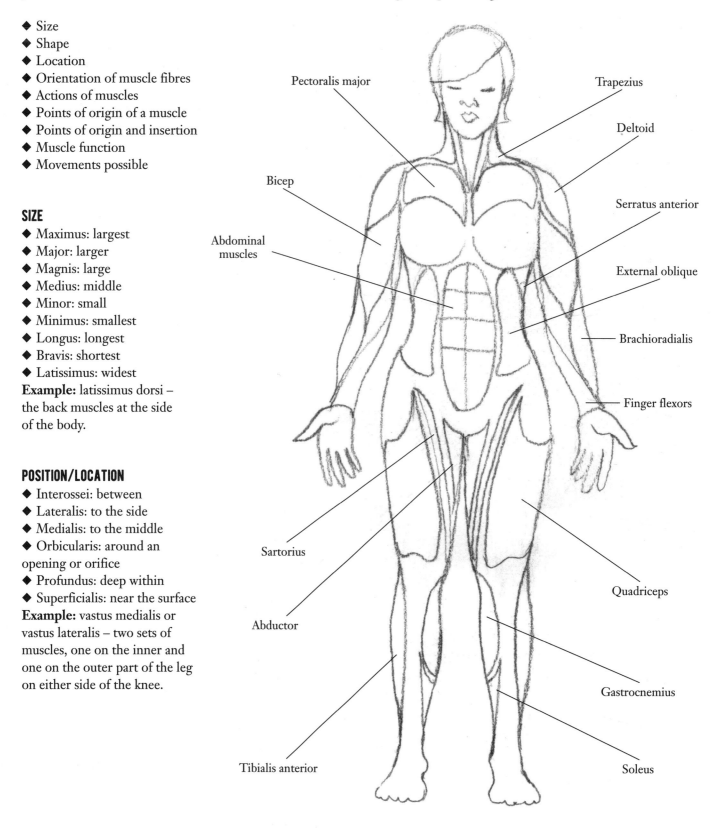

Pectoralis major

Trapezius

Deltoid

Bicep

Serratus anterior

Abdominal muscles

External oblique

Brachioradialis

Finger flexors

Sartorius

Abductor

Quadriceps

Gastrocnemius

Tibialis anterior

Soleus

SHAPE

- ◆ Trapezius: trapezium-shaped
- ◆ Deltoid: triangular
- ◆ Serratus: 'serrated'
- ◆ Platysma: flat and broad

Example: trapezius muscle.

ORIENTATION

- ◆ Rectus: fibres run parallel to midline or spine
- ◆ Oblique: at an angle
- ◆ Transverse: across

Example: External oblique.

NUMBER OF ORIGIN POINTS FROM BONE AND INTERSECTION

- ◆ Bi: two
- ◆ tri: three
- ◆ Quad: four

Example: biceps, triceps and quadriceps.

FUNCTION

- ◆ Masseter: chewing muscles
- ◆ Risorius: smiling muscles

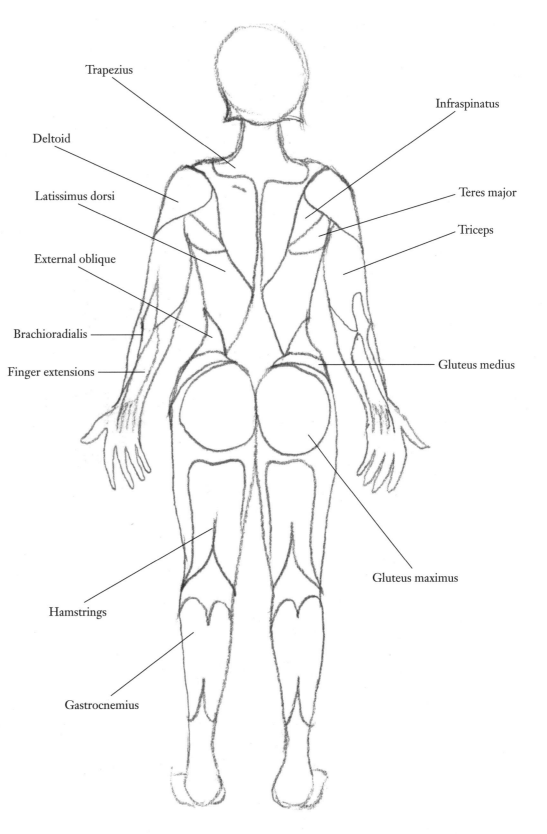

Trapezius

Infraspinatus

Deltoid

Teres major

Latissimus dorsi

Triceps

External oblique

Brachioradialis

Gluteus medius

Finger extensions

Gluteus maximus

Hamstrings

Gastrocnemius

SURFACE ANATOMY

This refers to the structures of the body that are visible from the outside, primarily related to the musculoskeletal system. These are the main concern of this book, as they are the anatomical structures that we can see in a model.

Skin, bones, muscles, tendons, fascia, ligaments, cartilage, fat and joints will be the main areas of anatomy that we will observe. The combination of the different elements of surface anatomy creates the appearance of observable 'landmarks' caused by underlying structures such as the ridge of a bone, muscle shapes or pockets of fat pushing up beneath the skin. Anatomical landmarks are helpful to observe when you work on a drawing – they can help with measurement, as well as creating a more representational figure.

Throughout this book we will refer to landmarks on the body, and these will differ depending on what can be seen. They are the result of individual anatomical variation and lighting, and also the intention of the artist in their drawing. Some examples of landmarks are illustrated below.

SYSTEMS OF THE BODY

Human anatomy is divided into different 11 main systems, each of which interact with each other.

Cardiovascular: the heart; veins and arteries; red blood cells that carry oxygen and have no nucleus; white blood cells; plasma and platelets.

Respiratory: alioli in the lungs allow carbon dioxide and oxygen to permeate during gas exchange.

Digestive: includes the whole digestive tract from mouth to anus, and the liver.

Renal: includes the kidneys and bladder, which filter toxins from the blood.

Nervous: cells can send and sense electrical signals.

Endocrine: the system of hormones that the body needs to self-regulate, including the adrenal and pituitary glands, pancreas, ovaries, thyroid, brain, testicle and thymus.

Immune: cells, tissues and organs that fight infection, including spleen cells.

Integumentary: hair, nails and skin cells; layers include oil glands, fat cells, skin cells containing melanin, and sweat glands.

Skeletal: osteogenic (bone-making) cells develop into osteoblasts which create the biomineral bone matrix and form osteocytes.

Muscle: these cells have 'contractile' proteins that help muscles to stretch.

Reproductive: external genitals and inner reproductive organs.

MOVEMENT

Anatomists use specific words to name and describe muscles in terms of how they move, what movements they can enable, and movements in relation to other anatomical structures.

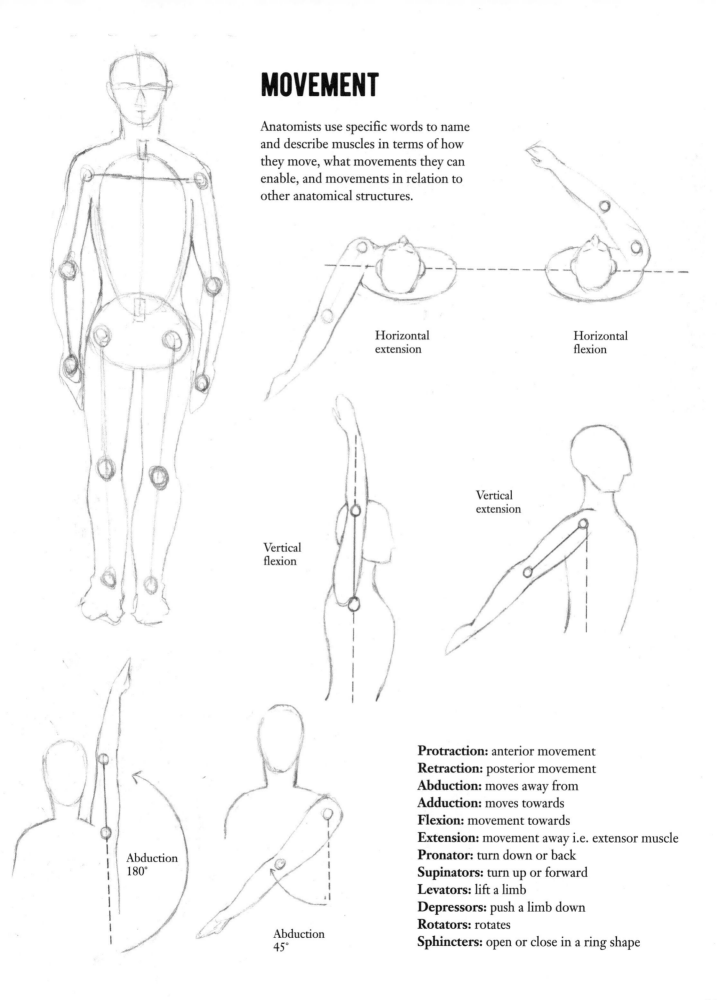

Horizontal extension

Horizontal flexion

Vertical flexion

Vertical extension

Abduction 180°

Abduction 45°

Protraction: anterior movement
Retraction: posterior movement
Abduction: moves away from
Adduction: moves towards
Flexion: movement towards
Extension: movement away i.e. extensor muscle
Pronator: turn down or back
Supinators: turn up or forward
Levators: lift a limb
Depressors: push a limb down
Rotators: rotates
Sphincters: open or close in a ring shape

2 THE FORMAL ELEMENTS OF DRAWING

The formal (or visual) elements in art describe the component parts of the visual world. They include line, shape, space, form, tone, texture, pattern, colour and composition. You could even include shadow, light, rhythm and other descriptive features as visual elements too.

These elements can be made to interact with each other to define how an image is perceived. Developing your understanding of the formal elements and how to use them will help you interpret something you see or imagine and want to draw. It can help you translate what you want to draw into gradations of tone, textures, drawn or painted marks, and recombine these elements through drawing (or painting) to create the image you want to make.

By using a combination of what might seem to be simple gestures or actions that result in marks, tones, dots or lines on a page, you can design and organise a piece of art. The formal elements and how they interact determine what a finished artwork looks like.

We can practise how to see art (and create it) by breaking down the use of these elements of line, shape, space, form, tone, texture, pattern and colour. We can think about how they create unity, dissonance, chaos or harmony, balance, rhythm, contrast, dominance or gradation in an image. The visual elements also relate to composition, emotion, aesthetics and the use of space and scale.

Drawing is a way of communicating and expressing what you feel about what you see or experience, whether it's a seated figure or an object from your imagination. A drawing can be a sketch, plan, design or graphic representation made with the help of pens, pencils or crayons.

IMAGE-MAKING AND REPRESENTATION

Drawing can be used for many different types of image:

Illustrations can represent narratives and concepts and can be stylised and imaginative as well as instructive, and include characters for graphic novels and animation.

Life drawing is what we will focus on most in this book. This is drawing from direct observations of a person. Life drawing or figure drawing portrays expressions as perceived by the artist, and it doesn't have to be photorealistic or realistic at all to capture or communicate what we want to say. The human figure is important in portraiture, sculpture, medical illustration, character design, dance, movement, costume design, animation and illustration … and many other artistic approaches.

Perspective drawing is the creation of three-dimensional images on a two-dimensional surface, sometimes drawn in scaled-down proportion. It is used to represent space, distance, volume, light, surface planes and scale, all viewed from a particular eye level.

Diagrams visually explore and investigate a concept, mechanism or process.

Geometric drawing is used in sacred artworks such as Islamic and Celtic patterns. It is also needed in design and construction fields, and is important in mathematics too.

HOW TO MEASURE WITH THE 'RULE OF THUMB'

Proportions of observed objects can be measured by holding up a pencil and using your thumb to compare the length of one point with another, as shown in the diagrams here. To maintain accuracy, hold the pencil at arm's length and at 90 degrees (right angles) to your line of vision.

Hold the pencil so that the end of it appears to line up with the end of your observed subject, then line up your thumb with the end of whichever structure of your subject you are starting to measure.

Hold arm out straight if possible

The example above shows a drawing of a house, where the width of part of it is being measured. Hold the pencil at 90 degrees to your arm such that you move your thumb downward until the end of your thumb comes between the eye and the width of the wall you are measuring.

Then hold the pencil so that its tip lines up with the end of your observed subject (A), and move your thumb so that it lines up with the other end of the structure you are starting to measure (B).

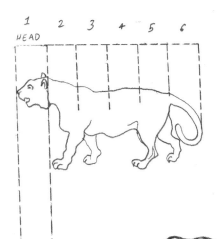

LIGHTING, SHADOWS AND CONTRAST

Lighting and a contrasting background can make drawing from a model easier to do. You may create one final image by combining several 'studies' of a person, object and places.

DRAWING FROM A PHOTOGRAPH

Drawing from a photograph is very different, and it can be hard to get a sense of scale, depth and volume when using a photograph as a basis for your drawing. Photographs can, however, be useful starting points for line work, and they are extremely useful when combining different images as well as helping you remember poses from one sitting to the next.

REALISTIC DRAWING

Drawing using pencil, ink and charcoal and creating monochrome drawings when you are learning to draw subjects in a realistic style is an interesting way to make you focus on shape, form, outline and tone.

COUNTING HEADS

You can use the rule of thumb to calculate how big you have to draw subjects in order to keep them in proportion, if that is what you want to do. Anatomical drawing doesn't have to be perfectly proportioned or realistic for it to be interesting and expressive, but if something that looks realistic is what you want to draw, then the rule of thumb is really helpful.

The illustration above shows a hand demonstrating the rule of thumb to measure the width of a panther's head. You can count how many of those head widths are needed for the length of your subject's arm, leg and body, and you can then draw your model's arm, leg or body based on the equivalent number of head widths that you have drawn. You could even measure how many leg lengths fit diagonally across a seated figure from their shoulder to their hip.

This drawing of a model shows that her head length fits just over seven times into her overall height. This is a good indicator that the drawing is in proportion, as many adults are between seven and eight heads tall (see pages 68–9 for more on this way of measuring proportions).

SCALE

It's useful to practise drawing on different scales. Practise drawing on large sheets of paper as well as in small sketchbooks.

DRAWING FROM MODELS

You can practise drawing anything and everything if you want to develop drawing skills. You can also use your own hand, leg or face if drawing someone else is not possible.

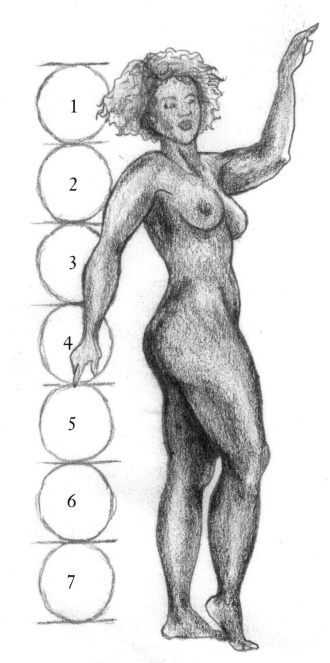

DRAWING TOOLS

It's quite useful to experiment with a number of drawing tools, from mechanical pencils to graphite, chalk, charcoal, ink, oil, pastel and crayon. Mechanical pencils can be very useful for fine detail, while charcoal or graphite can create really interesting textures and can be used to create blended tones. Using a putty rubber/eraser is also quite useful – you can softly remove layers of graphite and charcoal with them, and they are available in different softnesses. The softest ones are very squishy and can lift up layers of graphite off the page. Sometimes, however, you need a harder rubber to remove more pencil from the page. Putty rubbers are excellent for blending and creating highlights. As they are 'putty', they can be formed into a shape that corresponds to the round shape of a highlight.

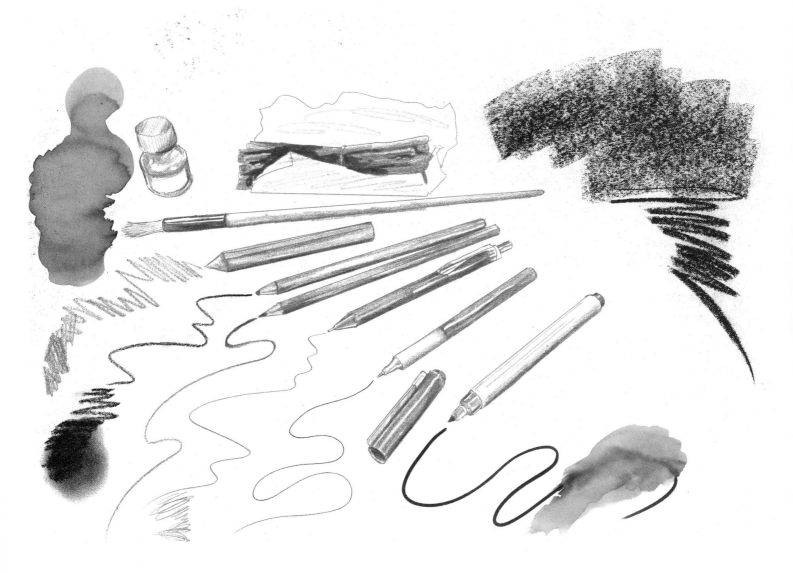

3 LINE, MARKS AND TEXTURE

Line is used to create edges of different objects and subjects. It can suggest form and structure as well as movement and gesture. (Gestural contour drawing is looked at in more detail in later chapters.) Line can be used to indicate tonal or textural values as well as the direction of light sources. When line is used to create shading, it is often used in the form of hatching or cross hatching. The thickness of a line can also vary in order to denote tone, emphasise movement and add character to a drawing.

USING INK

Ink is an interesting medium to use for creating forms and experimenting with line weight and hatching. This page presents ink and brush experiments; they are challenging to do because you cannot rub them out. The key to having more control over the use of a brush is not to press hard, otherwise the bristles will splay out in all directions. You can dampen your brush with some water or your ink to shape it into a point. Rest your hand on a piece of scrap paper or blotting paper against the page or drawing surface for balance – this will stop the natural oil from the skin of your hand from marking the paper.

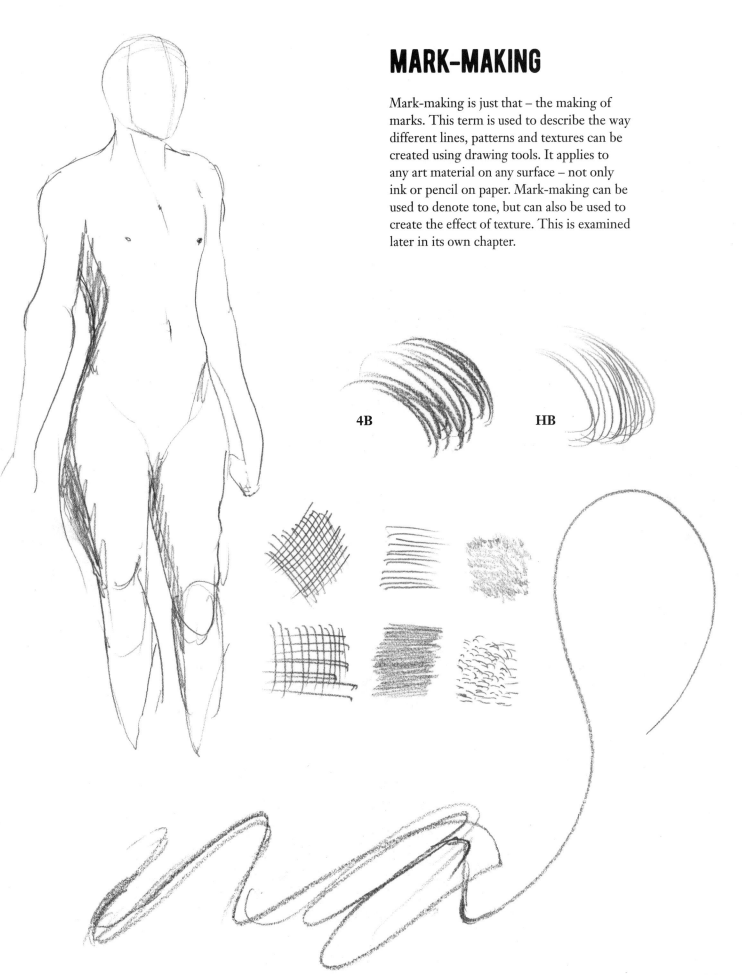

MARK-MAKING

Mark-making is just that – the making of marks. This term is used to describe the way different lines, patterns and textures can be created using drawing tools. It applies to any art material on any surface – not only ink or pencil on paper. Mark-making can be used to denote tone, but can also be used to create the effect of texture. This is examined later in its own chapter.

4B

HB

PENCIL WEIGHT

The relative hardness or softness of a pencil will make a difference to the kind of marks you can create with it and the darkness of the shading. How you use the pencil also allows you to vary the strength of the marks quite significantly. The marks on this page show the strength of shading that you can achieve with a range of pencils from HB (hard black) to 8B (the softest and darkest pencil).

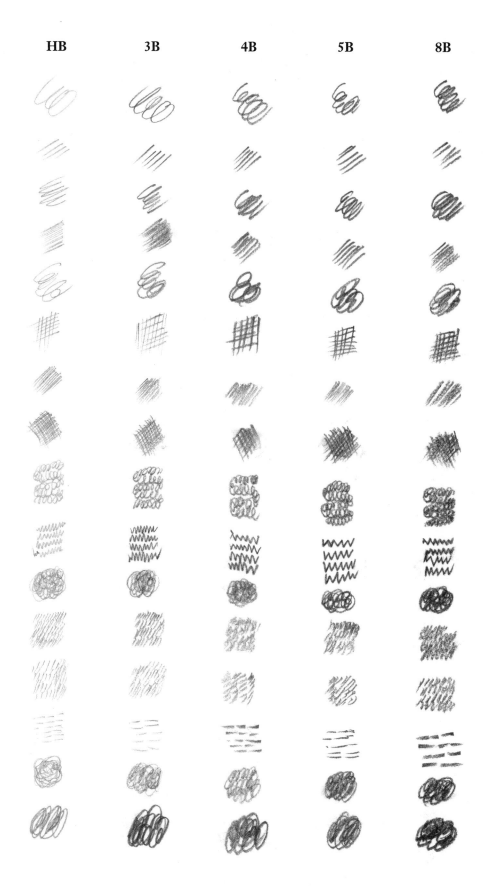

HB	3B	4B	5B	8B

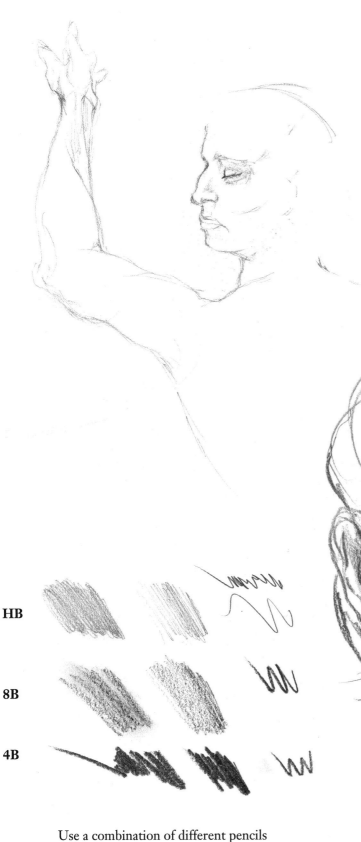

TEXTURE AND TONE

Different textures can be made with mark-making, and this is explored in its own chapter. The illustrations here show the depths of tone that you can achieve with different pencil weights.

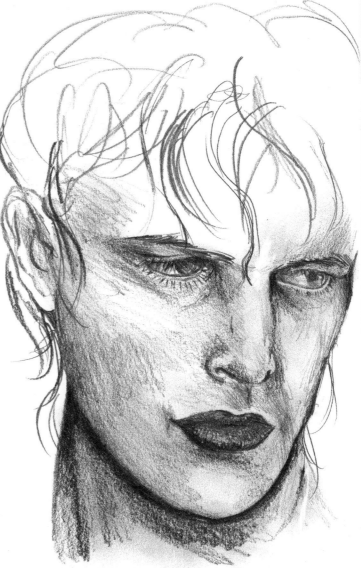

HB

8B

4B

Use a combination of different pencils and thicknesses of line when drawing. Keep your mark-making tight and don't overdo the hair.

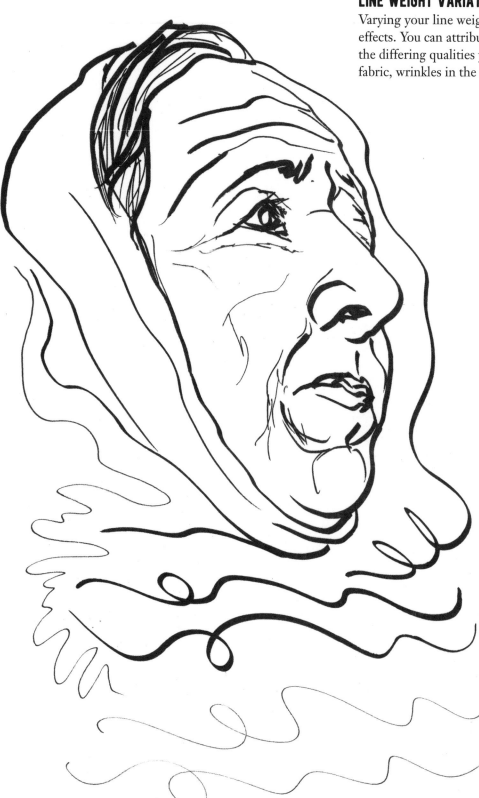

LINE WEIGHT VARIATIONS

Varying your line weight will create different effects. You can attribute different line weights to the differing qualities you observe, such as folds in fabric, wrinkles in the skin or a frown.

Practise line work by simply trying to draw some smooth lines with a range of different drawing materials.

LINE WEIGHT, HATCHING AND TONE IN INK

This example shows how line weight and density of hatching can correlate to different tonal qualities in a drawing. The drawing shows hatching using straight lines so all the hatching marks go in the same direction – but they do not have to be used this way. You can draw curved lines to help emphasise volume and the curvature of a figure resulting in a more 'realistic' representation of muscle, fat, skin and soft tissue. The straight lines in this example express tone and shadow.

Use a page in a sketchbook (or a piece of paper) to practise different lines. Experiment with line weight and a broken line (one that is incomplete or not solid).

EXPLORE MARK-MAKING

Use charcoal, chalk, pastel or whatever drawing materials you can get hold of to create a mark-making swatch. It is fun to experiment with mark-making, and this will be useful for later chapters when we look at parts of the body in more detail. Try blending part of the charcoal (and blending will be looked at in more detail in the section about tone). You can apply water to ink to create a wash for your swatch too.

COPYING DRAWINGS

Copying drawings that you see in galleries, libraries and museums is sometimes acceptable, depending on the copyright. Practising drawing by copying a drawing can be helpful; some artists like to draw from or copy old artworks, particularly iconic Renaissance drawings. If you do this, please ensure that this is allowed by the artist or institution that makes the artwork publicly available. Copying a drawing can be an easy way to work out how the formal elements are being used, but if you want to experiment with this, always cite the artist whose drawing you copied, and never try to pass someone else's original work off as your own.

The image below is a copy of a drawing by the Italian artist Baldassare Tommaso Peruzzi (1481–1536). The original drawing is in a collection held by the Metropolitan Museum of Art in New York. Many large museums and galleries have high-quality scans of old drawings available online, which the public are free to view, download and draw from, if they wish.

Experiment with different line weights

Use curved hatching to complement the curvature of the muscles of the body

Hatching does not always have to go in the same direction

Different lines can overlap each other

A broken line is one that is not continuous – this can be very expressive

Use a combination of broken and unbroken lines to denote different tonal qualities

Use thicker lines to denote darker tones or areas in shadow, including depressions resulting from bone protuberances such as the patella (kneecap).

4 FORM, SHAPE AND VOLUME

The use of geometric shapes is a common drawing technique that can help you to draw more complex forms such as a body. It requires you to think slightly differently about what you are looking at, but once you get used to it, it can make drawing much easier. Simple shapes such as circles, ovals, lines, rectangles, squares and other shapes are used to construct the rough shape of a body, and then refined into increasingly accurate shapes. The use of lines as well as shapes in order to identify a line of bilateral symmetry and the breaking of a complex form into simpler sections makes it possible to maintain as close a resemblance as possible to what you observe.

ELLIPSES

An ellipse is an oval-like geometric shape. If we view a circular shape in perspective – from an angle – the circle resembles an ellipse. Depending on the vantage point of the viewer, the ellipse will look more or less circular. Drawing an ellipse accurately can really help with drawing the human body, and many other things as well.

The drawn examples on this page show how an ellipse works in a few contexts. If we take the cylinder viewed from above, you can imagine that all you would see is a circle. If you are looking at it exactly straight on, it will resemble a rectangle. Many objects are either circular or have a circular aspect to their structure, for example a vase. This is why they are used quite frequently to demonstrate this technique.

Practise drawing lots of ellipses by drawing a glass or roll of tape. At eye level, the rim of the glass or roll of tape looks flat. Draw the tape from different angles, moving from seeing it almost directly above to the front and the side.

Ellipses drawn in perspective are shown on the next page.

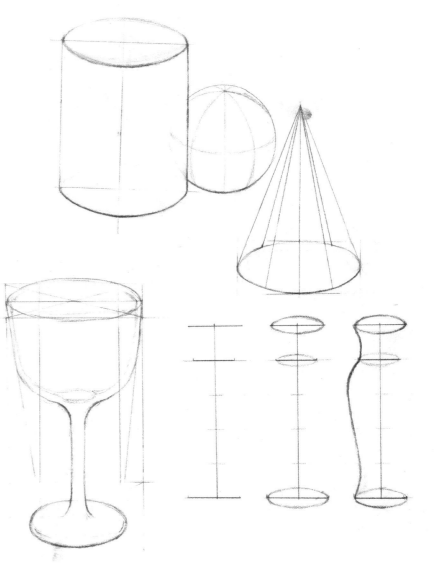

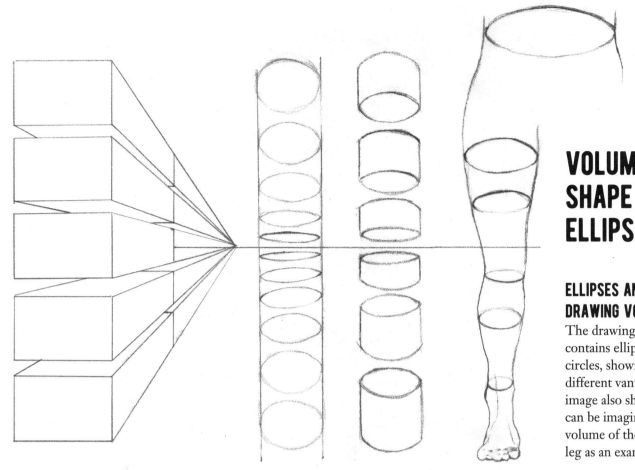

VOLUME, SHAPE AND ELLIPSES

ELLIPSES AND DRAWING VOLUME

The drawing to the left contains ellipses as distorted circles, showing them at different vantage points. The image also shows how ellipses can be imagined within the volume of the body, using the leg as an example.

SCAFFOLDING USING SIMPLE SHAPES

In addition to the use of geometric shapes, a curved line to represent the curvature of the spine is helpful in capturing the gesture and pose of a person. This curved line can represent:

The curvature of the head and neck (the cervical vertebrae).

The torso, including the thorax and abdomen (the thoracic vertebrae).

The pelvic region and lower abdomen (lumbar spine).

Practising mark-making can help improve the quality of the line and shape that you draw.

USING SHAPES TO CAPTURE THE VOLUMES OF A FIGURE

The examples below show how cubes and curved lines can be used to draw the proportions of a figure. This technique or methodology can be practised a number of times in order to help you familiarise yourself with it.

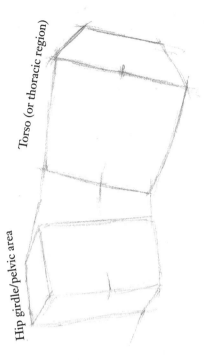

Torso (or thoracic region)

Hip girdle/pelvic area

Contour can be used to capture the volume. This is looked at in more detail in later chapters.

Volume of the torso and hip girdle interpreted using cuboids.

LINE AND SHAPE

Both contour lines and shapes can be used together to create a form that resembles a body.

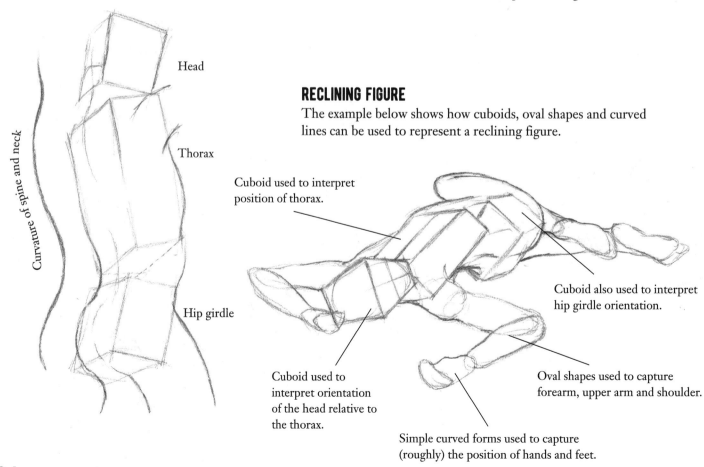

Head

Thorax

Curvature of spine and neck

Hip girdle

RECLINING FIGURE

The example below shows how cuboids, oval shapes and curved lines can be used to represent a reclining figure.

Cuboid used to interpret position of thorax.

Cuboid also used to interpret hip girdle orientation.

Cuboid used to interpret orientation of the head relative to the thorax.

Oval shapes used to capture forearm, upper arm and shoulder.

Simple curved forms used to capture (roughly) the position of hands and feet.

THE INTERPRETIVE FRAMEWORK

As well as cubes, circles and cylinders, improvised curved or hybrid forms can be used too, and you can use any shape you like. It might not always be necessary for you to draw something complex such as a body using simple geometric shapes, but thinking and drawing in terms of 3D shapes will help you to draw an image that has a sense of depth and volume.

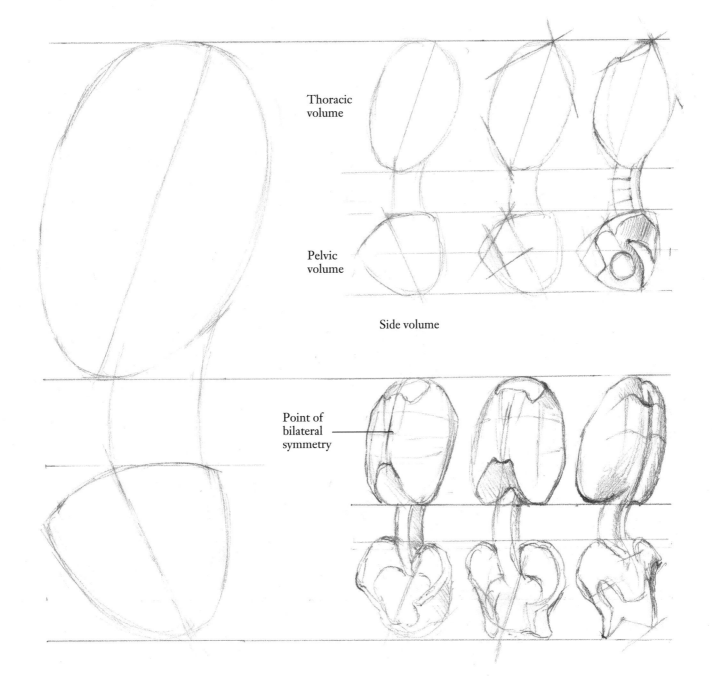

Thoracic volume

Pelvic volume

Side volume

Point of bilateral symmetry

Many artists use this method, as it helps them to construct a figure that has fullness, depth and volume. It helps to play close attention to where the middle of the chest, abdomen and pelvis fall in a drawing. Be aware of lines of bilateral symmetry, so that you can draw a more balanced figure.

PRACTISE SKETCHING

Practise makes progress, rather than practise makes perfect. Perfection is not a helpful concept when you're learning something new. The freer are you are with your practice, the more you will learn, and you won't pencil yourself into a corner stylistically.

When you practise, try sketching the whole figure rather than creating refined drawings every time. Don't worry about getting everything right at once; putting pressure on yourself to create something perfect is unnecessary, as is the idea that we should be able to draw perfectly on the first sitting with a model. Instead, try sketching your model or figure using cubes and cuboids for the head, torso and hips. Use a series of lines, dots and circles to serve as joints for the limbs. This will help you to estimate the volume of whoever you are drawing.

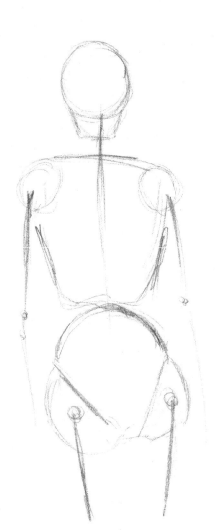
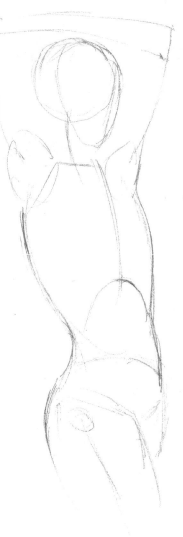

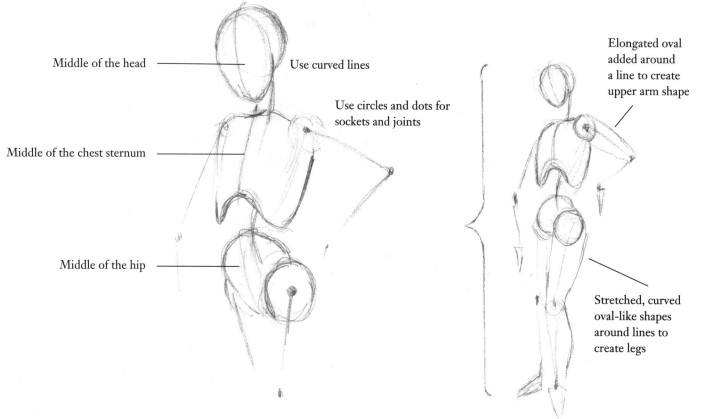

Middle of the head —— Use curved lines

Use circles and dots for sockets and joints

Middle of the chest sternum ——

Middle of the hip ——

Elongated oval added around a line to create upper arm shape

Stretched, curved oval-like shapes around lines to create legs

WORKED EXAMPLES

The worked example on this page shows you how you might add more detail step-by-step from one drawing to the next, erasing the borders of the shapes as you go, to create a connected figure. Remember to press lightly when you draw, so that it is easier to rub out these 'construction lines'.

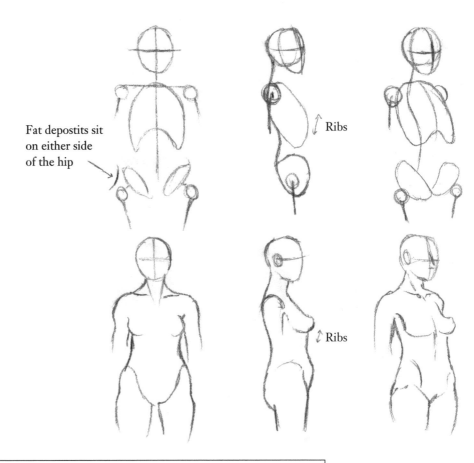

Fat depostits sit on either side of the hip

Ribs

Ribs

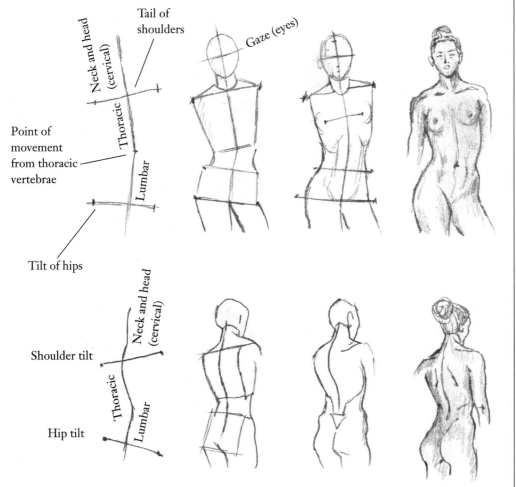

Tail of shoulders

Neck and head (cervical)

Gaze (eyes)

Thoracic

Point of movement from thoracic vertebrae

Lumbar

Tilt of hips

Shoulder tilt

Neck and head (cervical)

Thoracic

Lumbar

Hip tilt

SAME POSE, DIFFERENT ANGLE

Observing the difference between the tilts of the shoulders, hips and the gaze (eyes) is another technique used to interpret the figure. A series of lines can be drawn to indicate where the gaze is in relation to the tilt of the shoulders and the tilt of the hips.

In the example here, the difference in tilt helps to create a figure that interprets the possible movement of the cervical, thoracic and lumbar regions of the vertebrae.

We will look at this technique again in the chapters about pose, gesture and movement.

USING A MANNEQUIN

A mannequin (also called a manikin, dummy, lay figure or dress form) is an articulated doll used by artists, tailors, dressmakers and window-dressers to display or fit clothing.

An artist's mannequin helps to break down areas of the body into simpler, curved, geometric shapes. Not everyone will have access to a mannequin, but if you do, try putting it in different poses and practise drawing it. If you are taking a drawing course, it can be helpful to use a mannequin to practise specific poses that you find particularly difficult.

Of course, mannequins can seem quite rigid, as they are not as articulate or squishy as humans. Do be aware of the hip and shoulder tilt of the figure (as illustrated below) in order to make your figures more realistic.

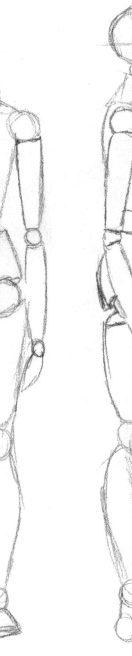

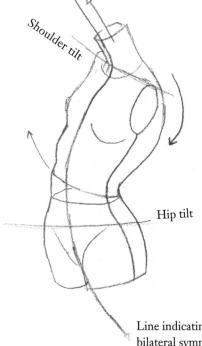

Shoulder tilt

Hip tilt

Line indicating bilateral symmetry

Visualise where in the figure the weight is being held.

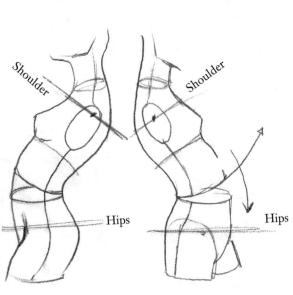

Shoulder tilt

Hip tilt

Shoulder

Hips

Shoulder

Hips

PRACTISE DRAWING SHAPES

Geometric shapes of all kinds can be used to construct almost any complex object that you wish to draw. At some point you may need to use cuboids, while in other instances ovals will suffice. A combination of the two may also be helpful.

Refining a drawing that is composed of geometric shapes will require that you shift regularly from pencil to eraser. Moving back and forth frequently between a pencil and eraser is good practice. Remember never to press hard and never to focus on one single area for too long. During this process, you are carefully lifting the whole image up together, adding line or tone to different areas of the drawing, moving from one part to another, and never spending too long in one spot.

DRAWING A HEAD STARTS WITH A CIRCLE, AN OVAL AND A CROSS

These shapes need to be positioned according to where the gaze is directed. There is more on this in the section on heads and facial expression.

◆ The circle represents the skull, in which the brain is housed.
◆ The oval is the front of the face and jaw.
◆ The cross is the middle of the oval, and marks out the eye line and the position across the face where the nose sits.
◆ Another oval can be added to mark the side of the head, where the ears are.

DRAWING FEET

Using shapes can help you practise drawing feet, as well as preventing them from looking flat.

Ensure that you mark out features such as the arc of the foot with a curved line.

Interpret your model in terms of planes: think of what anatomical structure is facing towards or away from you, or at a three-quarter angle.

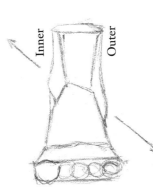

Inner

Outer

Ensure that you position the ankles so that the inner ankle medial joint is higher than the outer lateral joint. See also the section on the leg and foot.

5 PERSPECTIVE AND ANATOMICAL DRAWING

Perspective drawing is a technique used to draw spatial volume and depth. It is a framework that some people use to draw the world in a way that creates the impression of distance and three-dimensional space. As a technique, it allows you to accurately draw a three-dimensional object or environment on a two-dimensional plane such as a piece of paper. There are three main types of perspective drawing: one-point perspective, two-point perspective and three-point perspective (although multi-point perspectives can also be used to create fascinating optical illusions and effects).

PERSPECTIVE

One-point and two-point perspectives are the most commonly used in the context of anatomical or observational drawing. What is meant by a perspective point is a point in the horizon (or eye line) where parallel lines would converge (get closer together) and meet at a point. Linear or point-projection perspective comes from the Latin word *perspicere* which means 'to see through' (like the word *perceive*, which means 'to see').

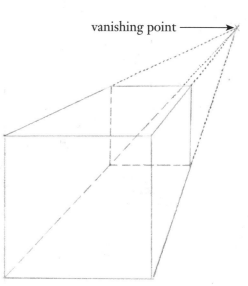

vanishing point

POINT PERSPECTIVE

Linear or point-projection perspective is interesting because it requires the use of a kind of visual mathematical framework to help us create approximate representations of volume, depth and space. A characteristic feature of point perspective is that it helps us to draw objects as proportionally smaller the further they are from the observer. Objects drawn in this way are said to be foreshortened.

All objects drawn using point-perspective techniques will recede (get smaller) to specified points in the distance (maybe there is one point, maybe two), and parallel lines will converge towards the horizon line. One-point perspective contains only one vanishing point (a point towards which all objects get smaller), two-point perspective includes two, and three-point contains three.

Two-point perspective, showing two vanishing points.

ELLIPSES

In the example below, you can see how we can visualise transverse sections in the arm using ellipses. The ellipse (a circular form seen at an angle) can help to gauge the volume of the arm. This kind of exercise in thinking, visualising and sketching while observing the body – or a part of the body, like an arm – encourages us to realise that, when drawing an outline of part of a body, it does indeed contain volume that is not depicted by an outline.

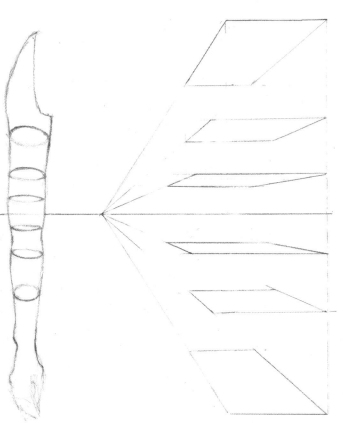

Behind the arm you can see a horizon line has been drawn. At this point, you are looking at an ellipse edge on. The image also includes rectangles drawn in perspective at various heights above and below the horizontal line. You can compare the perspectival differences between the rectangles and the ellipses drawn in the arm to help you to understand ellipses in more depth. Drawing your own images like this might also be helpful, but remember that perspective is a visual mode of representation and doesn't need to be done in perfect mathematical accuracy for it to be effective becuase it is all about illusion: using this kind of drawing we can trick the viewer into seeing depth and volume.

Examples of two-point perspective applied to geometric shapes.

PRACTISING PERSPECTIVE

Perspective drawing looks difficult, but like all skills, it is just about practice and technique. Perspective is more often associated with the drawing of architecture, large structures and landscapes, but it can offer an interesting and useful method for making something look three-dimensional on a two-dimensional surface such as paper.

Sometimes the pose of a figure you are drawing might look foreshortened (an arm or leg or part of the body might be positioned moving away or towards you), and perspective drawing can help to make foreshortened features look more realistic.

You might also be interested in drawing a figure in an architectural or scenic environment, in which case perspective is also useful.

Applying two-point perspective to a figure.

Perspective images are 'worked out' usually using a sharp or mechanical pencil and a good ruler. Perspective works according to a particular vanishing point, and we decide where we put these vanishing points. We can put them anywhere we choose to look when creating a drawing.

Don't restrict yourself by getting bogged down with perspective drawing and accuracy. You'll find that simply moving your posture while sitting – and even breathing – will alter (ever so slightly) what you are observing. So it's best to be loose with perspective when applied to anatomical drawing, and just use it as a way of interpreting volume and translating it into a drawing on paper.

PERSPECTIVE AND VIEWING ANGLE OF A DRAWING

If you look down at someone's head, the parts closest to you will appear slightly larger. Your seated or standing position is as important as your model's and must be able to incorporate flexibility. Photographs can be used as references to get structures into their correct positions.

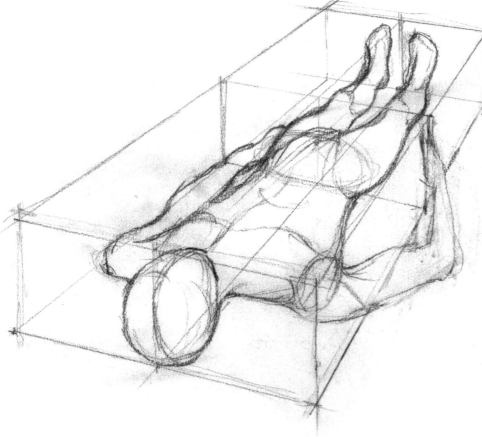

FORESHORTENING

Using perspective can help create an accurate foreshortened figure. The head, feet or other structures are in the foreground, creating relative sizes in a drawing that look out of proportion.

In the foreshortened figure, the proportions of your model look distorted. Those in the foreground look enlarged, while structures in the distance look strangely small.

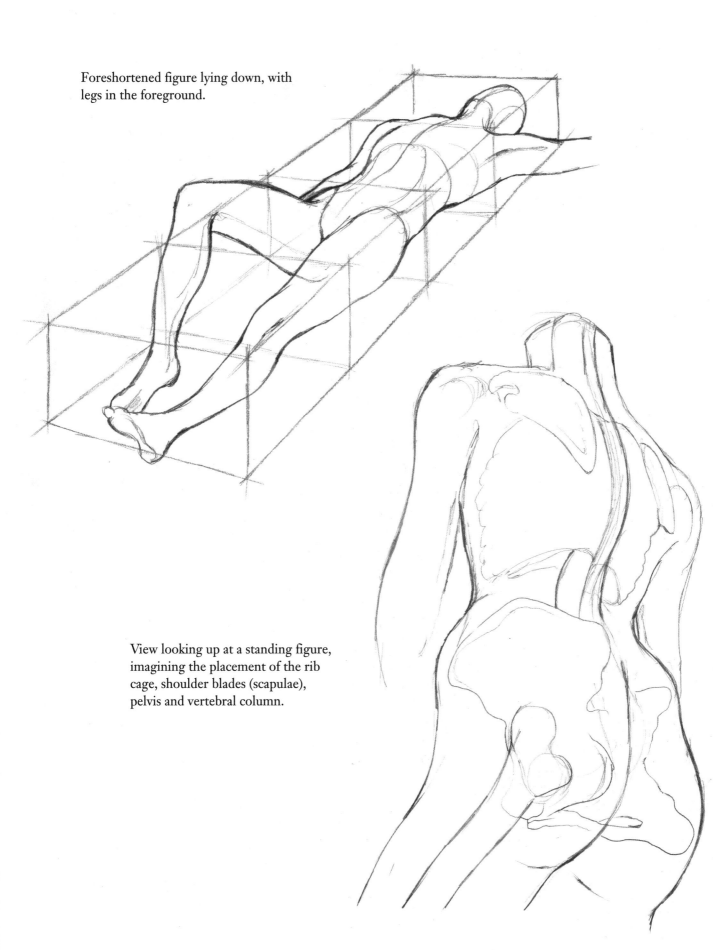

Foreshortened figure lying down, with legs in the foreground.

View looking up at a standing figure, imagining the placement of the rib cage, shoulder blades (scapulae), pelvis and vertebral column.

6 TONE AND SHADING

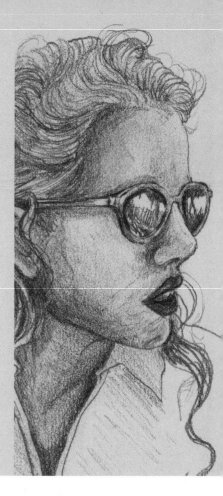

A very good exercise for practising tone is to create a tonal ladder, whereby you use a drawing tool to create a blended tone of the deepest, most intense tone you can. You gradually get lighter and lighter until the shading fades off into nothing, leaving the colour of the page. Tone is used to portray the effects of light and shadow, to capture skin tones and textures of skin and hair. The examples below are created using an HB pencil; try this to build up layers of shading, rather than pressing very hard to create an area of intense tone. Excessive force will distort the surface of the paper and also makes it very difficult to rub out anything that you want to remove from your drawing.

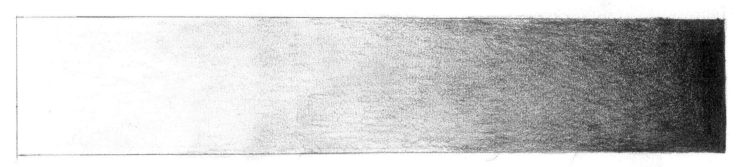

The same principle of blending a gradient applies to anything you want to draw (whether it is observed or imagined). You can see in this example of a ball and shadow how the different intensities of shadow and light are marked out with a light outline. These can then be shaded and blended, as shown in the completed image.

Blending exercises such as the blended tonal ladder (or gradient) shown above can help you practise how light and dark a pencil can be. You can try this with all kinds of different pencil weights and drawing tools. If you enjoy drawing 'little and often', you can consider practising these when you don't feel like doing anything observational.

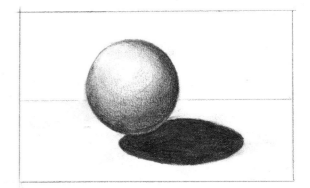

TONAL LADDERS

Experiment to create a blended tonal ladder as well as a tonal ladder in which all the shades are in boxes alongside each other. This exercise can be varied by reducing or increasing the number of boxes you fill; this can make it quite difficult to estimate what intensity of tone to create. Practise creating tone using pencil, ink scribbles and ink wash.

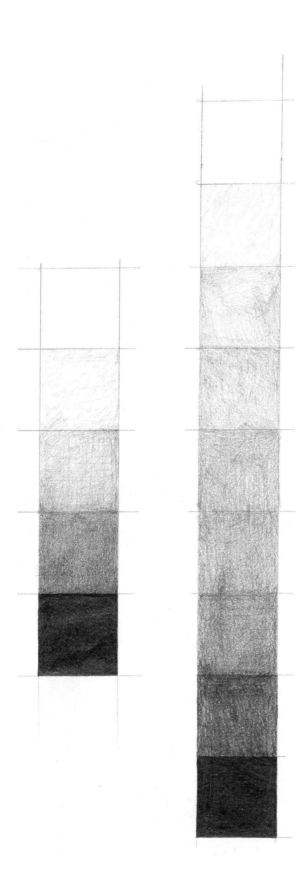

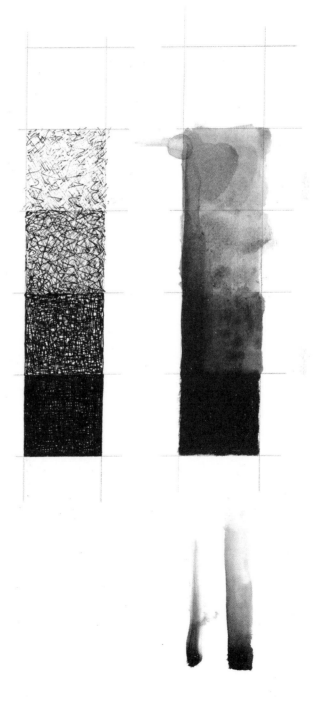

CONTRAST AND GRADIENTS

Tonal contrast and gradients can be used to create all kinds of optical effects, such as chrome and 3D.

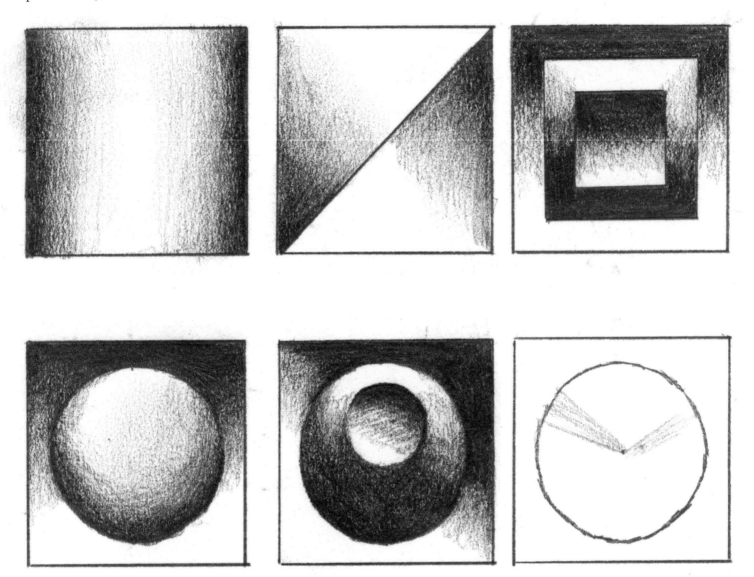

USING PUTTY ERASERS AND HARD ERASERS

A putty eraser is a soft, malleable eraser that can be squashed into different shapes. It can be gently pressed, squashed into a point and wiped over a drawing and on top of your tonal work to carefully lift away layers of graphics and lighten sections that are highlighted. You can use both a putty eraser and a hard eraser to create highlights in your drawings, and you'll find that blending or removing graphite from the page can really fine-tune a tonal study. A putty eraser works like the opposite of a soft pencil; it is quite sticky and will gently lift away more material from a drawing than a hard rubber, using less force and friction against the page.

LIGHT AND SHADOW

Another useful exercise is to study a simple object with light pointing at it from different angles. Remember not to press hard, but build up tone by layering and using different pencil weights, if you can. A softer pencil will create a more intense area of shadow in a drawing compared to a harder pencil. A combination of both can be used to create a blend of intermediate, graduating tones that eventually blend into the tone of the page. Use an eraser to create a night light, if you need to. Sometimes creating tone becomes a back-and-forth process between pencil and eraser.

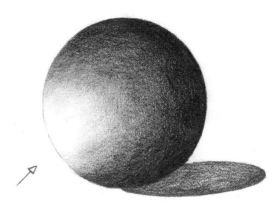

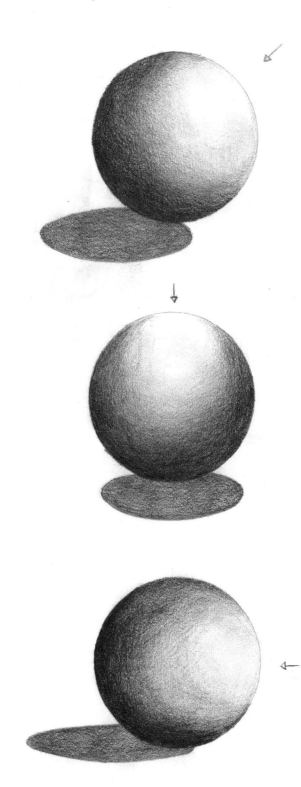

THINK OF DRAWINGS AS A SCULPTURAL ACTION

It's helpful to be as tactile as possible when drawing. You may need to use your imagination for this, but try imagining you are sculpting when you draw. Imagine you are sculpting into the page when you add tone, so that you are creating a deep shadow. Imagine that every mark you make is removing material from a 3D form, even though you are doing the exact opposite – adding material to a 2D page. Imagine that when you use your erasers and blend graphite that you are squashing material in the same way that you would clay. This act of imagining helps some people 'get into' a drawing.

TONAL MARK-MAKING

Marks and textures on a living subject or object that you are drawing can affect the appearance of tone.

Hatching

Cross-hatching

Stippling

Circular scribbles

Hatching is the use of fine parallel lines close to each other.

Cross-hatching is an extension of hatching, using parallel lines crossing over each other at an angle.

Stippling is a drawing technique that uses nothing but dots to build up tone.

Charcoal blend uses a piece of paper or tissue to blend tone from dark to light.

Random marks are lines, marks or scribbles used seemingly at random to create tone.

Circular scribbles are useful for creating texture and tone.

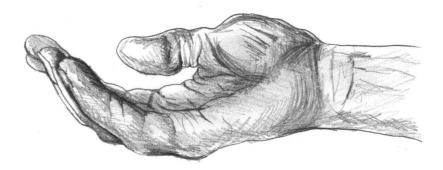

TONAL OUTLINES

Making a tonal outline is a useful technique when beginning a tonal drawing. Create an outline of the structure and angle of your figure (or head in this example), then softly draw in the wiggly outlines of different tones. The resulting drawing will look something like a 'paint by numbers'.

After this, tonal outlines are drawn out. It's just a matter of applying the range of your tonal ladder to the image.

Ensure you use the whole tonal range of HB first, then add softer (darker) or harder (lighter) pencils where necessary.

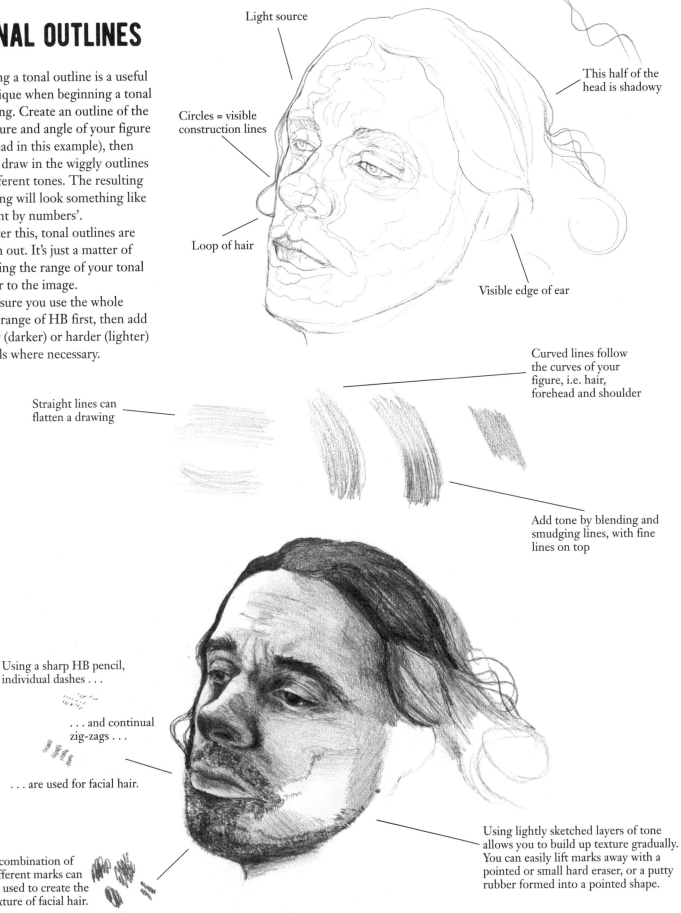

Light source

This half of the head is shadowy

Circles = visible construction lines

Loop of hair

Visible edge of ear

Curved lines follow the curves of your figure, i.e. hair, forehead and shoulder

Straight lines can flatten a drawing

Add tone by blending and smudging lines, with fine lines on top

Using a sharp HB pencil, individual dashes . . .

. . . and continual zig-zags . . .

. . . are used for facial hair.

A combination of different marks can be used to create the texture of facial hair.

Using lightly sketched layers of tone allows you to build up texture gradually. You can easily lift marks away with a pointed or small hard eraser, or a putty rubber formed into a pointed shape.

BUILDING UP TONE

The sequence of drawings here were created using the techniques described on the previous page.

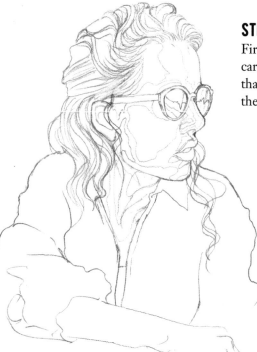

STEP 1

Firstly, create a careful line drawing that delineates all of the tonal areas.

STEP 2

Begin to add tone using a light hatching technique. In the darker areas, build up the tone in layers.

STEP 3

Continue adding tone over the face, leaving just the brightest areas untouched. Blend your shading a little to create a smoother look.

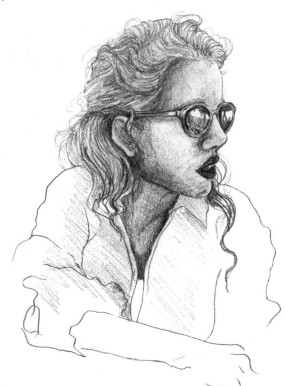

STEP 4

Add the very darkest tones on the lips and sunglasses to give the drawing some depth. Where you have indicated the waves of hair, keep adding lines in the same direction to build up a realistic look. The hair behind the ear and beneath the waves will be darker. Finally pick out any very bright highlights with an eraser.

REFLECTION AND LIGHTING

The images here show how the direction and quality of light can be used to add strength and detail to a portrait.

The skin reflects light. Be attentive to where light sources are coming from, and how reflective skin can be. Sometimes light can reflect under the chin and illuminate areas that might be in shadow under other lighting conditions. The faintest slither of reflection can be made using a putty eraser, or if the reflection is even brighter, a hard eraser in addition to (and after using) a putty eraser. You can even cut erasers into different shapes to help you capture the shape of the reflection you observe.

7 CAPTURING TEXTURE

Creating texture depends on filling in tone and creating a base layer, then layering over this and blending with different marks. Tone, line and mark-making can be used to create any texture, and practising on pillows and fabric can be very helpful. The incomplete example below illustrates potential textures that could be used to draw hair.

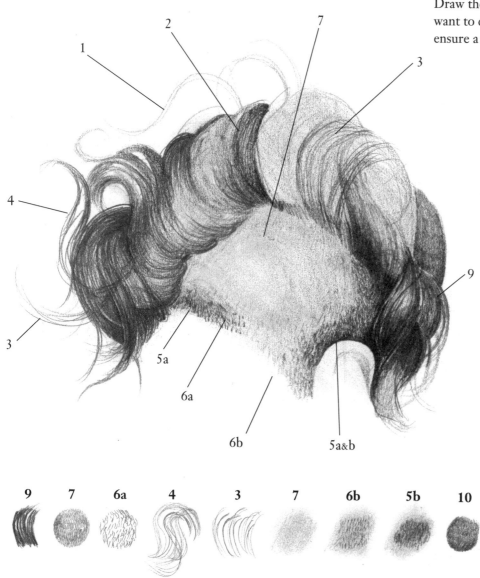

Draw the shape of the object/subject/structure you want to draw, then softly shade it in, smudging to ensure a smooth effect. This is your base layer.

1. Add marks corresponding to the shape you see. In this case, elongated and stretched C-shapes are used to resemble the texture of hair. Vary the weight and thickness of your pencil.
2. Draw darker pencil marks in the direction of the hair.
3. Add marks to create flyaway hairs.
4. S-shaped marks.
5. (a) Add short intense marks for shorter hair.
 (b) Smudge and add more marks to create a thicker effect. Create darker layers of marks.
6. (a) Add short marks for shorter hair.
 (b) Smudge and add more marks to create a thick but lighter coloured effect for a highlight. Create lighter layers of marks.
7. Smudge to create a blended tone.
8. Add light marks to create a sense of depth. This can be achieved using a putty rubber.
9. Add dark marks to emphasise different thicknesses of hair, to create a more realistic texture.
10. Add shadows where necessary. Repeat these steps in any order to build up to complete your image.

STILL LIFE TO HELP PRACTISE TEXTURES

Drawing a fruit such as a tangerine or orange can be useful in practising anatomical drawing. Just like bodies, fruit and vegetables can have textured skin and can be covered in intriguing bumps. The segments allow light through ever so slightly and are softly illuminated from the inside, which is an interesting effect to try to capture in pencil. The skin of some fruit is also similar to human skin in some ways: oranges have pores, can be oily and have bumps and some scratched textures on them. If you wish, consider practising drawing fruit – whether it's ten minutes a day or ten minutes a week. Drawing something with a different texture such as a pillow, a smooth egg or a spikey pineapple would be a contrasting challenge too.

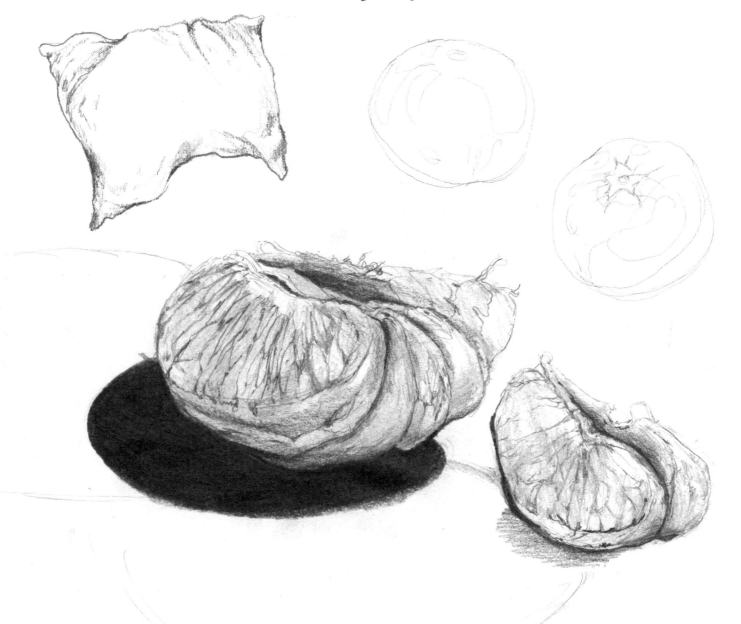

STRUCTURE AND TEXTURE

These drawings show a dried cut flower and an eye.
Practising drawing any organic texture – be it fruit,
plants or eyes – will help you hone your skills.

Dried or dead flowers can be lovely
to draw; consider drawing cut flowers
repeatedly, from when they are fresh and
alive to when they die, so that you can
capture organic textures as they change.
Decay can be a fascinating subject for
drawing as well.

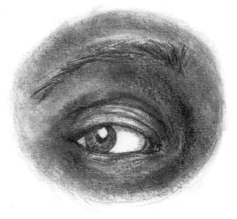

Drawing an eye will allow you to
practise blending skin tones and making
deep shadows as well as working on
texture in the hairs of the eyebrow and
creating the highlight inside the eye.

ORGANIC TEXTURE

These drawings are of vertebrae. When you study bones, you will see that they have slightly truncated parts or areas; this is to spread out weight distribution and thus reduce the strain on other parts of the body. Drawing bones (or stones or shells if you don't want to draw bones) is another way to practise your drawing skills on harder, naturally formed or organic materials. Combine blended pencil shading using a blending tool (a tissue, finger or a putty eraser) to create a smooth base effect. You can add shade marks that capture the texture and then a sharp pencil to add details of the texture.

TEXTURE AND MARK-MAKING AND LAYERING

The example on this page is of a close-up view of the left-hand side of someone's face, showing part of the nostrils and the cheek to the left of the drawing. A range of marks have been used in this drawing, including: small dots to create the faint texture of pores that you cannot quite see but whicht still create a texture; larger dots for pores and possibly scars that are more visible; circular marks to emphasis the curvature of the forms we see (cheek, nostril etc), and hatching with a very soft pencil. All these marks are blended variously depending on what details and textures can be observed.

INK AND BRUSH: TEXTURE AND LINE WORK

A number of techniques can be used in drawing texture, but in this example only one of the visual elements is being used – line. Line work can create texture by using different kinds of marks such as lines, dots and dashes. As you may have guessed from previous examples looking at line, of course it is possible to also apply cross-hatching, blending and points to create texture.

The images here may seem more stylised and suited to illustrations, but they are fun to do. Sometimes with these sorts of drawings, better results are achieved with a 'less is more' approach.

Open space to show where the light is hitting

Thicker line for the back of the head

Broken lines of various thicknesses

Combination of layering of lines and dots

Combined solid tones with more sparse line for a more painterly effect

Stray hairs

Lines + dots = texture

Lighter dots to create shadow

Curved short lines for eyebrows and eyelashes

Short dashes to create beard texture (no actual 'outline' per se)

DEPTH AND TEXTURE

Texture has a different appearance depending on how close or far away it is to you. The further away something is, the less detail you can actually see. So it's alright to simplify fine details or blur part of an image in a way that is similar to a 'soft focus'.

TEXTURE OF THE IRIS

In humans and many types of mammals and birds, the iris (plural: irises or irides) controls the amount of light that enters the eye and is sensed by the retina. We will return to the eye, but it is an interesting example of texture because the eye is comprised of layers of thin, circular and radial muscles which relax and contract to control the diameter and size of the pupil. Eye colour is defined by the iris. Drawing the iris requires a layering technique starting with line, then tone.

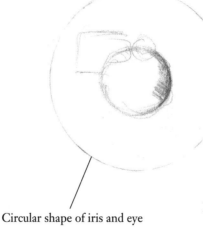

Circular shape of iris and eye

Circular shading to follow shape of iris

Filling in of background texture radially

Radial marks to mimic texture of iris

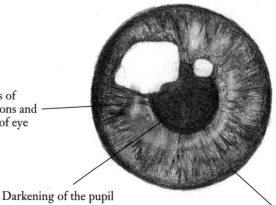

Details of directions and layers of eye

Darkening of the pupil

Smudging of fine layers of texture

HAIR: STEP BY STEP

The three images of hair shown on the following pages demonstrate some layering and blending techniques. We will return to hair in more detail later in the book.

IMAGE 1

◆ Begin with an outline.

◆ Add the first background layer of tone and texture.

◆ In this example of afro hair, fill in the area within your outline with both loose and tight circular marks in order to follow the shape and structure of the curls. Use whichever marks best match the shape of whatever you are drawing.

◆ Eventually, you will cover the whole area with a base layer. In this example, the entire area within the outline will be covered with this texture and tone.

◆ When the area is filled, blend this first layer together, then add more circular marks on top of this blended layer.

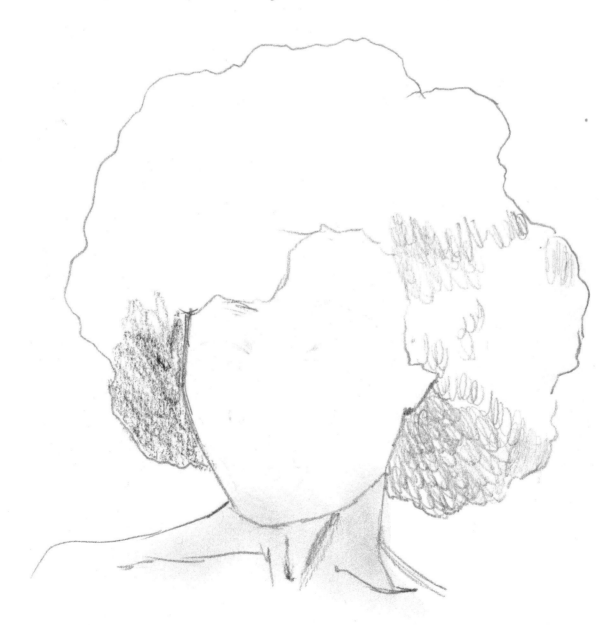

IMAGE 2

◆ Keep layering your circular marks and blending them. Repeat two or three times. Don't press too hard at this stage; use layering to create intensity and darker areas, rather than forcing with the pencil.

◆ Begin to add lines or circles that can guide curls, details and textures that you want to emphasise. Do this over the whole shaded area within your outline.

◆ On the left-hand side of this second image, you can see some thick blended lines moving out from the face towards the outline of the hair. This acts as a kind of scaffold that you can use to slowly draw the shape of the curls.

◆ Using a wavy line, try to capture some of the stray curls.

◆ Make sure you don't over-structure your drawing at this stage, or it will look too rigid.

◆ Soften the marks you make as they pass over your outline; this enables you to create the effect of softness.

IMAGE 3

◆ Repeat the previous steps until the hair area is filled. Now refine your drawing.

◆ Using a putty eraser, remove some of the pencil marks in order to try to represent the reflections of light on the curls.

◆ Draw more wavy lines or relevant marks to capture the detail of how the hair falls around the face. Draw this gently, and repeat your lines and marks over each other to create more definitions.

◆ Look at your model and shade in any darker areas using small, soft, round marks. In my drawing, I had to build up tone particularly nearer the scalp, as there was more overlapping hair and more shadows on this area of the hair.

◆ Create soft hair ends by pressing lightly with your pencil, past where the outline was previously visible.

◆ Blend areas that do not look as tight and defined as other areas, that is, those that appear softer and fuzzier.

WHAT NEXT?

To improve this drawing, I would add more tiny highlights on some of the curls. You can do this by using either a putty eraser or a white pencil.

8 CONTOUR, POSE AND GESTURE

Together, these three elements help create an expressive image. Contour is mainly concerned with outline, pose is the shape that the model's body takes on, while gesture gives expression to the pose. Practising exercises in the chapter on line will help you to develop more confidence in using just a single stroke; it will help you to learn your skills and build confidence in using them.

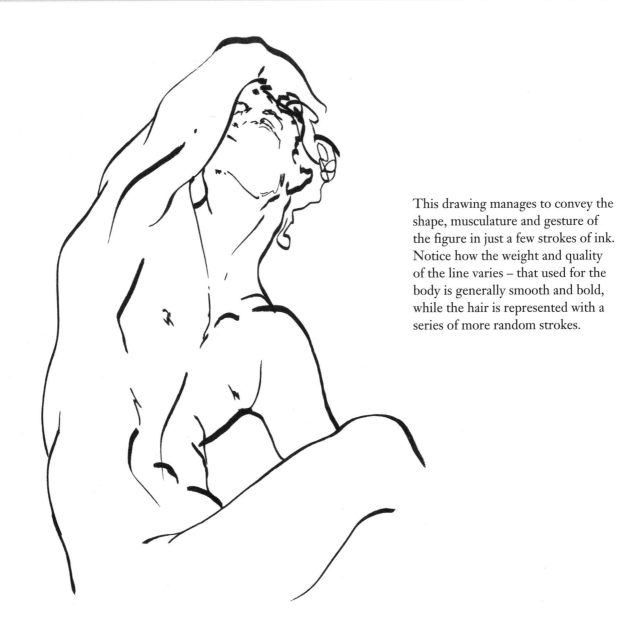

This drawing manages to convey the shape, musculature and gesture of the figure in just a few strokes of ink. Notice how the weight and quality of the line varies – that used for the body is generally smooth and bold, while the hair is represented with a series of more random strokes.

You can use a block of ink, pencil or whatever medium you are working in to fill in sections such as hair

DRAWING USING CONTOUR

Contour drawing is an interesting activity because you only want to capture outline and the gesture or feeling of the pose. Practising this can help you to create very expressive images. Don't worry about realism in all features.

Use simple line within the contours to outline shadows

Vary the weight of your line

Use a broken line if you like

DRAWING GESTURE

A gestural drawing is one that captures the action, form and pose of a moving figure. Typically, an artist may want to draw a series of drawings and poses, studying what muscles, fat and bones are prominent in certain positions. A drawing may be made in as quickly as ten seconds or as long as five minutes, depending on the intention of the artist.

To capture movement, it is important to think about how weight is distributed across the body of the model. Observe if there is more weight on one side than the other. If it is possible for you try to put yourself into the same pose as the model, this will give you an even greater understanding of how the pose affects the body. Some poses are very difficult to hold for a long time, so you must be conscious of this and aware of the needs of your model. Photographs may be useful from different angles in order to be able to recreate the pose or go back to it at a later time, or even with a different model.

With their permission or using a device owned by them, photography can be used to help models remember their poses. But if there is a slight difference in the pose between sittings, then it is up to the artist to make it work and to approximate the pose using their understanding of the body. The creation of careful studies of a body is a collaboration between the artist and the sitter. It's not as simple as just lying down or simply sitting there.

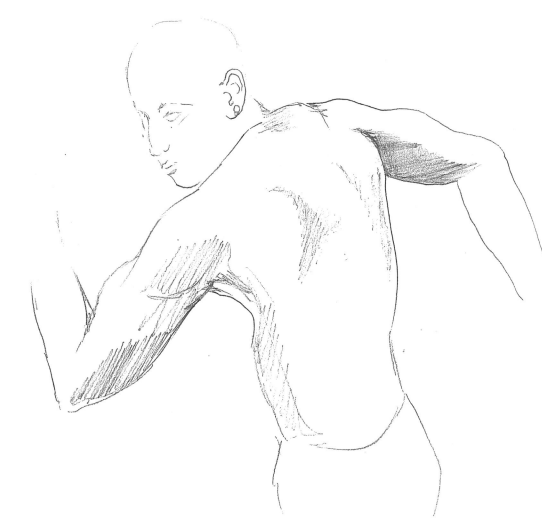

PLACING THE MODEL

Unless there is contrast in light or colour in a drawing, it is difficult for the eye to discern details, shapes and definition. For example, if you want to draw your own hand, place it on a plain piece of paper so that you are only focusing on the hand when you draw. For a larger-scale drawing of a whole person, you might want to include a simple background. In one sitting you might establish the foundations of a drawing, but you will probably need to return to the pose several times to finish your work.

Seated and still figures can still be gestural. In this image you can see how the line of the back of the head curves outwards, then curves in at the neck and back out again around the top of back (this curve is created by the scapula, trapezius and curvatures of the spine due to the rib cage). Creating fluid or sketched lines to match such curves is useful to practise, particularly when you are creating rapid sketches. More detail has been added to this drawing but it began with gestural curved lines.

9 PROPORTIONS AND THE HUMAN FIGURE

Proportions are important in anatomical drawing, but they are not the most important thing. If you are aiming to create drawings that are realistic, proportions are certainly useful. One interesting fact is that the relationship between the length of some individuals' outstretched arms is very similar to their total height: this proportion is very consistent between individuals.

Ideas about proportions do not indicate an abstract idea of 'truth' or the ideal body, but rather they reflect our similarities and should therefore just be seen as guidelines. It is not true that every human has exactly the same anatomical proportions, but many adult humans measure between seven to eight lengths of their own head. Proportions for adult humans with dwarfism will differ from this. The proportions of individuals also vary from childhood to adulthood and into old age, as our bodies change throughout our lives.

THE 'RULE OF THUMB' AND 'ANATOMICAL YARD STICKS'

The 'rule of thumb' (see also page 21) makes use of a pencil, thumb and your straight, outstretched arm to approximate how many versions of your model's head would fit stacked one on top of the other. The length (or width) of the head can be measured using the rule of thumb and used as an 'anatomical yard stick' to help you create a representation of what you see. In fact, different parts of the sitter's body can be used to compare relative sizes (using the rule of thumb) to help you check that the proportions you draw make sense to you. The images opposite shows some examples of 'anatomical yard sticks' (and there are infinite possibilities) being used with the 'rule of thumb'.

PROPORTIONS OF *SOME* BODIES

The examples below illustrate how some human proportions can be drawn using circles and squares. Leonardo da Vinci's *Vitruvian Man* is one of the best-known artistic representations of what, at the time, was said to be the human body in perfect proportion. While *Vitruvian Man* is problematic for what it has come to symbolise, the circles and squares that it features are useful for mapping out the symmetries of any standing or seated figure. The proportions of the head, arm, trunk, leg span and height of your model can be measured using circles and squares.

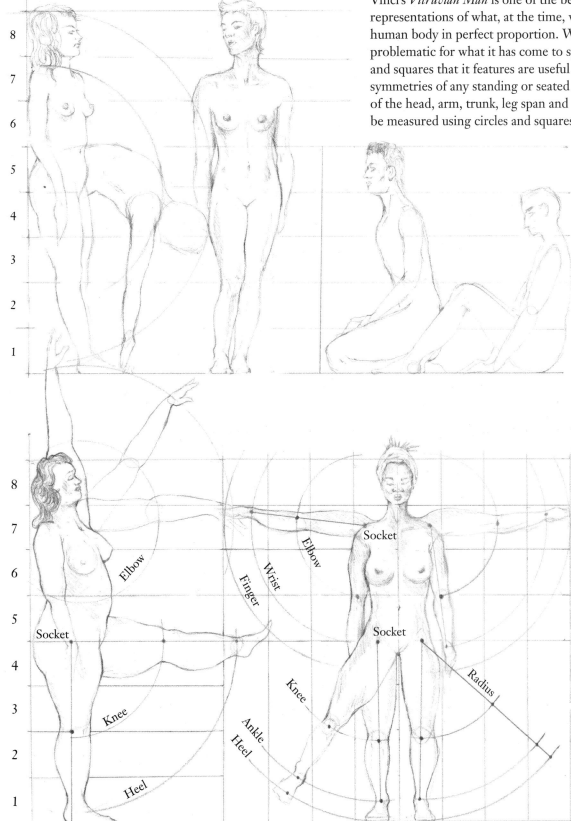

Use sockets to visualise points from which an arc can be sketched.

DIVIDING THE BODY INTO EQUAL SECTIONS: SIDE VIEW

Whoever you draw and whatever their sex, gender, age, ethnicity, weight or whether they are disabled or able-bodied, the the only rule is to make a rule for each person you draw. Use the rule of thumb to figure out how many heads lengths fit from their head to their ankle or feet. Hair may even act as another feature and add more height to a person. These illustrations show two people standing, with a grid superposed over their bodies to show that eight head lengths fit into their heights from head to heel.

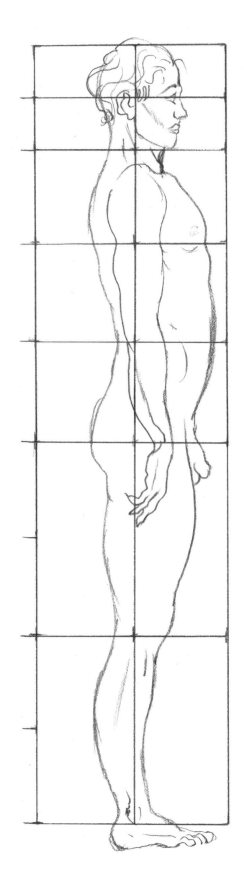
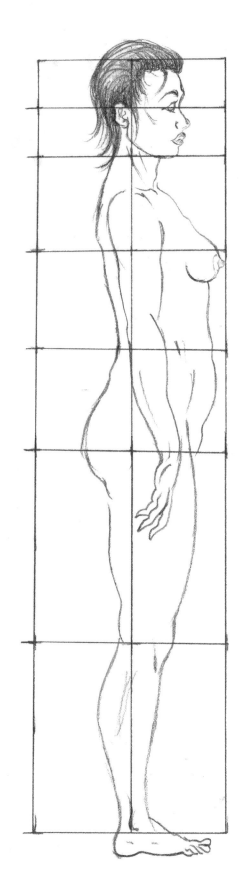

POSTERIOR VIEW

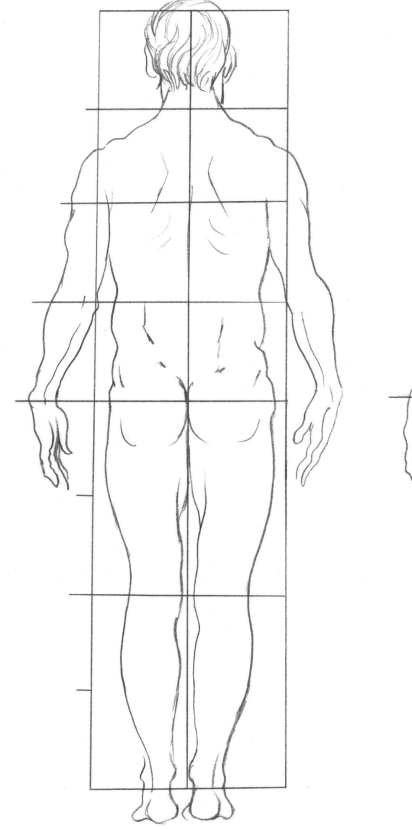

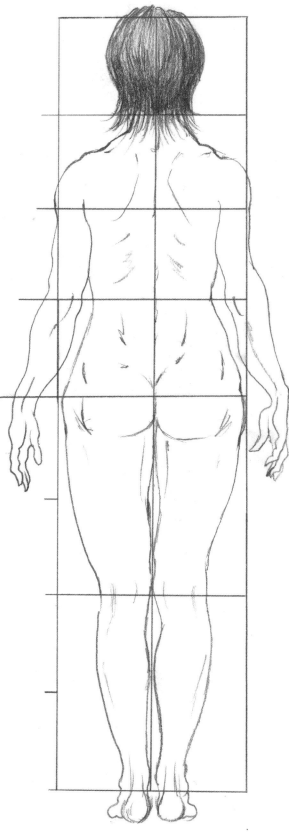

USING A CIRCLE TO MEASURE PROPORTIONS

Chin

Chin

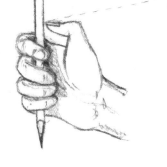

The application of the 'rule of thumb' can help resolve issues of proportion. Ensure that if you use this measurement technique, you do so with a fully extended arm. Regardless of the individual proportions of your model, you can use this technique to see if you are capturing scale and proportion as you see it. This rule of thumb gives you an anatomical yardstick to use to keep drawings in proportion.

Scaled figures may be in a pose with a twist in the spine, but the rule of thumb can still be used.

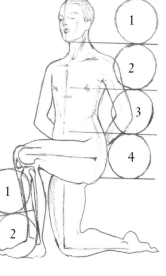

One head height's width

From the knee bone to the floor, you can fit two heads.

Be attentive to any limbs at right angles, or if these angles are smaller than 90.

Top of head

Bottom of foot

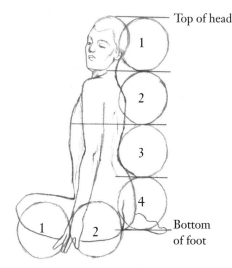

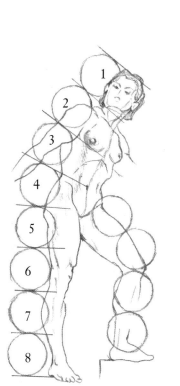

½

Not everyone's height is exactly eight heads; you may find that some are seven-and-a-half heads in height.

LANDMARKS

Using the rule of thumb to compare individual proportions, you can measure a foot, width of the pelvis, length of the shin or forearm of whatever anatomical structure is clearly visible from where you are drawing. Perhaps your model's hand is the same distance as their chin to their hair line. Perhaps their feet are as long as their head. Everyone is different but can be drawn using the same techniques and approach to measurement, if you want to create something that accurately captures their proportions.

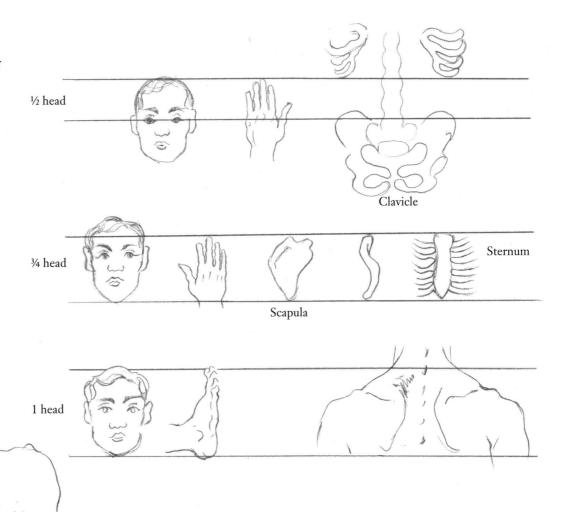

½ head

¾ head

1 head

Clavicle

Sternum

Scapula

Create an anatomical yardstick for each drawing. Maybe the height of two heads fits in the distance between the knee and the ankle. Maybe this same length can be used to compare the distance between the fingertips and the elbow, or the top of the knee and the groin.

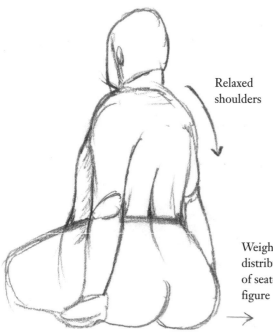

Relaxed
shoulders

Weight
distribution
of seated
figure

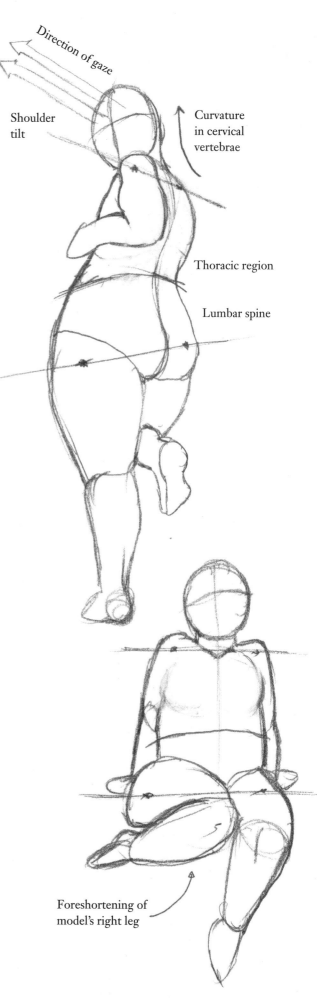

Direction of gaze

Shoulder
tilt

Curvature
in cervical
vertebrae

Thoracic region

Lumbar spine

Hip tilt

POSE AND GESTURE

Drawing an expressive figure is all about capturing the pose
and gesture (or movement) in your drawing. Shoulder tilt,
hip tilt and possible movement in the different sections of the
vertebrae will help you to capture the pose and gesture of a
figure. The annotated sketches here are examples of these.

Shoulder tilt, hip tilt and
weight distribution of a
reclining figure

Foreshortening of
model's right leg

AGE AND PROPORTIONS

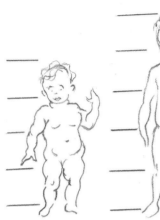

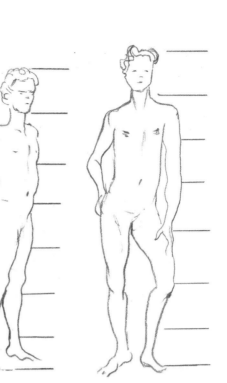

There is no set rule for everyone, but all people change throughout their lives. Babies have a much bigger head in proportion to their bodies, and as they age, their head gets proportionately smaller. These proportions stabilise when we reach adulthood, but the body can go through many more changes that will alter our proportions. People tend to lose some of their height after age 40, although, as with all things anatomy, there is variation to this. Height loss does usually increase further after the age of 70.

1 year 4 years 8 years 12 years

Hormonal changes throughout our lives affect fat distribution in our bodies. Fat distribution is very unique to people's lifestyles and individual biology. Similarly, the proportions of the facial features of babies, toddlers and children differ from the facial proportions of adults and old people. Young humans' eyes appear larger in proportion to those of older people, while older humans have larger ears and noses. The skin on our face and neck also changes with age due to loss of muscle tone and thinning skin.

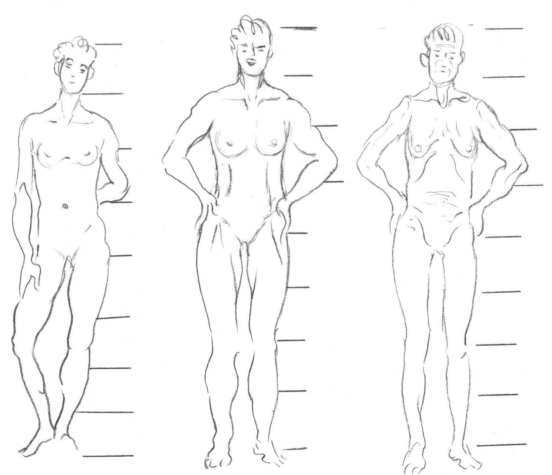

17 years Adult Old age

10 ANATOMY: THE SKELETON

The skeleton is the central structure of the body. The adult skeleton is made up of 206 bones; children have more, which fuse as they approach adulthood. The skeleton is also comprised of joints and cartilage, which provide the framework for muscles and give the body its defined shape. The skeleton has six main functions: support, movement, protection, production of blood cells, storage of minerals and endocrine regulation.

ARTICULATION OF THE SKELETON

The skeleton is made up of two parts: the appendicular skeleton and the axial skeleton. The appendicular skeleton includes the skeletal elements of the limbs and extremities as well as the pectoral and pelvic girdles. The axial skeleton includes the central axis of the skull, the vertebral column (or spine) and the thorax. The vertebral column can be divided into three main sections which enable movement: the cervical, thoracic and lumbar regions. The pelvic region could also be added, as it contains the sacrum and coccyx, but the five vertebrae in the sacrum are fused and do not articulate, and the four tiny vertebrae in the coccyx are also fused.

The cervical region includes the head and neck, and contains seven vertebrae. Neck movement is dictated by the sternocleidomastoid, longus colli and longus capitis for flexion, a concerted effort of the splenius capitis, semispinalis, suboccipitals and trapezius for extension, and the scalenes, sternocleidomastoid and fibres from the trapezius to control lateral bending. All movement in the neck depends on the interactions between the vertebrae and all of these muscles. The cervical spine's range of motion is approximately 80° to 90° of flexion, 70° of extension, 20° to 45° of lateral flexion, and up to 90° of rotation to both sides.

The thoracic region, where the thorax and rib cage are located, contains 12 vertebrae. Motion here is fairly restricted on account of the ribs. Any relative motion of the thoracic vertebrae and the associated ribs both as moving bones (osteokinematics) and moving joints (arthrokinematics) is important in all motions of the trunk. During axial rotation, each rib posteriorly rotates with the rib on the opposite side anteriorly rotating both in space and relative to the vertebrae that comprise the thoracic ring. The ranges of motion just for the thoracic spine include 30° of rotation.

The lumbar region contains five vertebrae and connects to the pelvis. This is where much movement of the back between the hips and ribs occurs. Usual lumbar motion ranges from 60° of flexion, 25° of extension and 25° of lateral (or side) bending.

FRONT VIEW

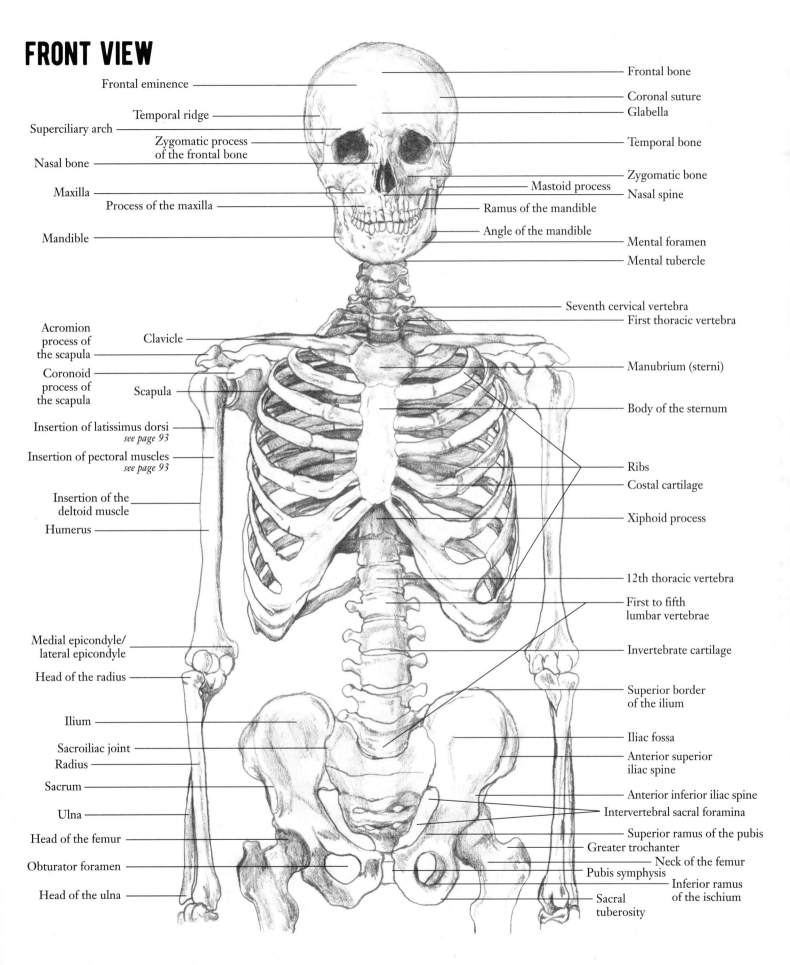

Frontal eminence

Temporal ridge

Superciliary arch

Zygomatic process
of the frontal bone

Nasal bone

Maxilla

Process of the maxilla

Mandible

Frontal bone

Coronal suture

Glabella

Temporal bone

Zygomatic bone

Mastoid process

Nasal spine

Ramus of the mandible

Angle of the mandible

Mental foramen

Mental tubercle

Seventh cervical vertebra

First thoracic vertebra

Acromion
process of
the scapula

Coronoid
process of
the scapula

Clavicle

Scapula

Manubrium (sterni)

Body of the sternum

Insertion of latissimus dorsi
see page 93

Insertion of pectoral muscles
see page 93

Insertion of the
deltoid muscle

Humerus

Ribs

Costal cartilage

Xiphoid process

12th thoracic vertebra

First to fifth
lumbar vertebrae

Invertebrate cartilage

Medial epicondyle/
lateral epicondyle

Head of the radius

Ilium

Sacroiliac joint

Radius

Sacrum

Ulna

Head of the femur

Obturator foramen

Head of the ulna

Superior border
of the ilium

Iliac fossa

Anterior superior
iliac spine

Anterior inferior iliac spine

Intervertebral sacral foramina

Superior ramus of the pubis

Greater trochanter

Neck of the femur

Pubis symphysis

Inferior ramus
of the ischium

Sacral
tuberosity

SKELETAL MOTION OF THE SPINAL CORD

Breaking down complex structures into simple shapes can help us to interpret movement in our drawings, and we all have different mobility. One way to think about this is to think of the body as if the different sections of the head, neck, torso, lumbar spine and pelvis are all strung together like beads on a necklace or mobile. Not all bodies are actually symmetrically structured like the one shown in the images below, but we all move in an articulated and interconnected way.

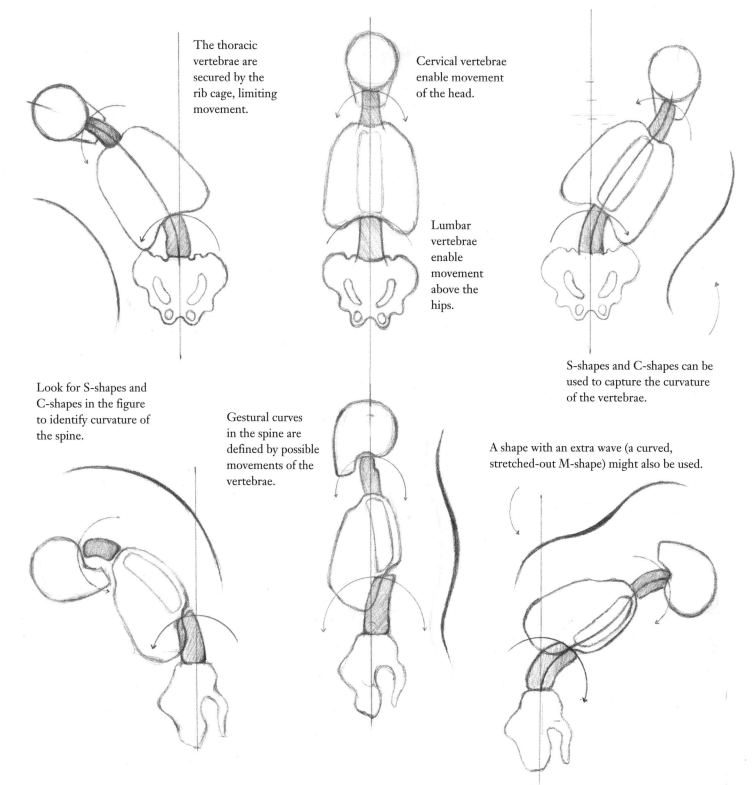

The thoracic vertebrae are secured by the rib cage, limiting movement.

Cervical vertebrae enable movement of the head.

Lumbar vertebrae enable movement above the hips.

S-shapes and C-shapes can be used to capture the curvature of the vertebrae.

Look for S-shapes and C-shapes in the figure to identify curvature of the spine.

Gestural curves in the spine are defined by possible movements of the vertebrae.

A shape with an extra wave (a curved, stretched-out M-shape) might also be used.

SIDE VIEW

Our skeletons support and protect our internal organs and enable us to move around. The shape of each individual skeleton varies from person to person, even though we share a very similar skeletal structure. We are similar but different. Bones are hard, calcified, living tissues, supplied with blood and nerves. They are only properly formed when we reach adulthood, which is around the time the human brain is fully developed. Humans have around 206 bones; some may fuse together, while some of us are born with extra or missing bones. Some people may also have accidents or conditions that change their bones in some way.

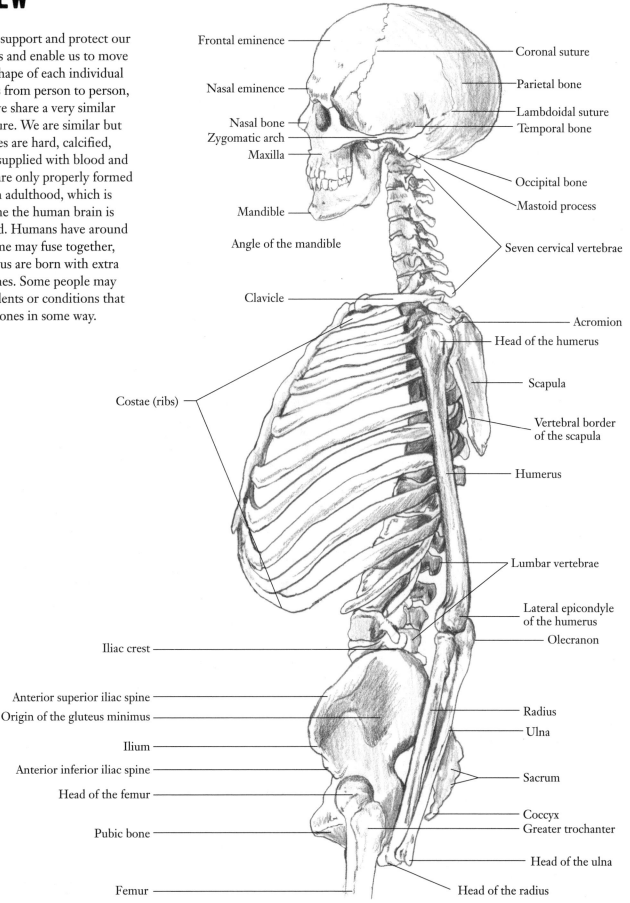

Frontal eminence

Nasal eminence

Nasal bone

Zygomatic arch

Maxilla

Mandible

Angle of the mandible

Clavicle

Costae (ribs)

Iliac crest

Anterior superior iliac spine

Origin of the gluteus minimus

Ilium

Anterior inferior iliac spine

Head of the femur

Pubic bone

Femur

Coronal suture

Parietal bone

Lambdoidal suture

Temporal bone

Occipital bone

Mastoid process

Seven cervical vertebrae

Acromion

Head of the humerus

Scapula

Vertebral border of the scapula

Humerus

Lumbar vertebrae

Lateral epicondyle of the humerus

Olecranon

Radius

Ulna

Sacrum

Coccyx

Greater trochanter

Head of the ulna

Head of the radius

POSTERIOR VIEW

Understanding articulation
helps you to see why certain
poses are possible and why
others are not. This can
inform you as to where weight
is being carried in a figure you
are drawing.

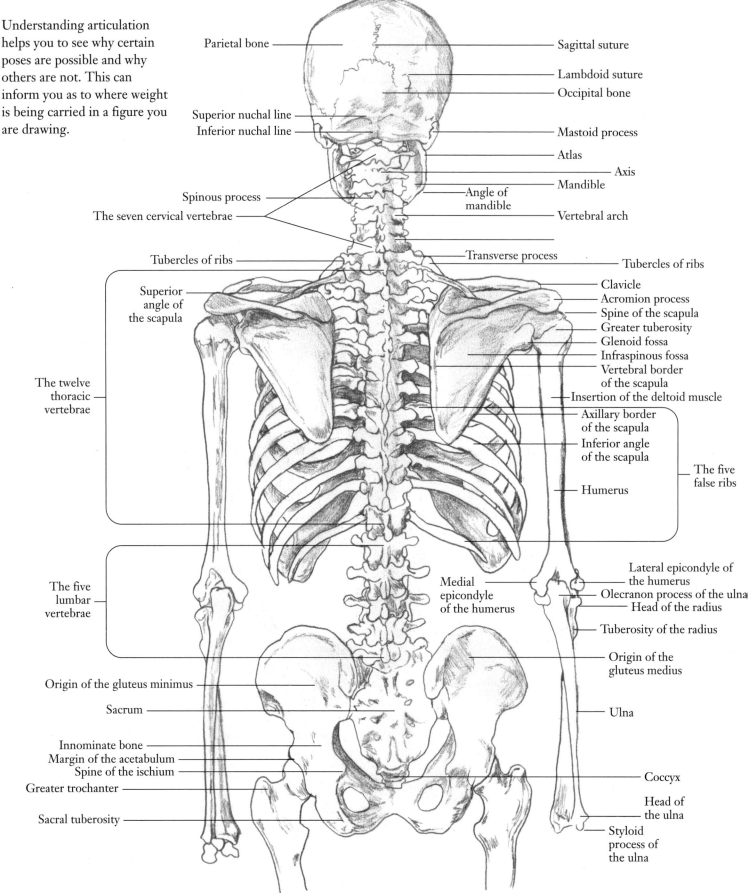

Parietal bone

Sagittal suture

Lambdoid suture

Occipital bone

Superior nuchal line

Inferior nuchal line

Mastoid process

Atlas

Axis

Mandible

Angle of
mandible

Vertebral arch

Spinous process

The seven cervical vertebrae

Tubercles of ribs

Transverse process

Tubercles of ribs

Superior
angle of
the scapula

Clavicle

Acromion process

Spine of the scapula

Greater tuberosity

Glenoid fossa

Infraspinous fossa

Vertebral border
of the scapula

Insertion of the deltoid muscle

Axillary border
of the scapula

Inferior angle
of the scapula

The twelve
thoracic
vertebrae

Humerus

The five
false ribs

The five
lumbar
vertebrae

Medial
epicondyle
of the humerus

Lateral epicondyle of
the humerus

Olecranon process of the ulna

Head of the radius

Tuberosity of the radius

Origin of the
gluteus medius

Origin of the gluteus minimus

Ulna

Sacrum

Innominate bone

Margin of the acetabulum

Spine of the ischium

Coccyx

Greater trochanter

Head of
the ulna

Sacral tuberosity

Styloid
process of
the ulna

THE AXIAL SKELETON

The term *axial* is related to the word 'axis'; as such, bones of the axial skeleton are located along a central axis. As well as providing support and protection for organs of the dorsal and ventral cavities, the axial skeleton provides a surface for the attachment of muscles and parts of the appendicular skeleton which enable movement mainly centred around this axis. Joints form the connections between the bones and enable movement; some joints are termed 'cartilaginous' or' synovial'. A human's axial skeleton is made of 80 bones, and the vertebral column can be divided into the following three sections to make sense of the primary aspects of movement and skeletal function.

◆ **Cervical**: includes the head and bones of the skull (cranium), face, auditory ossicles and hyoid bone. (The head is omitted in the example on this page.)

◆ **Thorax**: includes the rib cage and sternum.

◆ **Lumbar:** connected to the hip girdle or pelvis. In the pelvis, we find the sacrum and coccyx.

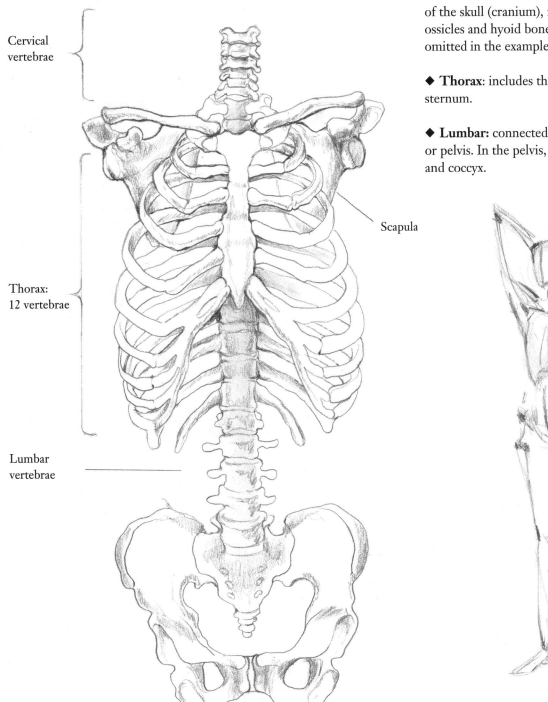

Cervical vertebrae

Scapula

Thorax: 12 vertebrae

Lumbar vertebrae

BONES IN THE TORSO: ROTATIONS

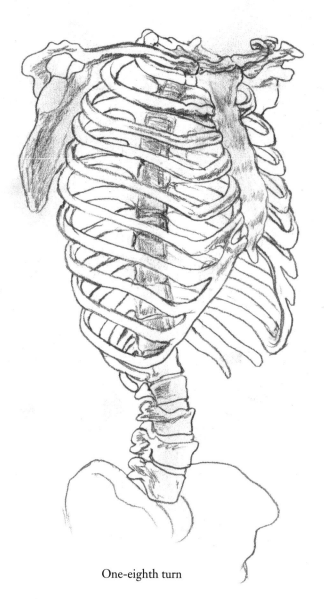

One-eighth turn

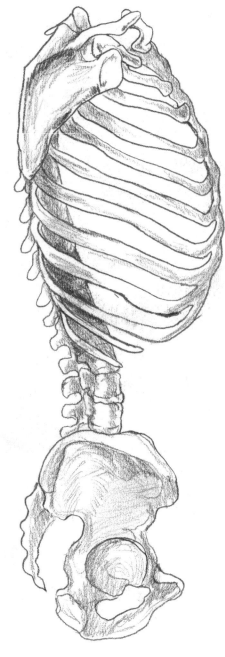

Side view

RIB CAGE

The rib cage is composed of 25 bones that include the 12 pairs of ribs plus the sternum. It functions as protection for the vital organs of the chest, such as the heart and lungs. The rounded ends are attached at joints to the thoracic vertebrae posteriorly, and the flattened ends come together at the sternum anteriorly.

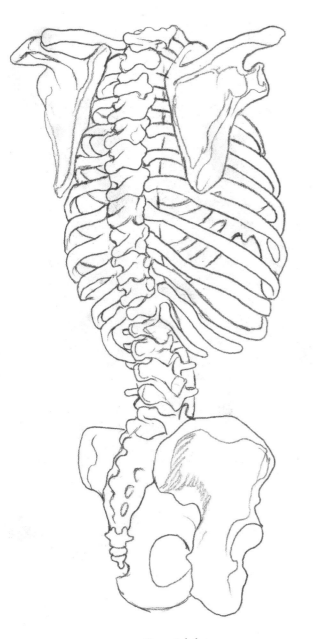

One-eighth turn

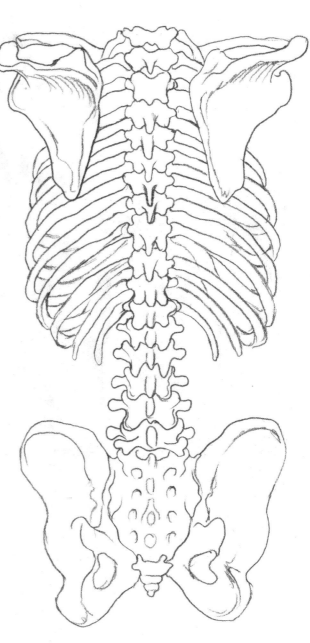

Back view

RIBS: VERTEBRAE 8–19

The first seven pairs of ribs are attached to the sternum with costal cartilage; these are called the 'true ribs'. The ribs increase in length as we move down from 1–7 (or vertebrae 8–14). Ribs 8–10 (or vertebrae 15–17) are connected to each other with noncostal cartilage. The last two ribs (or vertebrae 18 and 19) are called 'floating ribs', as they are not attached to the sternum or to other ribs.

VERTEBRAL COLUMN

There are usually 33 vertebrae in the human vertebral column. The upper 24 vertebrae are articulate, unfused and enable movement. The lower nine are fused and form two distinct structures, the sacrum and the coccyx.

The articulating vertebrae are named according regions:

◆ **1–7:** Cervical vertebrae (seven vertebrae).

◆ **8–19:** Thoracic vertebrae (12 vertebrae).

◆ **20–24:** Lumbar vertebrae (five vertebrae).

The fused vertebrae:

◆ 4 fused in the sacrum.

◆ 5 fused in the coccyx.

The top two vertebrae of the seven cervical vertebrae are the atlas and axis. These provide the head with movement, in addition to giving support to numerous muscles.

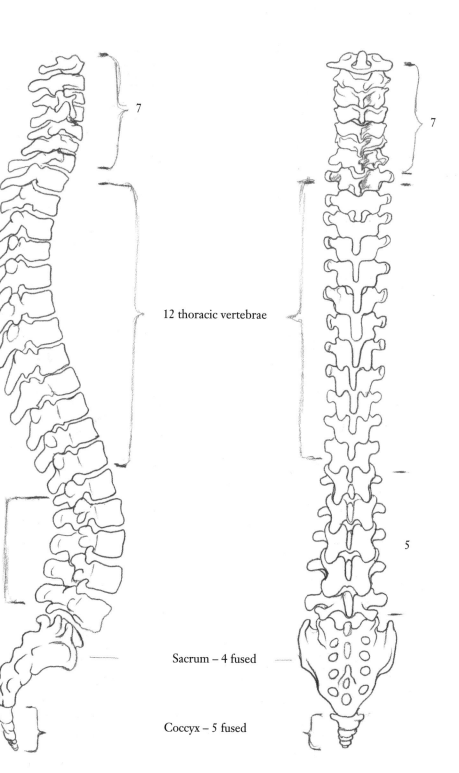

7

12 thoracic vertebrae

5

Sacrum – 4 fused

Coccyx – 5 fused

BIOMECHANICS AND GRAVITY

Biomechanics is the science of movement of a living body. It includes how muscles, bones, tendons and ligaments interact to enable movement. The wider field of kinesiology includes biomechanics, which focuses on the mechanics of the movement.

All life forms on Earth, including humans, constantly experience the universal force of gravity. Thus, our bodies are subject to forces from within and surrounding us. Our centre of gravity sits in the pelvis and falls between our feet. This enables the human skeleton to be bipedal.

The direction of the force of gravity through the body is focused downward towards the Earth's centre. It is important to understand and visualise this line of gravity when determining one's ability to maintain balance. It may affect how your figure is seated or stands, and thus will affect how you draw a figure, be they in mid-motion, standing or seated.

BALANCING AND CENTRE OF GRAVITY

Gravity exerts itself on everything that has mass, and affects our bodies and how they move. The centre of gravity is the point in the body where our body mass is concentrated or focused. Exactly where this is located depends on an individual's body, height, age, etc. Position and relative length of the limbs, as well as the width of the pelvis, will all affect it. In a standing position, the centre of gravity tends to be below the belly button, within the volume of the pelvis. If leaning forward, the centre of gravity will move in order to make it easier to balance – whenever we move, our centre of gravity moves too. Centre of gravity affects posture and pose as well. It varies between a seated person and someone using a wheelchair, and this is important when capturing movement, particularly if the arms are being used in movement.

FORM AND FUNCTION

The form and function of the bones in our bodies are related. For example, the femur or thigh bone is the largest bone in the body and is incredibly strong, and it is crucial in supporting the body's weight and in other lifting tasks. By contrast, the numerous tiny bones in the wrist and hand allow a high degree of flexibility and dexterity.

Deadlift

Squat

Single-leg squat

Reach for
the ground

Lift

TYPES OF JOINTS IN THE HUMAN BODY

The joints connecting the bones of the arms and legs together resemble levers and sockets, and provide similar movement. The shoulder blade (or scapula) is connected to the rib cage using muscles and tendons that allow it to move in all directions. Here, we can see how form matches function.

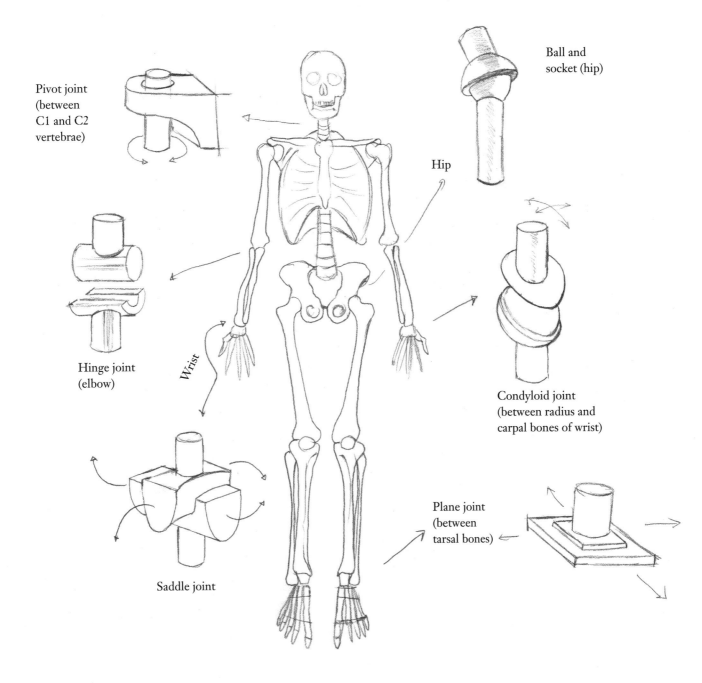

Ball and socket (hip)

Pivot joint (between C1 and C2 vertebrae)

Hip

Hinge joint (elbow)

Wrist

Condyloid joint (between radius and carpal bones of wrist)

Saddle joint

Plane joint (between tarsal bones)

BONE STRUCTURE, JOINTS AND WEIGHT DISTRIBUTION THROUGH THE BODY

Most joint types are known as synovial joints. They contain synovial fluid that lubricates the cartilaginous surface of the bones to allow movement. In a few other joints such as the sutures in the skull there is no appreciable movement. The principal movements of the joints are *flexion*, which means bending to an acute angle; *extension* or straightening; *adduction*, which means moving towards the body's midline; *abduction*, which means moving away from the midline; and *medial and lateral rotation*, or turning towards and away from the midline.

DIFFERENT JOINT TYPES

Plane joint: formed by flat or slightly curved surfaces, allowing a small amount of movement.

Socket joint: arc of the bone moving in a spherical excavation of another, such as the hip joint movement.

Saddle or biaxial joint: gives limited movement in two directions at right angles to each other. Where people are double-jointed or even triple-jointed, they might have more movement in their thumb.

Hinge joint: bending and straightening movement is possible on one plane only. such as in the knee, elbow or the fingers.

Pivot joints: one bone moves around another on its own axis, such as the radius and ulna.

In this image, you can see some of the possible movements allowed by certain joints. The knees and elbows are limited to the movement of a hinge, while the extent of the shoulder and hip joints can be more far-ranging.

FORESHORTENED DRAWING OF THE BONES OF THE LEG

We have discussed foreshortening on previous pages. This image of the femur, knee bone and lower leg bones shows them in perspective, with the hips (top of the femur) further away from the viewer.

When we draw a foreshortened figure, we can make use of converging lines to guide us, but notice how in the image the femurs (thigh bones) do not need to be drawn as converging towards each other because of the space that is between them where the pelvis would be. Rather, the top of each femur bone is drawn smaller. These areas are further away from the viewer relative to the knee or lower leg, so they are drawn smaller.

11 THE MUSCULOSKELETAL SYSTEM

Under gravity and other forces such as weights, loads and actions, movement is achieved through a complex and highly coordinated mechanical interaction between bones, muscles, ligaments and joints within the musculoskeletal system, all controlled by the nervous system. Injury to, or lesions in, any single component of the musculoskeletal system alters the mechanical interactions within the whole system. One minor injury can affect stability and movement.

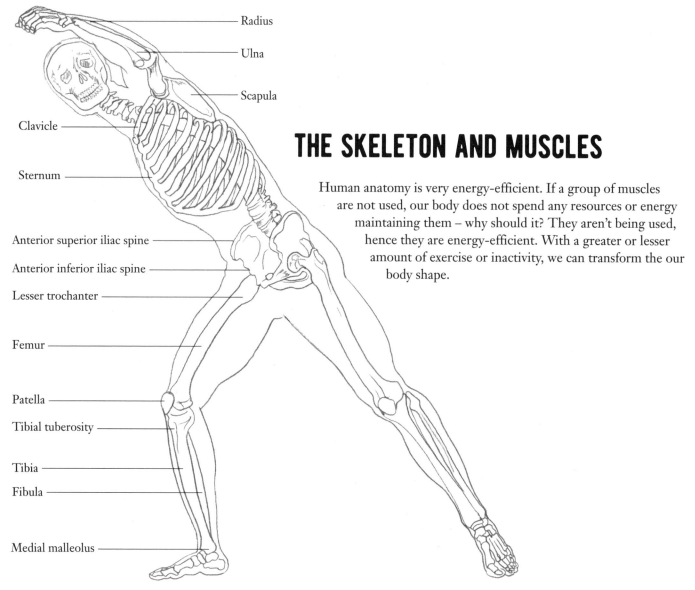

Radius
Ulna
Scapula
Clavicle
Sternum
Anterior superior iliac spine
Anterior inferior iliac spine
Lesser trochanter
Femur
Patella
Tibial tuberosity
Tibia
Fibula
Medial malleolus

THE SKELETON AND MUSCLES

Human anatomy is very energy-efficient. If a group of muscles are not used, our body does not spend any resources or energy maintaining them – why should it? They aren't being used, hence they are energy-efficient. With a greater or lesser amount of exercise or inactivity, we can transform the our body shape.

MUSCULAR SURFACE ANATOMY OVERVIEW

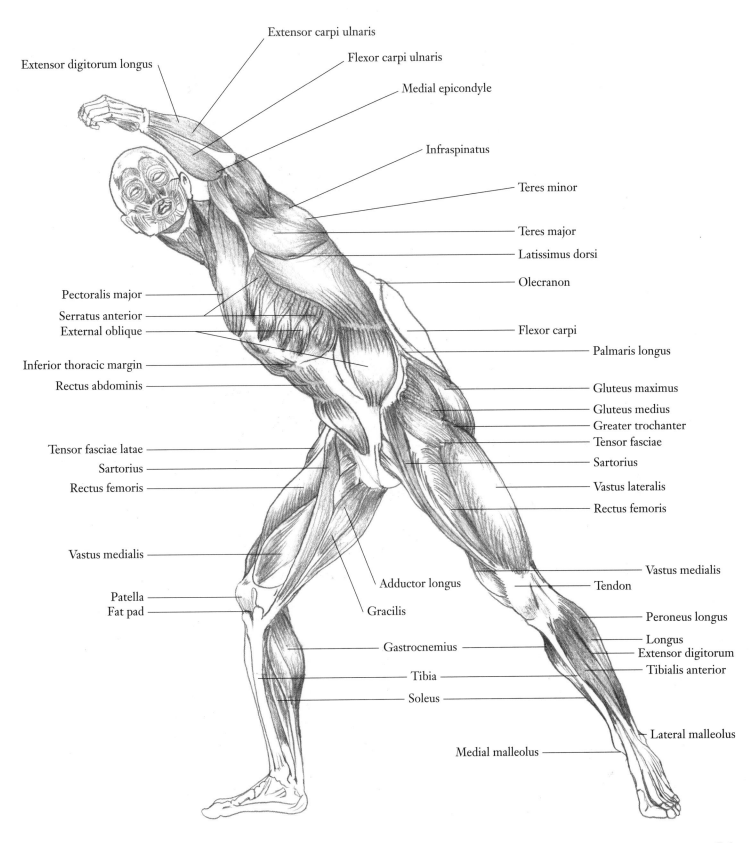

Extensor carpi ulnaris

Flexor carpi ulnaris

Medial epicondyle

Extensor digitorum longus

Infraspinatus

Teres minor

Teres major

Latissimus dorsi

Olecranon

Pectoralis major

Serratus anterior

External oblique

Flexor carpi

Palmaris longus

Inferior thoracic margin

Rectus abdominis

Gluteus maximus

Gluteus medius

Greater trochanter

Tensor fasciae

Tensor fasciae latae

Sartorius

Rectus femoris

Sartorius

Vastus lateralis

Rectus femoris

Vastus medialis

Vastus medialis

Tendon

Patella

Fat pad

Adductor longus

Gracilis

Peroneus longus

Longus

Extensor digitorum

Tibialis anterior

Gastrocnemius

Tibia

Soleus

Lateral malleolus

Medial malleolus

SIDE VIEW OF MUSCLES OF THE TRUNK

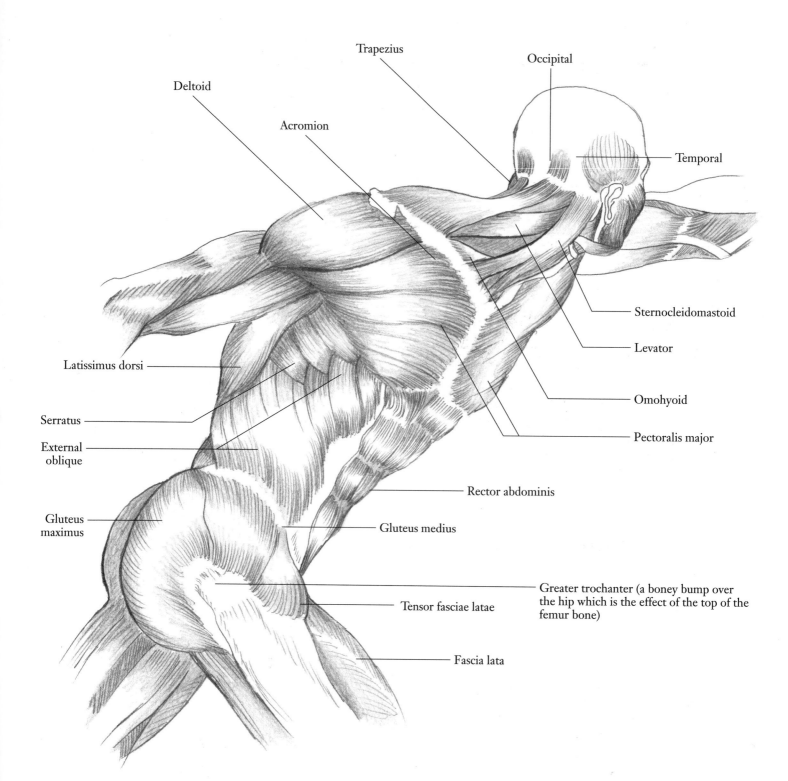

Trapezius

Occipital

Deltoid

Acromion

Temporal

Sternocleidomastoid

Levator

Latissimus dorsi

Omohyoid

Serratus

Pectoralis major

External oblique

Rector abdominis

Gluteus maximus

Gluteus medius

Greater trochanter (a boney bump over the hip which is the effect of the top of the femur bone)

Tensor fasciae latae

Fascia lata

PECTORALIS MAJOR

Clavicular head of pectoralis major

Acromion process of the scapula

Clavicular portion of the pectoralis major muscle

Space between sternal and clavicular portions of the pectoralis major muscle

Sternal portion

Insertion to the humerus

Sternocostal head of pectoralis

LATISSIMUS DORSI

Origin: inferior angle of the scapula

Origin: thoracolumbar aponeurosis and vertebral orients of the muscle

Insertion to the bicipetal groove

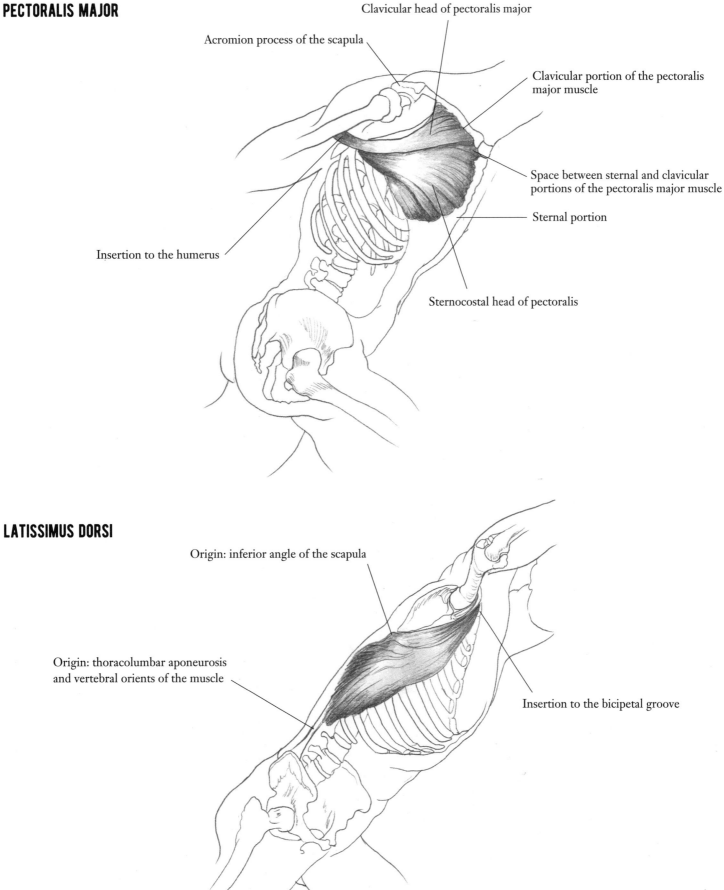

POSTERIOR VIEW OF MUSCLES OF THE TRUNK

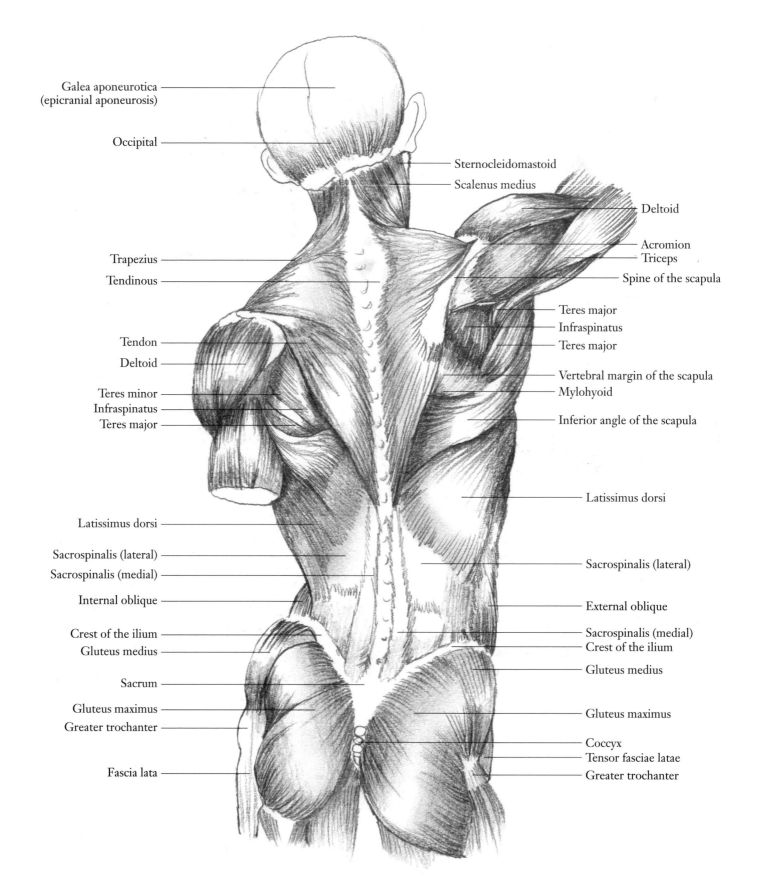

Galea aponeurotica (epicranial aponeurosis)

Occipital

Sternocleidomastoid

Scalenus medius

Deltoid

Acromion

Triceps

Spine of the scapula

Trapezius

Tendinous

Teres major

Infraspinatus

Teres major

Tendon

Deltoid

Vertebral margin of the scapula

Mylohyoid

Teres minor

Infraspinatus

Teres major

Inferior angle of the scapula

Latissimus dorsi

Latissimus dorsi

Sacrospinalis (lateral)

Sacrospinalis (medial)

Internal oblique

Sacrospinalis (lateral)

External oblique

Crest of the ilium

Gluteus medius

Sacrospinalis (medial)

Crest of the ilium

Gluteus medius

Sacrum

Gluteus maximus

Greater trochanter

Gluteus maximus

Coccyx

Tensor fasciae latae

Greater trochanter

Fascia lata

TWISTED TRUNK

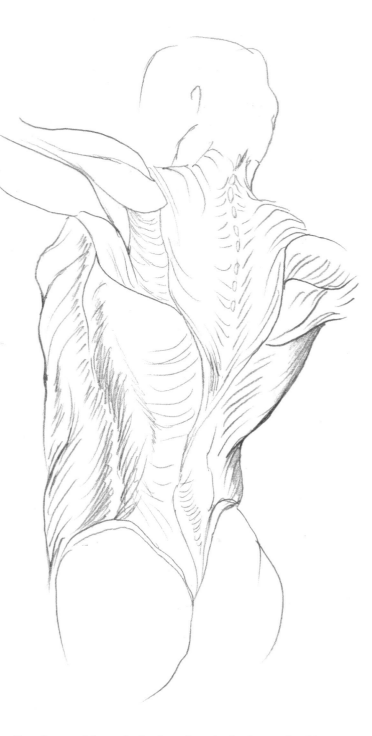

In a figure with a twist in the spine, the back muscles, hips and glutes are used, and twisting stretches muscles in other parts of the body too. The iliocostalis muscles help us to bend backwards and rotate around our spinal column, but these muscles are very deep within the body and are not visible as surface anatomy. All twisting poses connect the lower and upper parts of the skeleton in order to rotate the axial skeleton (which includes the spine and torso).

VISUALISING MUSCLE MOVEMENTS

Rotation of the spine can be directed by movement of the arms and shoulders. When drawing a model, it might help to visualise the movement of your model's muscles while they hold certain poses. It might not be obvious, but it does help to think about this and also to attempt the pose (or partially attempt it) yourself. This will help you to understand what it feels like, what pinches and what is stretched. Try out part or all of the pose, and think about how the muscles on the top and bottom halves of your body are used in a spine twist.

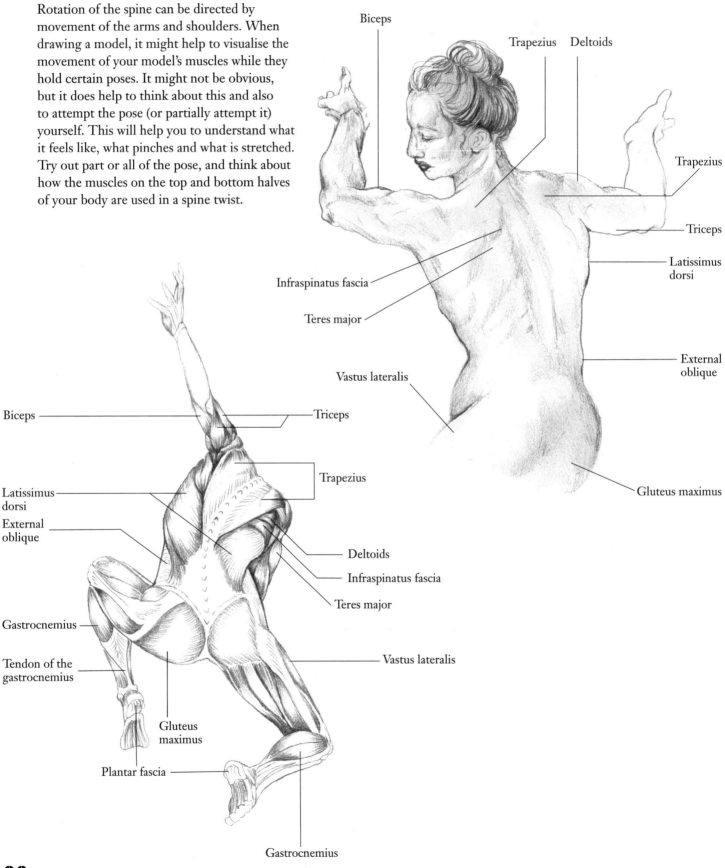

Biceps

Trapezius Deltoids

Trapezius

Triceps

Latissimus dorsi

Infraspinatus fascia

Teres major

External oblique

Vastus lateralis

Gluteus maximus

Biceps

Triceps

Trapezius

Latissimus dorsi

External oblique

Deltoids

Infraspinatus fascia

Teres major

Gastrocnemius

Vastus lateralis

Tendon of the gastrocnemius

Gluteus maximus

Plantar fascia

Gastrocnemius

MUSCLE DEFINITION IN A BODY BUILDER

Muscle definition changes in response to our physical activity, but that doesn't mean that we can all do the same exercises and end up with the same muscle definition. In some bodies and with the kinds of activities and exercises that athletes or body builders carry out regularly, some muscles can become much more visible and defined – such as the adductor muscles of the inner thigh, as shown in this figure (diagonal from knee to groin).

12 MUSCLES AND BONES OF THE LEG AND ARM

The muscles and bones of the leg and arm have similar functions and are used in many movements. The knee and elbow, for instance, both move like a hinge. They extend the arm or leg in an approximately straight line or by a 180-degree angle (although some people can hyper-extend these joints). We shall also look at the muscles of the feet and hands and how to draw surface views of these extremities.

ANATOMY OF THE LEG

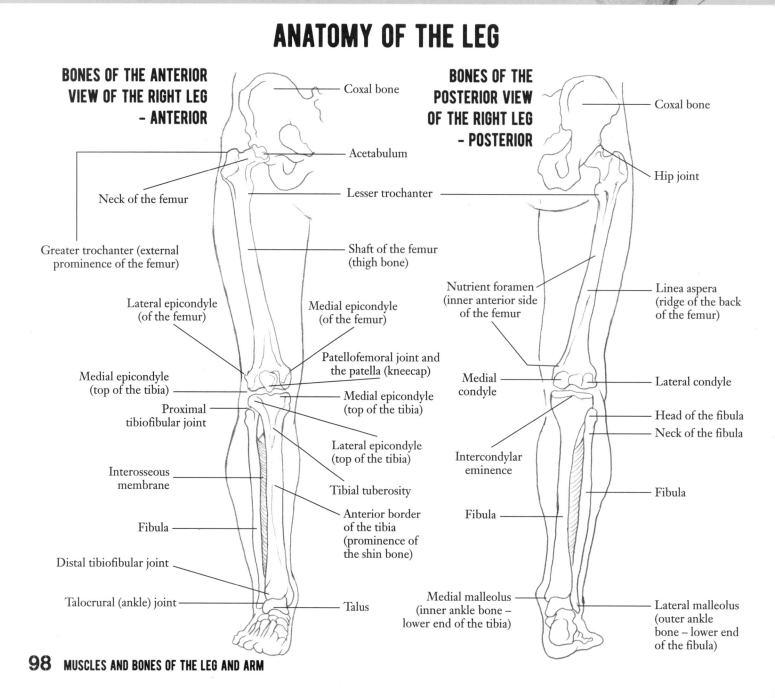

BONES OF THE ANTERIOR VIEW OF THE RIGHT LEG – ANTERIOR

- Coxal bone
- Acetabulum
- Neck of the femur
- Lesser trochanter
- Greater trochanter (external prominence of the femur)
- Shaft of the femur (thigh bone)
- Lateral epicondyle (of the femur)
- Medial epicondyle (of the femur)
- Patellofemoral joint and the patella (kneecap)
- Medial epicondyle (top of the tibia)
- Medial epicondyle (top of the tibia)
- Proximal tibiofibular joint
- Lateral epicondyle (top of the tibia)
- Interosseous membrane
- Tibial tuberosity
- Anterior border of the tibia (prominence of the shin bone)
- Fibula
- Distal tibiofibular joint
- Talocrural (ankle) joint
- Talus

BONES OF THE POSTERIOR VIEW OF THE RIGHT LEG – POSTERIOR

- Coxal bone
- Hip joint
- Nutrient foramen (inner anterior side of the femur
- Linea aspera (ridge of the back of the femur)
- Medial condyle
- Lateral condyle
- Head of the fibula
- Neck of the fibula
- Intercondylar eminence
- Fibula
- Fibula
- Medial malleolus (inner ankle bone – lower end of the tibia)
- Lateral malleolus (outer ankle bone – lower end of the fibula)

MUSCLES OF THE LEG

LATERAL VIEW OF THE LOWER LIMB

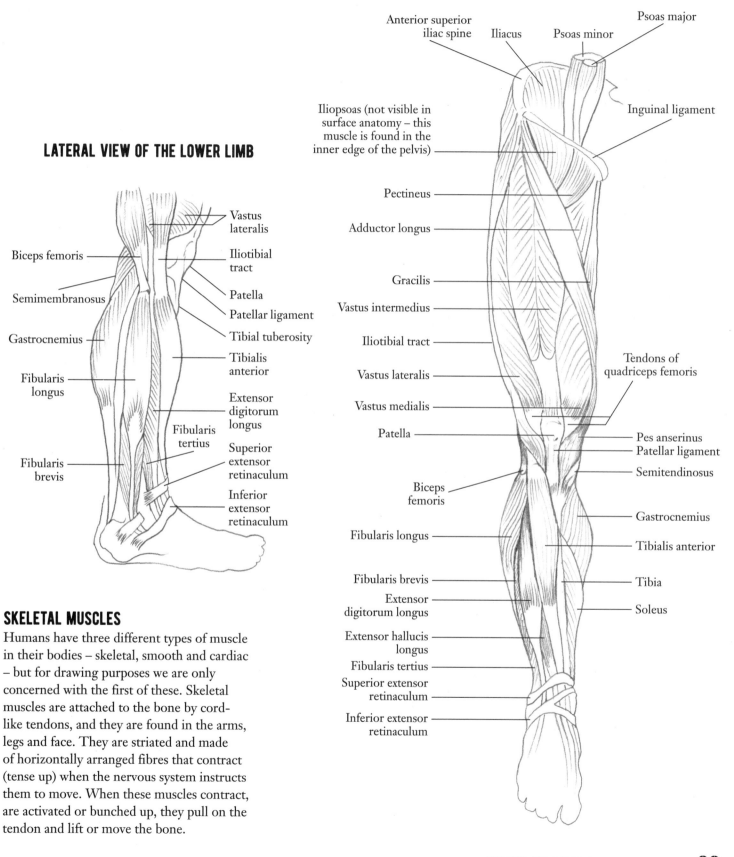

Anterior superior iliac spine

Iliacus

Psoas minor

Psoas major

Inguinal ligament

Iliopsoas (not visible in surface anatomy – this muscle is found in the inner edge of the pelvis)

Pectineus

Adductor longus

Gracilis

Vastus intermedius

Iliotibial tract

Vastus lateralis

Vastus medialis

Patella

Biceps femoris

Fibularis longus

Fibularis brevis

Extensor digitorum longus

Extensor hallucis longus

Fibularis tertius

Superior extensor retinaculum

Inferior extensor retinaculum

Tendons of quadriceps femoris

Pes anserinus

Patellar ligament

Semitendinosus

Gastrocnemius

Tibialis anterior

Tibia

Soleus

Vastus lateralis

Biceps femoris

Semimembranosus

Gastrocnemius

Fibularis longus

Fibularis brevis

Iliotibial tract

Patella

Patellar ligament

Tibial tuberosity

Tibialis anterior

Extensor digitorum longus

Fibularis tertius

Superior extensor retinaculum

Inferior extensor retinaculum

SKELETAL MUSCLES

Humans have three different types of muscle in their bodies – skeletal, smooth and cardiac – but for drawing purposes we are only concerned with the first of these. Skeletal muscles are attached to the bone by cord-like tendons, and they are found in the arms, legs and face. They are striated and made of horizontally arranged fibres that contract (tense up) when the nervous system instructs them to move. When these muscles contract, are activated or bunched up, they pull on the tendon and lift or move the bone.

OTHER VIEWS OF THE LEG MUSCLES

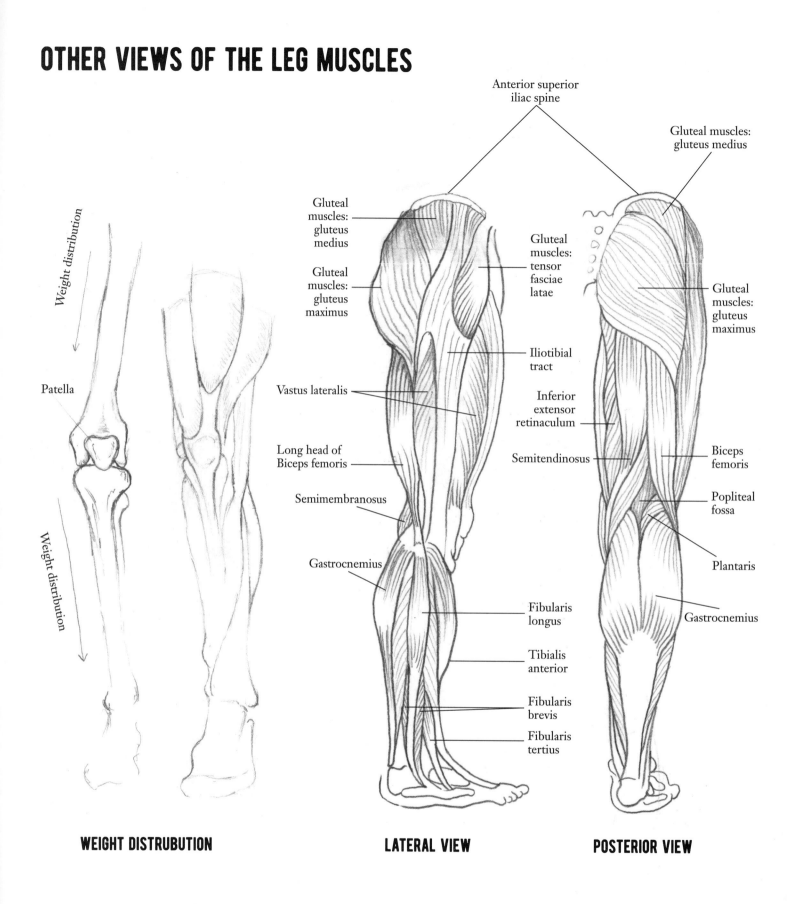

Weight distribution

Weight distribution

Patella

Anterior superior iliac spine

Gluteal muscles: gluteus medius

Gluteal muscles: gluteus medius

Gluteal muscles: gluteus maximus

Gluteal muscles: tensor fasciae latae

Gluteal muscles: gluteus maximus

Iliotibial tract

Vastus lateralis

Inferior extensor retinaculum

Biceps femoris

Long head of Biceps femoris

Semitendinosus

Popliteal fossa

Semimembranosus

Plantaris

Gastrocnemius

Gastrocnemius

Fibularis longus

Tibialis anterior

Fibularis brevis

Fibularis tertius

WEIGHT DISTRUBUTION

LATERAL VIEW

POSTERIOR VIEW

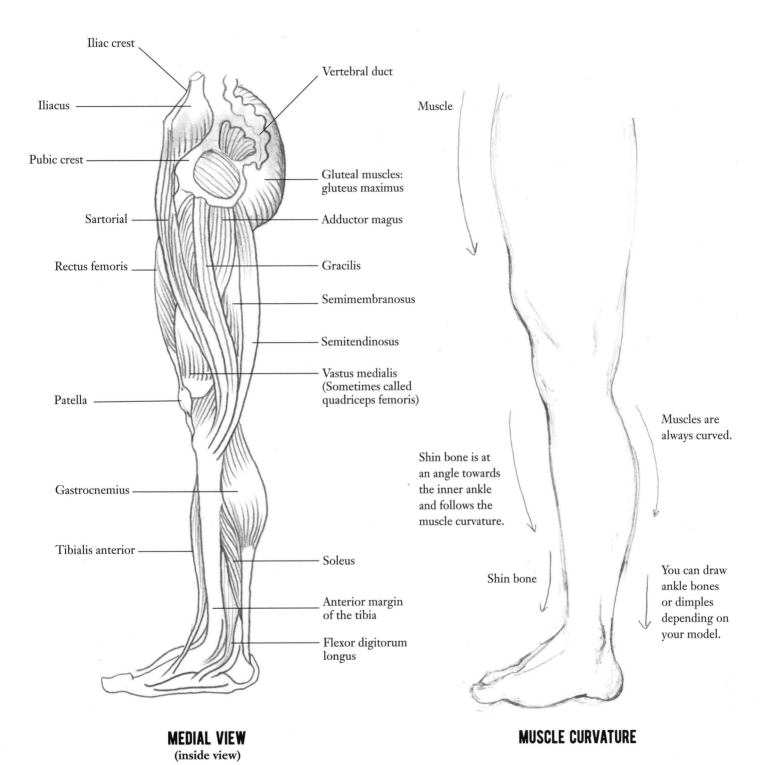

Iliac crest

Vertebral duct

Muscle

Iliacus

Gluteal muscles:
gluteus maximus

Pubic crest

Adductor magus

Sartorial

Gracilis

Rectus femoris

Semimembranosus

Semitendinosus

Patella

Vastus medialis
(Sometimes called
quadriceps femoris)

Muscles are
always curved.

Shin bone is at
an angle towards
the inner ankle
and follows the
muscle curvature.

Gastrocnemius

Tibialis anterior

Soleus

Shin bone

Anterior margin
of the tibia

You can draw
ankle bones
or dimples
depending on
your model.

Flexor digitorum
longus

MEDIAL VIEW
(inside view)

MUSCLE CURVATURE

MUSCLES AND STRUCTURE OF THE LEG

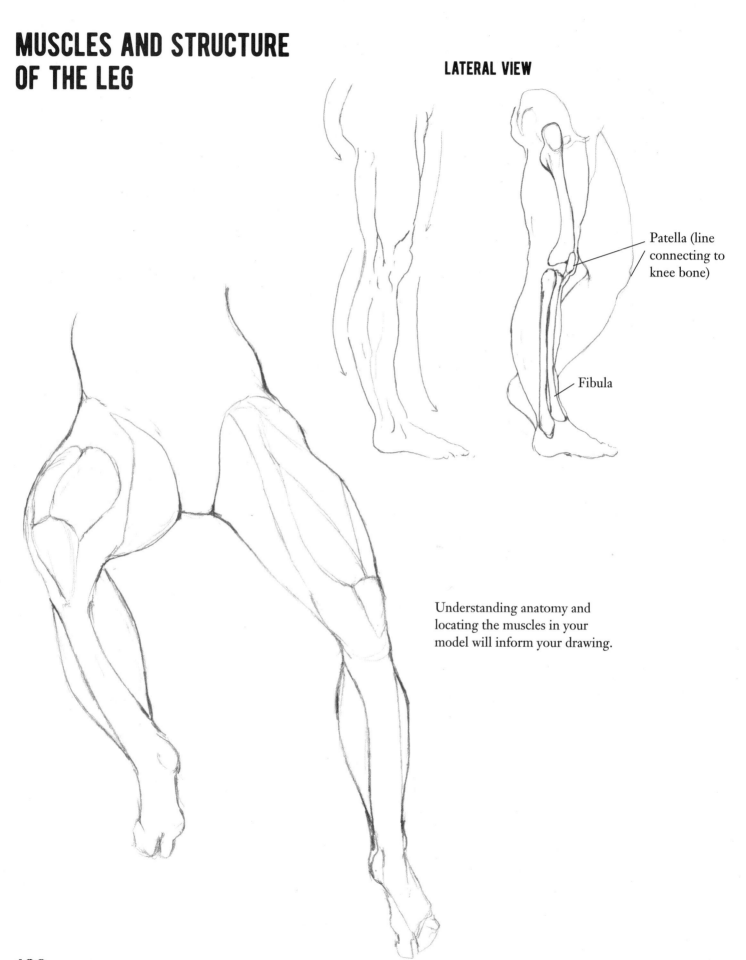

Patella (line connecting to knee bone)

Fibula

Understanding anatomy and locating the muscles in your model will inform your drawing.

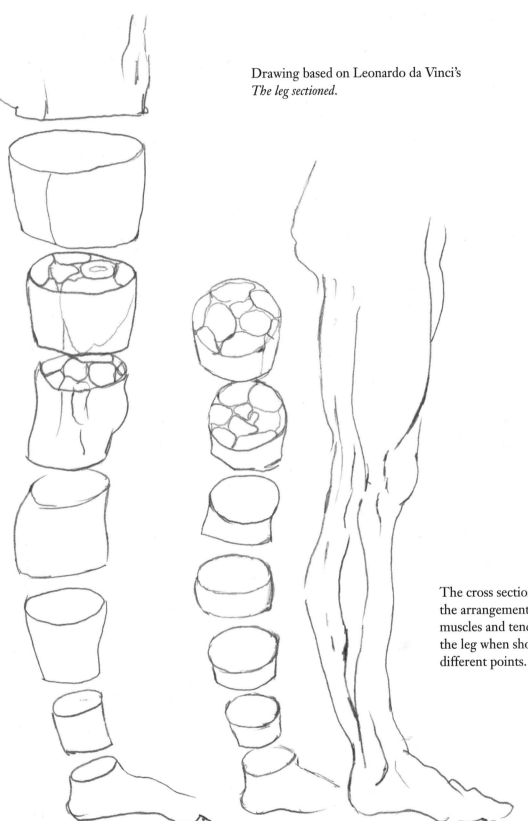

Drawing based on Leonardo da Vinci's
The leg sectioned.

The cross sections reveal
the arrangement of bones,
muscles and tendons within
the leg when shown at
different points.

ANATOMY OF THE FOOT

Feet help us to stand upright and move around. They are very complex and often flexible, and contain bones, joints, muscles and soft tissues. The anatomy of the foot can be understood as consisting of three main sections:

• The forefoot contains (most of the time) five toes called phalanges, as well as five longer bones (metatarsals).
• The midfoot has a pyramid-like structure and contains the bones that form the arches of the feet. It consists of three

cuneiform bones (medial, intermediate and lateral), a cuboid bone and a navicular bone.
• The hindfoot includes the heel and ankle. The talus bones are at the base of the leg bones (tibia and fibula), forming the ankle.

We can usually see the tendons and ligaments along the upper surfaces of the feet. These allow for complex articulation and balance. The Achilles tendon above the heel connects to the calf muscle, and stabilises body weight and contains tension and force when running, jumping and standing on tiptoes.

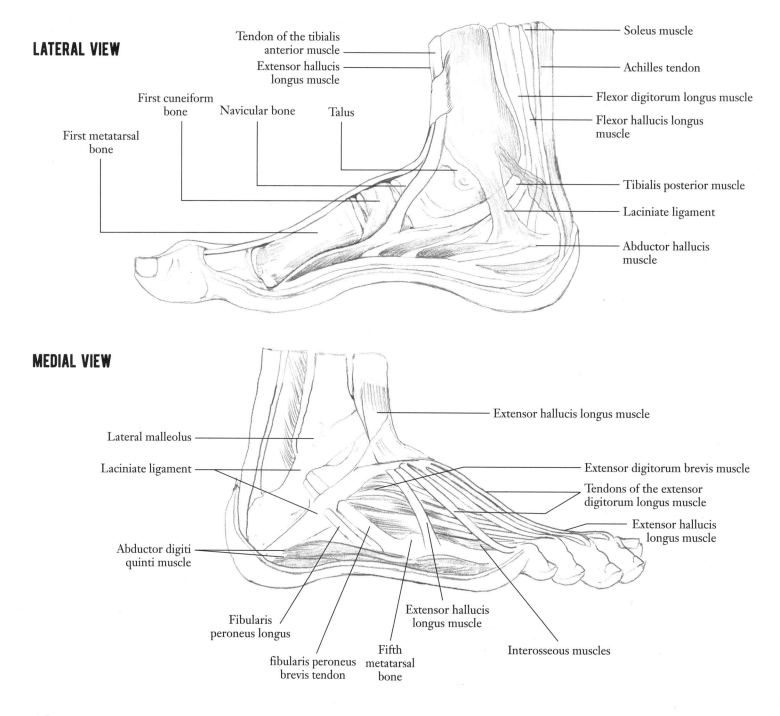

LATERAL VIEW

Tendon of the tibialis anterior muscle
Extensor hallucis longus muscle
First cuneiform bone
Navicular bone
Talus
First metatarsal bone
Soleus muscle
Achilles tendon
Flexor digitorum longus muscle
Flexor hallucis longus muscle
Tibialis posterior muscle
Laciniate ligament
Abductor hallucis muscle

MEDIAL VIEW

Lateral malleolus
Laciniate ligament
Abductor digiti quinti muscle
Fibularis peroneus longus
fibularis peroneus brevis tendon
Fifth metatarsal bone
Extensor hallucis longus muscle
Interosseous muscles
Extensor hallucis longus muscle
Extensor digitorum brevis muscle
Tendons of the extensor digitorum longus muscle
Extensor hallucis longus muscle

DRAWING FEET

You can use geometric forms such as a rectangles with a truncated end and a tapered end to capture the direction and volume of the midfoot, combining these with cylinder shapes and ellipses. When refining, use curved lines to accent the movement of the foot – try a heavier outline on the parts that are either overlapping, in contact with the ground or look like they are about to move. Observe particular positions of the toes (such as standing on tiptoes or lifting a big toe) in the forefoot or in the hindfoot. Much like hands, feet can be very expressive and unique.

Sole

When sketching a view of the foot where the sole can be seen, draw the sole as an individual facet of its own.

ANATOMY OF THE ARM

The upper arm is located between the shoulder and elbow joints, and the lower arm (or forearm) is located between the elbow joint and the fingertips or wrist (depending on how specific you need to be). The upper arm contains four muscles which, in some cases, connect to two or more points on different parts of the shoulder, back and arm bones. The triceps brachii is a three-headed muscle whose function is the extension of the arm at the elbow. The biceps brachii is a two-headed muscle whose function is the supination of the forearm and flexion of the arm at the elbow and shoulder. In the anterior compartment of the upper arm, you find the biceps brachii, brachialis and coracobrachialis (a deep muscle that is not visible in these drawings). In the posterior compartment, you find the triceps brachii. The pectoral and trapezius muscles are also used in the movement of the arm. The deltoid muscles connect the upper arm and are responsible for many movements concerning arm rotation: the deltoid allows a person to keep carried objects

and protect the upper arm joint from dislocation and any injury that might occur due to the humerus bearing heavy loads.

In the forearm, we find the flexor carpi ulnaris, palmaris longus, flexor carpi radialis and pronator teres. These muscles all originate from the same tendon, which is connected to the medial epicondyle of the humerus. The flexor carpi ulnaris is used in flexion and adduction at the wrist. The palmaris longus is, in fact, absent in about 15% of the population. It originates from the medial epicondyle and attaches to the flexor retinaculum of the wrist, and is used in flexion at the wrist. The flexor carpi radialis originates from the medial epicondyle and attaches to the base of metacarpals II and III. Its actions are to control flexion and abduction at the wrist. The pronator teres has two origins: the medial epicondyle and the coronoid process of the ulna. It also attaches laterally to the mid-shaft of the radius and is responsible for controlling the pronation of the forearm.

POSTERIOR VIEW **LATERAL VIEW** **ANTERIOR VIEW**
(forearm neutral) **ANTERIOR VIEW**
(forearm abducted)

Trapezius

Deltoid

Teres major

Latissimus dorsi

Triceps brachii

Extensor carpi ulnaris longus

Ulna (bone)

Flexor carpi ulnaris

Palmaris longus

Latissimus dorsi

Pronator teres

Sternocleidomastoid

Deltoid

Pectoralis major

Biceps brachii

Brachioradialis

Extensor carpi ulnaris longus

Extensors: extensor carpi ulnaris; extensor digiti minimi; extensor digitorum

Extensors: abductor pollicis longus; extensor pollicis brevis

Sternocleidomastoid

Trapezius

Deltoid

Biceps brachii

Pronator teres

Brachioradialis

Flexor carpi radialis

Pectoralis major

Triceps brachii

Pronator teres

Palmaris longus

Flexor carpi ulnaris

Flexor carpi radialis

MOVEMENT OF THE ARM

The abduction of the arm (movement away from the body) is very important in arm motion. The main muscles that control this are the supraspinatus, deltoid, trapezius and serratus anterior. The supraspinatus is a deep muscle that is not visible in these drawings, but is a main muscle used to abduct the arm to 15 degrees. The deltoid takes over to control movements from 15 to 90 degrees. The trapezius is a muscle of the back and neck, and it combines with the serratus anterior to connect to the scapula and enable abduction above the head higher than 90 degrees. Range of movement includes retraction, protraction, elevation, depression and rotation. These are controlled by different muscles which are illustrated here.

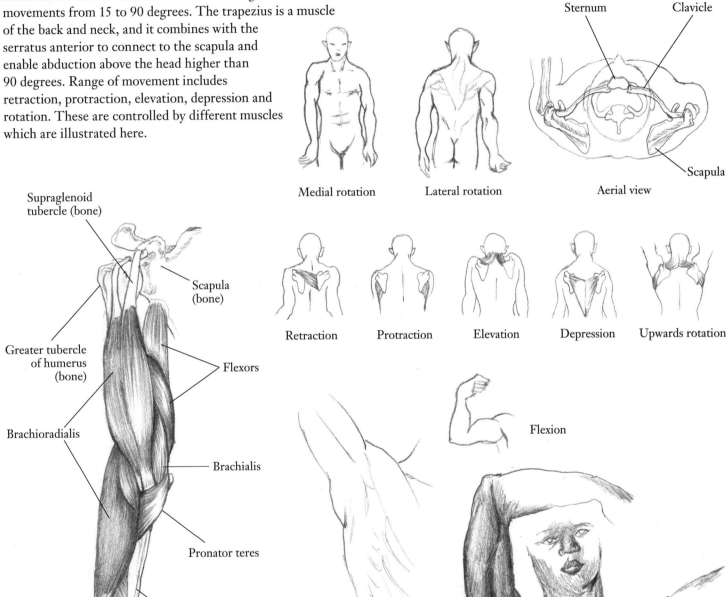

Sternum

Clavicle

Scapula

Medial rotation

Lateral rotation

Aerial view

Retraction

Protraction

Elevation

Depression

Upwards rotation

Supraglenoid tubercle (bone)

Scapula (bone)

Greater tubercle of humerus (bone)

Flexors

Brachioradialis

Brachialis

Pronator teres

Ulna (bone)

Radius (bone)

Flexion

DRAWING ARM MUSCLES

When drawing the arms, remember that the muscles overlap and interlace not only through each other but also across the forearm and upper arm. If you want to use oval-like shapes to sketch out the muscles (if you can see them or wish to draw them), make sure these shapes also overlap as illustrated in the image below (with the arrows inside). Include overlapping oval shapes to account for the different muscles used in any movement that you can see.

Correct:
Alternating bulges for correct muscle alignment.

Incorrect:
'Symmetrical alignment'.

STUDIES OF A LIFTING ARM

These studies show an arm lifting up. In this movement, you can see the way lines and overlapping ovals have been used to emphasise how the muscles are contracting.

ANATOMY OF THE HAND

The hand contains five metacarpal bones, each of which are numbered, starting with the thumb and ending with the little finger. These bones articulate proximally (nearest the body) using the carpals, and distally (furthest from the body) using the proximal phalanges.

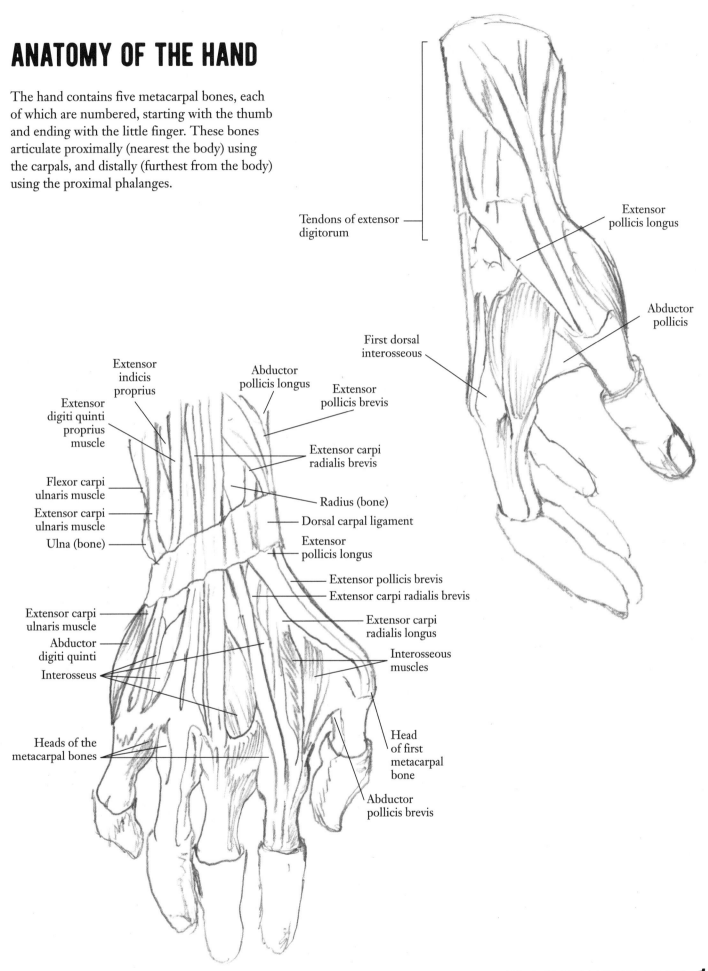

Tendons of extensor digitorum

Extensor pollicis longus

First dorsal interosseous

Abductor pollicis

Extensor indicis proprius

Extensor digiti quinti proprius muscle

Abductor pollicis longus

Extensor pollicis brevis

Flexor carpi ulnaris muscle

Extensor carpi ulnaris muscle

Ulna (bone)

Extensor carpi radialis brevis

Radius (bone)

Dorsal carpal ligament

Extensor pollicis longus

Extensor pollicis brevis

Extensor carpi radialis brevis

Extensor carpi radialis longus

Extensor carpi ulnaris muscle

Abductor digiti quinti

Interosseus

Interosseous muscles

Head of first metacarpal bone

Heads of the metacarpal bones

Abductor pollicis brevis

DRAWING THE HAND

Much like feet, hands are very complex. Also in common with feet, the tendons of the hands are often visible. To show the strain in them, you can exaggerate the tendons to depict a hand that seems to be holding something, clenching or lifting. You can also use truncated flat cuboid shapes to capture the depth of the palm, and lines and arcs to draw the fingers.

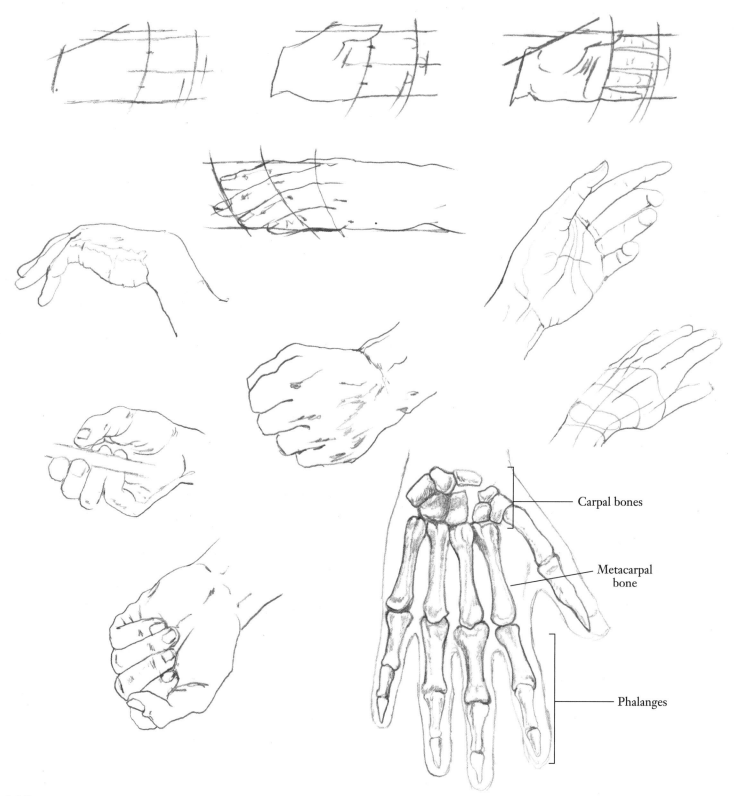

Carpal bones

Metacarpal bone

Phalanges

STUDIES OF THE HAND
These studies make use of truncated flat
cuboid shapes, lines and arcs to draw a hand.

13 SKIN AND FAT

The skin is a marvellous organ made of different layers and specialised structures. Wrinkles in skin are attractive, as is body hair, and fat is not bad; it is beautiful. It builds up in some parts of the body more than others. As artists, we should celebrate that bodies can endure and live through so much, rather than punishingly seek to perfect them according to bizarre and arbitrary beauty standards.

SKIN

Skin is the body's largest organ. It is a complex covering that protects us from microbes and the elements. It also helps to regulate body temperature and enables us to experience touch, heat, cold and other sensations. The skin has three main layers: the epidermis, dermis and subcutaneous tissue.

◆ **Epidermis**: the outermost layer that provides a waterproof barrier and from which hairs grow (in most people). Hair will grow differently over different areas of the body and depends on hormonal changes in many people. Skin also creates our skin tone and contains melanocytes; these produce the pigment melanin, which protects our skin from the sun.

◆ **Dermis**: this layer is beneath the epidermis and contains strong connective tissue as well as the hair follicles, the arrector pili muscles – which control hair movement (making the hair stand up on end) – and sweat glands.

◆ **Subcutaneous tissue** (hypodermis): is the deepest layer of the skin, and is made from fat and connective tissue.

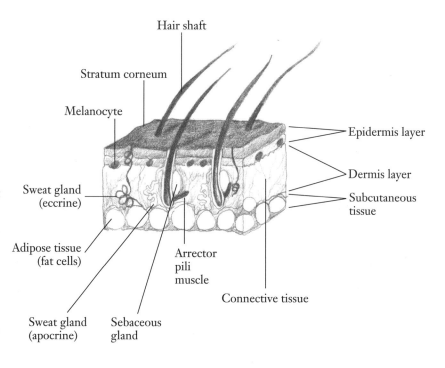

Hair shaft

Stratum corneum

Melanocyte

Epidermis layer

Dermis layer

Subcutaneous tissue

Sweat gland (eccrine)

Adipose tissue (fat cells)

Arrector pili muscle

Connective tissue

Sweat gland (apocrine)

Sebaceous gland

FAT

People bear weight differently. Some of us may bear more weight around the waist, while others bear more around the bottom, back or upper body. Fat distribution changes throughout our lives and with hormonal changes during a human's life. Fat cells are larger in people who have more body fat. The images on this page show some of the areas where fat tends to build up. Abdominal fat sometimes stretches out around the waist and up towards the chest. Some bodies have more distinct fat deposits forming around the pelvis, above the point at which the top of the femur locks into the hip socket, and over the abdominals. Some bony points of the body – such as the knees, elbows and ankles and, in slender bodies, the hip girdle – tend to protrude.

In this drawing, you can see how a dip is formed at certain points on the hip bone, above the pelvis and above where the femur locks into the hip bone.

USING PENCIL MARKS

When drawing older hands, draw the skin with more wrinkles. This image shows the construction lines, overlapping ovals and lines that were used to begin the drawing. You can also see the areas where mark-making has been used to create the texture of wrinkles.

This image is also incomplete, but you can see how pencil marks have been used and how they have been placed, blended and overlapped to create shadow and highlights on the skin's surface. Very light marks have been used to create the effect of stubble on the check, jaw and chin, and to create a more organic texture.

WRINKLES AND FAT ON THE FACE

In a younger face or one that is plump, try to observe where any shadows and highlights exist. Be attentive to the neck, as this is often included in portraiture as an important aspect of the pose and posture of the model. An older neck will have more wrinkles and creases, and a plump neck will include gentle or faint folds (depending on the light).

It may seem a little bit unrelated, but when observing and drawing the face, try to imagine the position of the spine and skull. This will help you to visualise how weight is being carried in the model, and you'll be able to create a more lively drawing.

OLD SKIN

Very old skin will be much thinner than young skin, and have a more papery and in some cases waxy appearance. Increasing the intensity of the marks you use in your drawing can help to capture the depth of these creases, while more blending can help to create the papery effect of old skin.

The muscles of the face beneath the skin can also affect how the skin in the face and neck appears. The image on this page is of someone who has experienced a stroke and developed facial palsy. A response to severe or intense stress caused by a stroke can cause facial palsy, which is a paralysis or severe weakening of the facial muscles on one side of the face. Like many ailments, there are multiple overlapping causes; one cause may be swelling of the nerves that control the facial muscles.

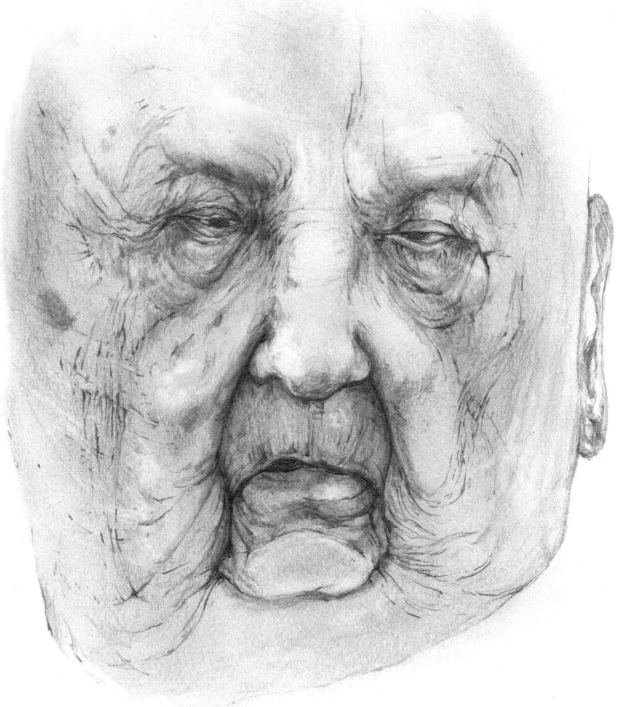

SIBLINGS

In this image, you can see an older child holding a toddler. The skin of younger people is plumper and less oily than older skin. You will need to bear this in mind when creating shadows, highlights and areas of light reflection.

DEEP WRINKLES

In this drawing of an old woman, you can see how some of the wrinkles resulting from years of facial expressions have deepened – there are creases around the eyes, lower jaw and between the eyebrows. These wrinkles are charming and full of character.

SKIN SHADOWS AND LINES

You might have to add more tone to folds that are in shadow, such as the areas under the flower in this drawing. Choose a mechanical pencil with HB lead to create a particularly crisp crease. The flower in this image has a very soft texture; you may consider drawing your own hand holding an organic object such as a shell, rock or flower to try to practise detail.

HAIRY SKIN

Not all bodies can produce hair in the same way. Some chests will be covered in light patches of hair that might be short, long or even tightly or loosely curled. Some people may have hair over their whole chest, back, legs or upper part of the forearm, but it might not be distributed evenly. Thicker or more dense hair can be drawn using a range of marks and shading, and may have a grain or direction. Body hair is beautiful to behold and to draw.

EXPERIMENTS WITH LINE AND MARK-MAKING

Mark-making can be used to show shadow, wrinkles and other textures on the face. Depending on the time you have between drawing sessions, you may create small quick sketches that focus on tone. The most important thing is to practise whatever drawing you like to do regularly, even if you don't finish a piece or create something that feels rushed. You might not like all of your drawings, but practice is how you'll develop your skills to a point that you are happy with.

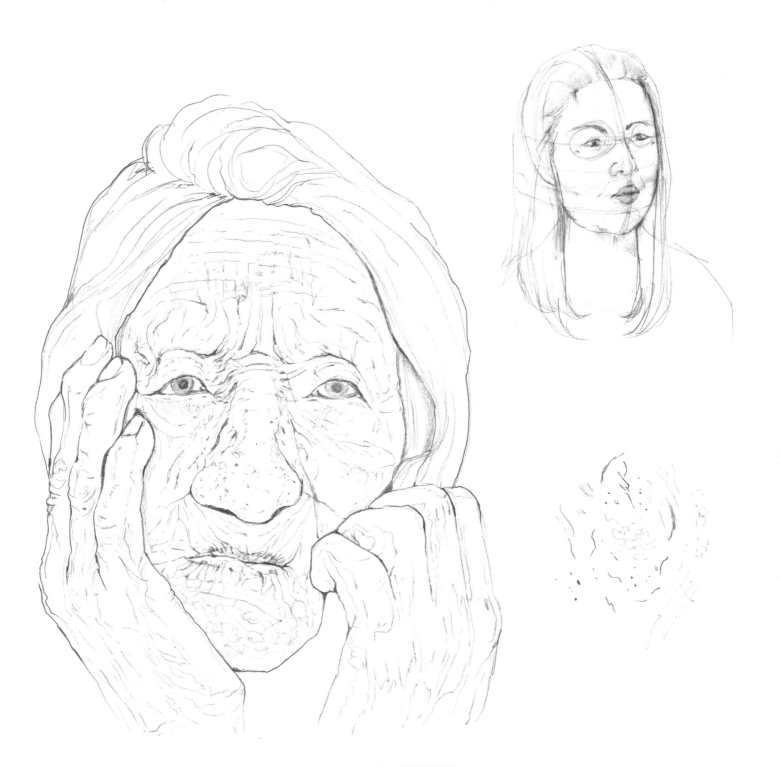

DETAILED AND QUICK SKETCHES

The smaller drawing (above right) was a quick sketch made with a limited range of marks compared to the larger drawing of an old face (above left). In an older figure, the nose, ears and hands might need more definition. The detailed sketch of old, wrinkled skin was made mainly using line and a selection of marks. The outline around the chin, the nose and places where the fingers touch the face and where the hair falls around or meets the forehead and face have been emphasised to resemble a shadow. When emphasising outlines, try to use a dynamic line that is not a consistent thickness all the way around or along its whole length. Drawing points within the line that are thicker and then thinner will make your images look more organic.

STRETCH MARKS

The skin is a fascinating part of the body. Almost all of us will have stretch marks by the time we reach adulthood, and these naturally occurring stripes add a lovely texture to the skin that can be captured using pencil marks, blending and a putty eraser. You can use line and mark-making to capture the textures of any skin you observe. If drawing scar tissue, you will observe a variation in the skin's texture and tone; any such textural variation can be be captured using these techniques.

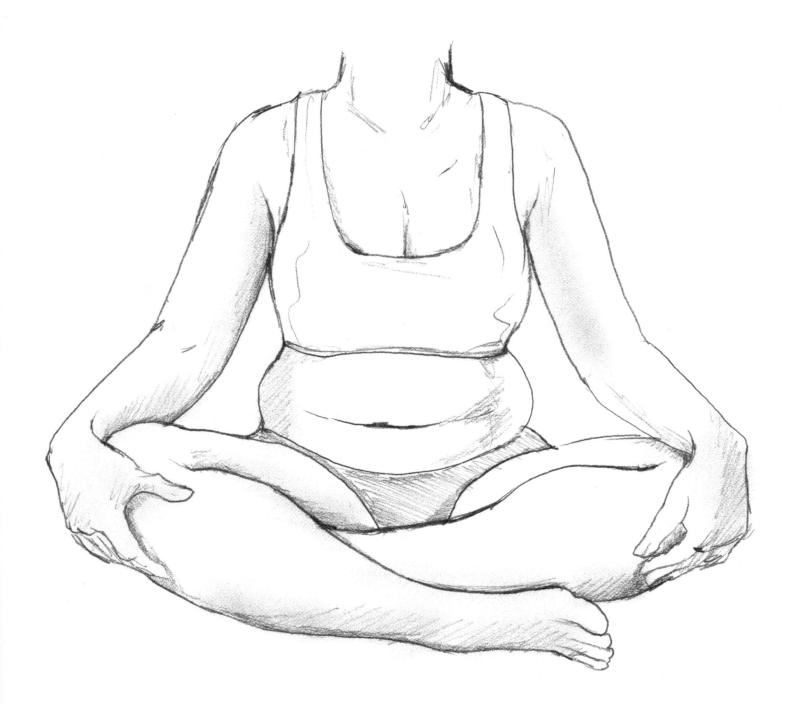

LINE WITHOUT TONE

In this drawing, smudging and tone have not been used. Only line and mark-making have been used to create the texture of skin. Try practisng your drawings of the skin's texture by not using tone at all. Experiment how limiting the techniques you use can help you to create the same texture in different ways.

DRAWING SKIN FOLDS AND TEXTILES

Folds in a figure can be achieved by including shadows using a graphite stick and a sharp soft pencil combined with a mechanical pencil. It's possible to draw textiles, particularly those around the skin, using similar techniques, but this will be time-consuming and might be a good challenge to explore another day. In this drawing, the pattern of the underwear has been generalised using large parallel lines. This effect is quite fun to use and can also help you to focus on the skin.

SHADOW AND ILLUMINATION CONTOUR LINES

In these standing figures, I have used line and a sharp HB pencil to outline shadows, depict folds, create texture and illustrate highlights and reflection on the skin's surface.

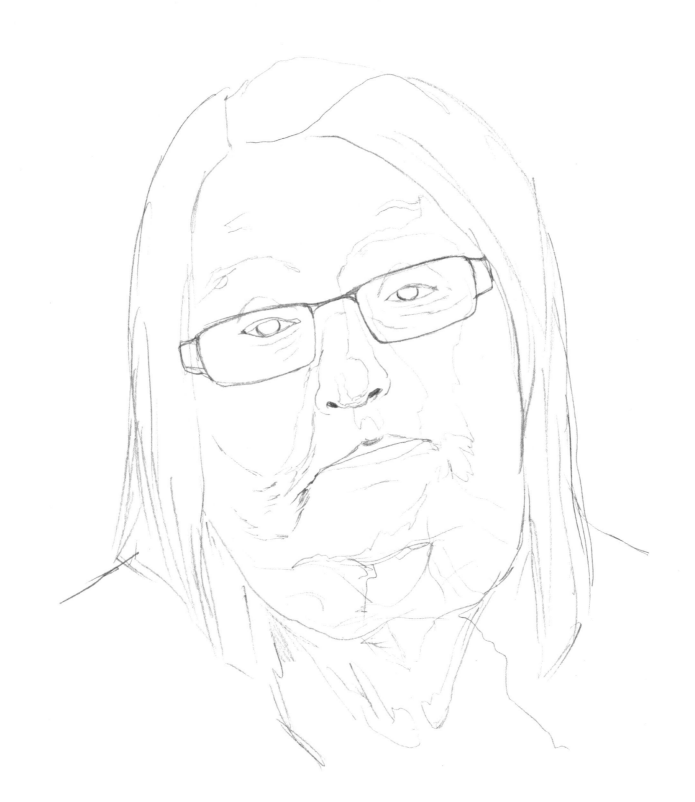

WRINKLES AND CONTOUR LINES ON THE FACE

Here is another example in which wrinkles are depicted using line
only. You can still get a good sense of the texture of the skin.

SIMILAR POSES, DIFFERENT SHADING

In these examples, I have made use of shading to express plump skins and a full figure. Tone and illumination with shading have been used to depict a similar pose and posture in the two drawings, but the model is wearing different clothes.

SEATED FIGURE

In this seated figure, we can see how fat is distributed in this individual and how their body is proportioned. Remember that proportions are personal and unique. In this rapid study, you can see how quick scribbles have been used to capture shadows.

BENT-OVER FIGURE

In this image that captures a hunched-over pose, you can see how different bones poke through the skin and how this figure's proportions are personal (as with the image above). Again, this was a quick sketch – rapid scribbles were used to depict the shadow around the scapula, and shadow was used around the ridge of the spine.

SMOOTH SKIN

There is not a lot of shading in this quick sketch, but the light blending technique shows the smoothness of the skin, punctuated by a few fold lines and a dark mark for the navel. The drawing was created using an HB pencil only. More pressure was added to create a darker tone which was applied to represent the navel and folds.

PREGNANCY: CONTOUR OUTLINING SHADOWS

Nipples on all kinds of chests vary a great deal. They change in shape and size during pregnancy. In these images, I have used contour lines to mark out the edges of different tones, shadows and highlights visible in the figure. I have also included an image which includes tone, shadow and reflection. In some instances, you may have have multiple light sources and shadows may overlay, such as the shadow of the breast and hand. Do not ignore this effect.

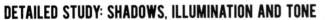

DETAILED STUDY: SHADOWS, ILLUMINATION AND TONE

Nipples are darker than the rest of the skin and have a
different texture. This is something we need to pay attention
to – be aware of light sources when capturing these textures.
In this drawing, you can see light reflecting off the skin and
up to the lower mass of the breast, which is also in shadow.
The lower part of the nipple is also reflecting light that is
reflecting up onto the figure, yet we can still tell that the
main light source is shining down from a source above the
model onto the upper portion of the chest.

BREASTS

Not all breasts are symmetrical, and this is a natural part of human diversity. Some people have breasts implanted, while some have them reduced or removed. Other people have breast-conserving surgery or a mastectomy in the case of breast cancer. Bodies are always changing throughout our lives, and will alter in response to surgery too. Breasts and scar tissue can be a very dynamic part of the body that changes dramatically.

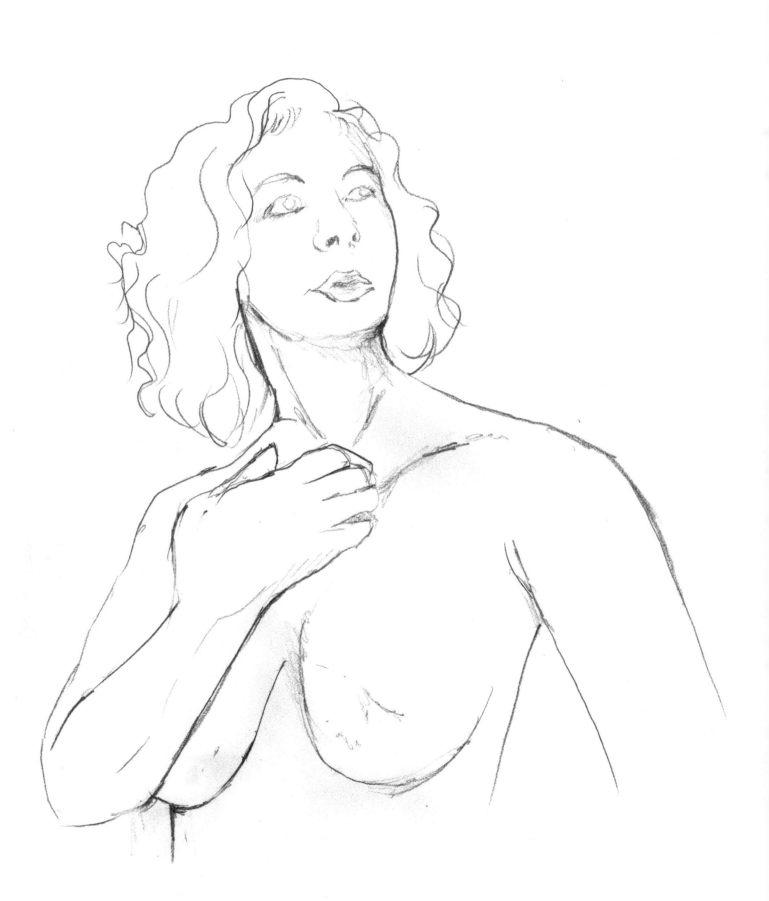

BUMS AND TUMS

Bottoms and tummies are also very interesting. The skin on the bottom and upper thigh can be slightly thicker or rougher than other parts of the body.

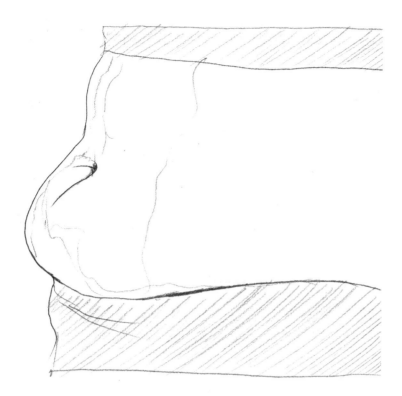

OBSERVE THE DIFFERENCES

Literally everyone's tummy is different. First of all we all have very unique belly buttons. Some tummies are hairy, while others are not. The folds of the tummy happen where there is a fold in the spine.

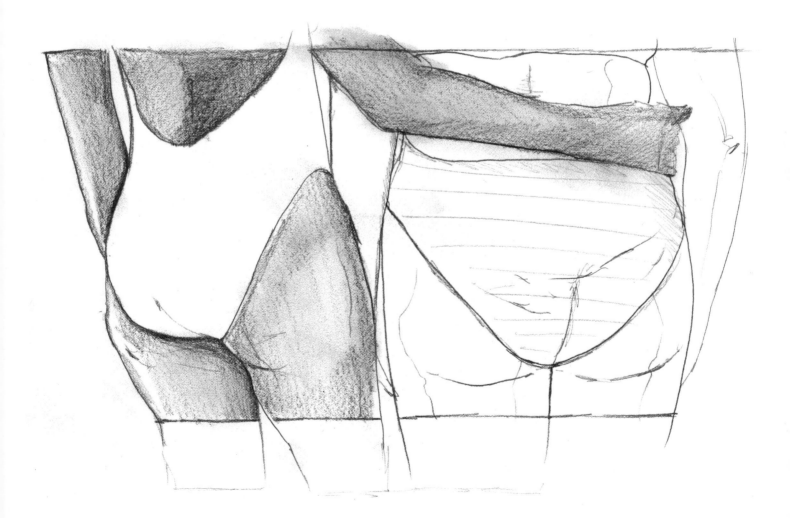

14 THE TORSO

Sometimes all a drawing might need is a carefully placed shadow or mark to emphasise the clavicle, sternum or deltoid in such a way that is anatomically convincing. The anatomy of the torso (front and back) and arms is illustrated and labelled below alongside a quick figure drawing. As you can see, not all the muscles are visible, but knowing where they are helps us to know our subject better and understand how the skin and fat fold over the torso.

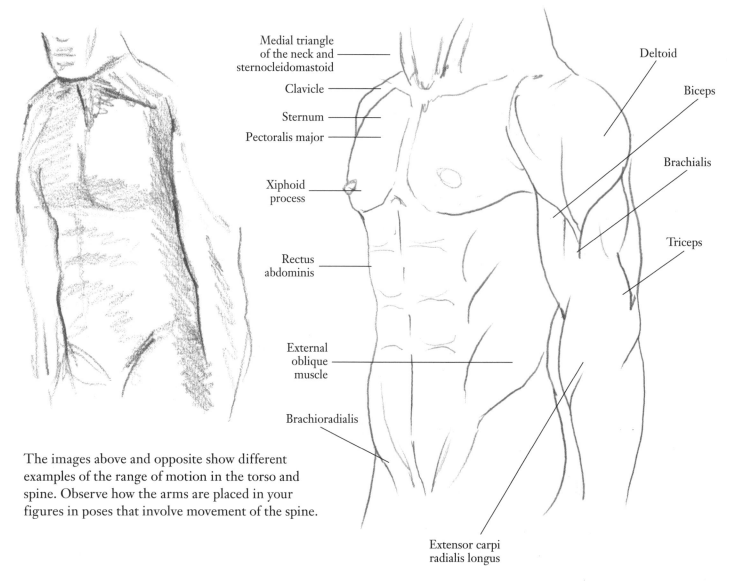

Medial triangle of the neck and sternocleidomastoid

Clavicle

Sternum

Pectoralis major

Xiphoid process

Rectus abdominis

External oblique muscle

Brachioradialis

Extensor carpi radialis longus

Deltoid

Biceps

Brachialis

Triceps

The images above and opposite show different examples of the range of motion in the torso and spine. Observe how the arms are placed in your figures in poses that involve movement of the spine.

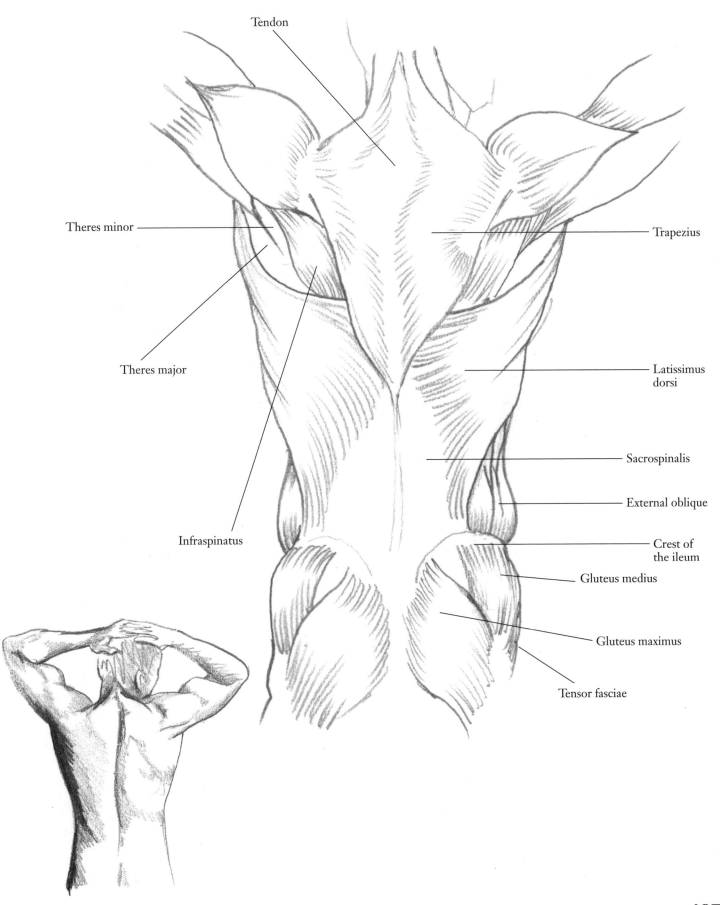

Tendon

Theres minor

Theres major

Infraspinatus

Trapezius

Latissimus dorsi

Sacrospinalis

External oblique

Crest of the ileum

Gluteus medius

Gluteus maximus

Tensor fasciae

THE SHOULDER

The scapula (shoulder blade) does not have any direct bony connection to the rest of the skeleton, which makes it an interesting anatomical structure. It is visible in some poses and can even protrude from the back. The scapula is a dynamic bone that is attached to the axial skeleton by muscles that connect it to various points on the spine. Not all the muscles of scapular stabilisation are visible from the surface, but being aware of them helps us to understand the movements and mobility of the scapula in a number of poses.

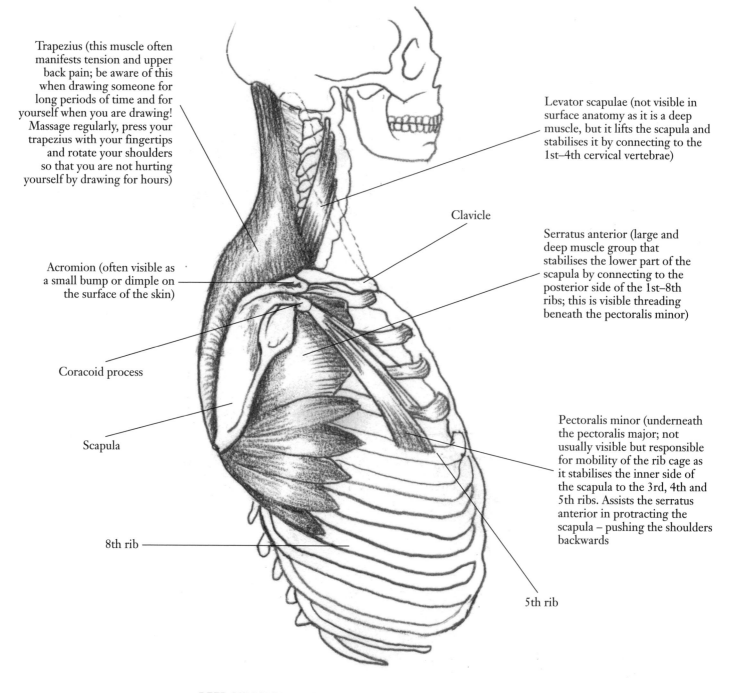

Trapezius (this muscle often manifests tension and upper back pain; be aware of this when drawing someone for long periods of time and for yourself when you are drawing! Massage regularly, press your trapezius with your fingertips and rotate your shoulders so that you are not hurting yourself by drawing for hours)

Acromion (often visible as a small bump or dimple on the surface of the skin)

Coracoid process

Scapula

8th rib

Levator scapulae (not visible in surface anatomy as it is a deep muscle, but it lifts the scapula and stabilises it by connecting to the 1st–4th cervical vertebrae)

Clavicle

Serratus anterior (large and deep muscle group that stabilises the lower part of the scapula by connecting to the posterior side of the 1st–8th ribs; this is visible threading beneath the pectoralis minor)

Pectoralis minor (underneath the pectoralis major; not usually visible but responsible for mobility of the rib cage as it stabilises the inner side of the scapula to the 3rd, 4th and 5th ribs. Assists the serratus anterior in protracting the scapula – pushing the shoulders backwards

5th rib

DEEP MUSCLES USED IN SCAPULAR STABILISATION

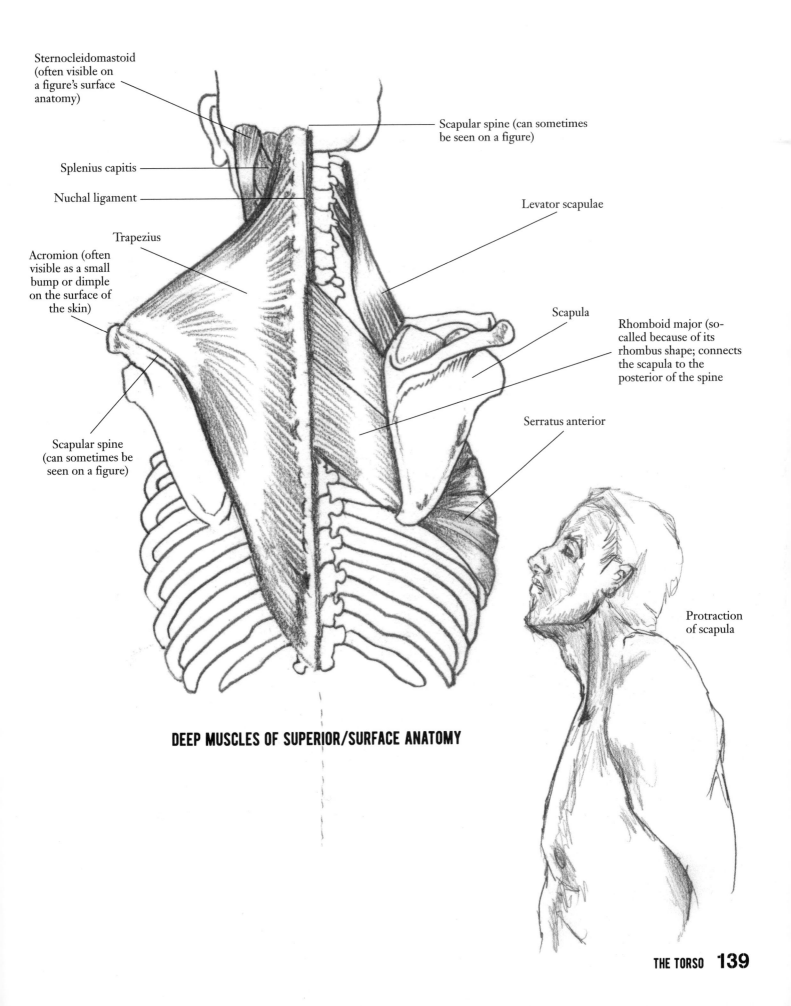

Sternocleidomastoid (often visible on a figure's surface anatomy)

Splenius capitis

Nuchal ligament

Trapezius

Acromion (often visible as a small bump or dimple on the surface of the skin)

Scapular spine (can sometimes be seen on a figure)

Scapular spine (can sometimes be seen on a figure)

Levator scapulae

Scapula

Rhomboid major (so-called because of its rhombus shape; connects the scapula to the posterior of the spine

Serratus anterior

Protraction of scapula

DEEP MUSCLES OF SUPERIOR/SURFACE ANATOMY

The torso is very complex, protecting vital organs, containing the spine and rib cage, and supporting the movement of the limbs. The torso can move in a range of twists and bends that can be incorporated into both seated, leaning and moving poses.

MOVEMENT OF THE TORSO

The two figures below focus on the torso. The first shows an expressive pose in which one shoulder is lower than the other, and the second pose has been captured in mid-movement. You can see how the placement of the shoulders is quite important in both of these poses.

A very quick expressive sketch can still contain anatomical detail. Here, the strong line of the sternocleidomastoid muscle is visible in the turning neck, and the bulge of the biceps muscle can be seen in the arm.

In this dynamic pose the model's near arm is raised and the rounded form of the deltoid muscle is clearly visible, as is the line of the scapula.

A standing figure may have more weight distributed on one side of the torso compared to the other. You can use the rule of thumb to check how the shoulders or the hips are aligned: are they angled to one side, leaning more on their left or right?

A model might have a twist in their spine that means their head is moving away (for example to their left) from the shoulders, which are also rotated away from the hips. In this example you can see the hips and knees are angled away from the shoulders.

BREASTS AND PECTORALS

The placement and movement around the breasts and pectoral muscles can vary a great deal. The breasts have been discussed previously, but in relation to the pectoral muscles, it will help to consider how they are placed across the rib cage, as illustrated in these images.

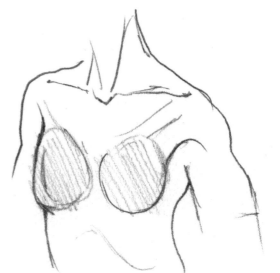

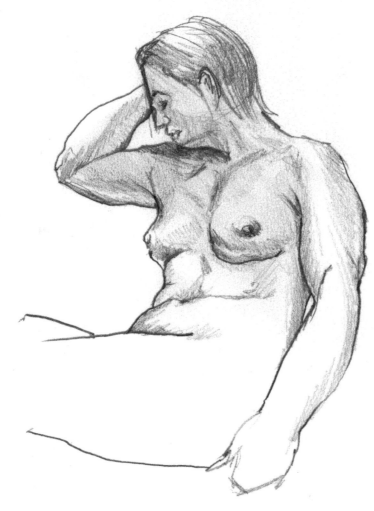

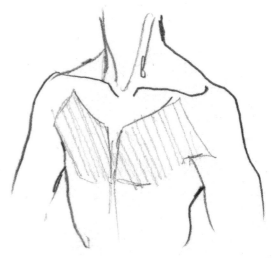

Similarly, when drawing the chest and pectorals, it is important to attend to the the clavicle, sternocleidomastoid, sternum and trapezius muscles, as shown in this study and overleaf.

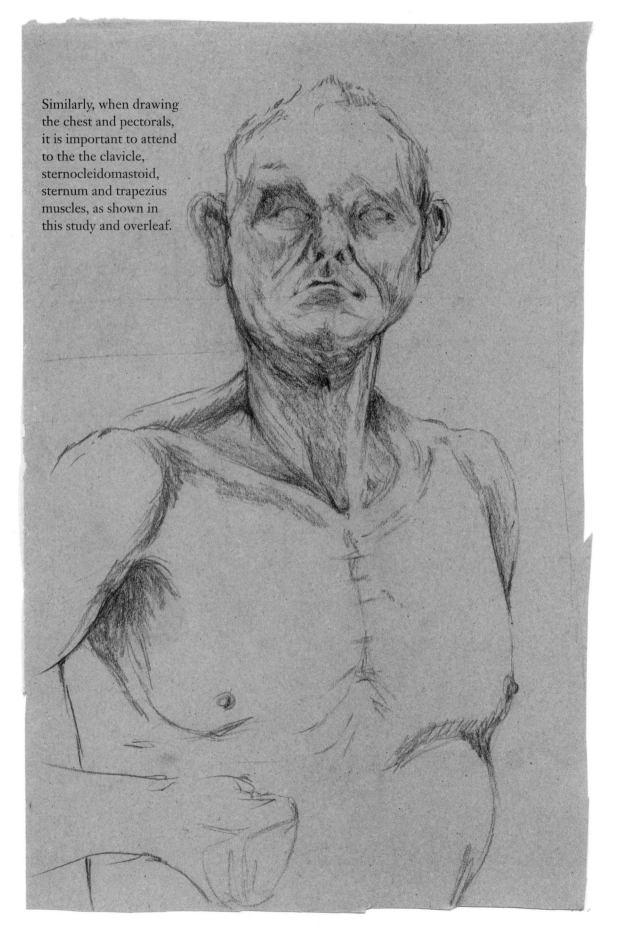

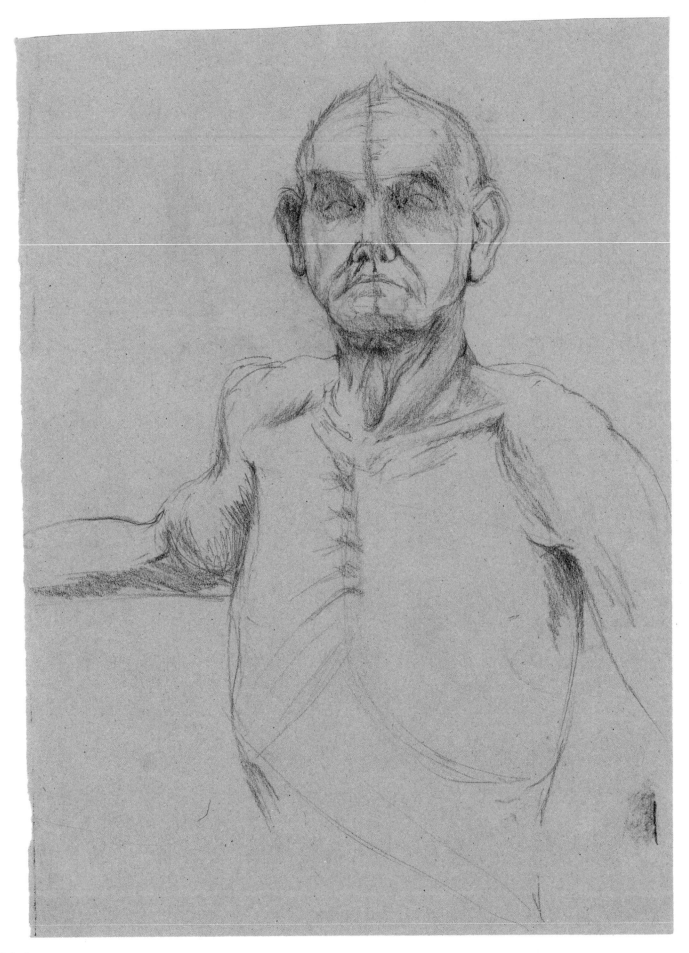

SCOLIOSIS

The spine is not always perfectly symmetrical, and in the case of a model with scoliosis, you may have a more dramatic asymmetry in the spine. This will affect the surrounding back muscles and the rest of the posture, shifting the shoulders away from the symmetry that we might assume in anatomy. In this figure, for example, notice that the elbows are not at the same height. The gesture, pose and resting posture of the model have all been accentuated.

SEATED FIGURE

A twist in the spine can be a very gestural thing to draw. This step-by-step example shows how curved lines and circles can be used to capture the overall direction and pose of the model. The final drawing includes shadows and highlights at the edge of the scapula, curve of the rib cage and lower back. These shadows communicate the anatomy underlying the pose. When drawing a figure, always compare the pelvis to the twist in the shoulders to help you understand the movement or pose.

15 FUNCTIONAL DESCRIPTIONS OF ANATOMY

Understanding the function of certain muscles, bones and tendons can be helpful for artists. It can also help to adopt the pose of the model yourself. Even if it is not possible to imitate a pose exactly, having a tacit feel for what pinches or feels stretched in a particular position can help you visualise which muscles your model is using, because you are trying to use those same muscles too.

Examples of function in the context of anatomy include which muscles lift which bones, where tendons are connected to muscle or bone, what movements the tendons enable, or what directions a join can be rotated in. Muscles can be rotators, flexors, extensors and abductors. Understanding function and anatomy is sometimes helpful for animators or artists drawing bodies in motion. Please be aware that the image opposite shows an overview of muscles and does not detail them all.

ROTATORS

Rotators are a group of muscles and tendons that surround a joint such as the wrist or shoulder. They enable circular and rotational movements.

FLEXORS

Flexion of the neck and and torso moves the trunk and torso towards the body's centre of gravity. This movement engages the muscles of the trunk (thoracic and lumbar).

EXTENSORS

When extended, weight-bearing joints move against gravity and weight. Extensor muscles tend to keep the body vertical.

ADDUCTORS

These muscles, whose contraction enables a limb or other body part to move towards the torso or a larger anatomical structure, are found in many parts of the body, including the hand, foot or thigh. The adductor hallucis (big toe tendon) will move the big toe up towards the body. Other examples include thigh adductors: the adductor longus, adductor brevis, and adductor magnus.

BONY PROTRUSIONS

Any part of a bone that protrudes outwards and is visible on the surface of the skin such as the clavicle (collar bone), scapula (shoulder blade) or parts of the hip, spine or sternum (breast bone).

SCAPULAR STABILISERS

These are the muscles that surround the scapula (shoulder blade). This group of muscles, together with the rotator cuff muscles (infraspinatus, supraspinatus, teres minor and subscapularis) support and enable shoulder biomechanics. The serratus anterior, levator scapulae and trapezii muscles are all scapular stabilisers. They are important because they enable movements of the arm as well, and the scapular is unique because it is only connected to other parts of the body via tendons, muscles and ligaments.

EVERTORS AND INVERTORS

These include muscles of the leg; they are not visible in the diagram opposite.

ABDUCTORS

Muscles that rotate a limb out to the side of the body. Abductor tendons in the hip, for example, will open and rotate the leg out and away from the midline of the body (abduction) while anchoring the pelvis to the femur.

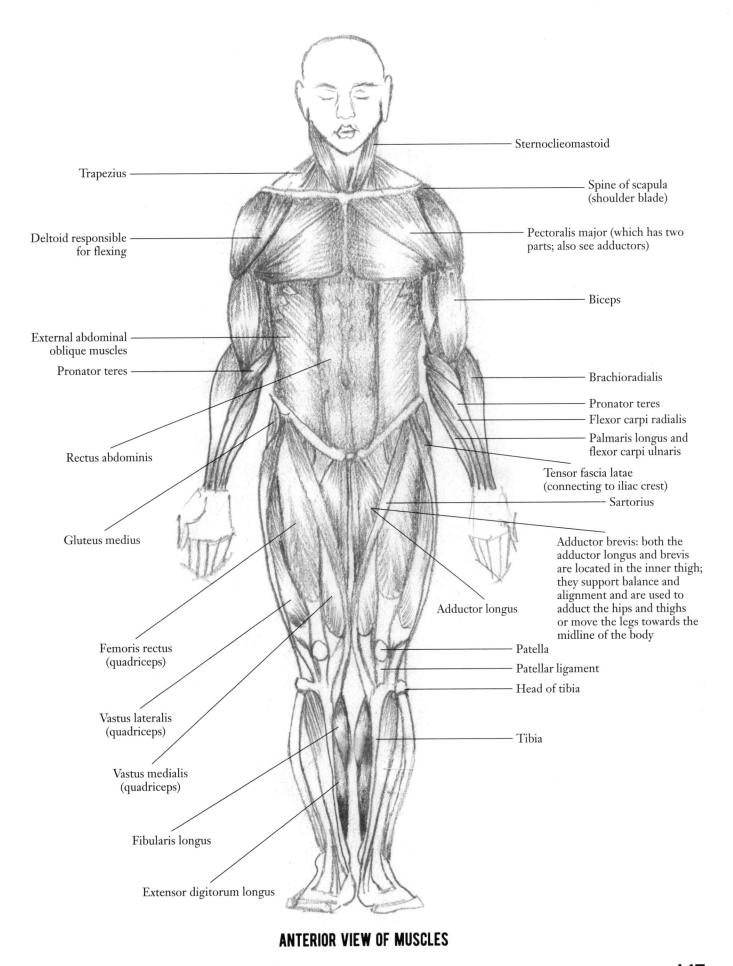

Trapezius

Deltoid responsible for flexing

External abdominal oblique muscles

Pronator teres

Rectus abdominis

Gluteus medius

Femoris rectus (quadriceps)

Vastus lateralis (quadriceps)

Vastus medialis (quadriceps)

Fibularis longus

Extensor digitorum longus

Sternoclieomastoid

Spine of scapula (shoulder blade)

Pectoralis major (which has two parts; also see adductors)

Biceps

Brachioradialis

Pronator teres

Flexor carpi radialis

Palmaris longus and flexor carpi ulnaris

Tensor fascia latae (connecting to iliac crest)

Sartorius

Adductor brevis: both the adductor longus and brevis are located in the inner thigh; they support balance and alignment and are used to adduct the hips and thighs or move the legs towards the midline of the body

Adductor longus

Patella

Patellar ligament

Head of tibia

Tibia

ANTERIOR VIEW OF MUSCLES

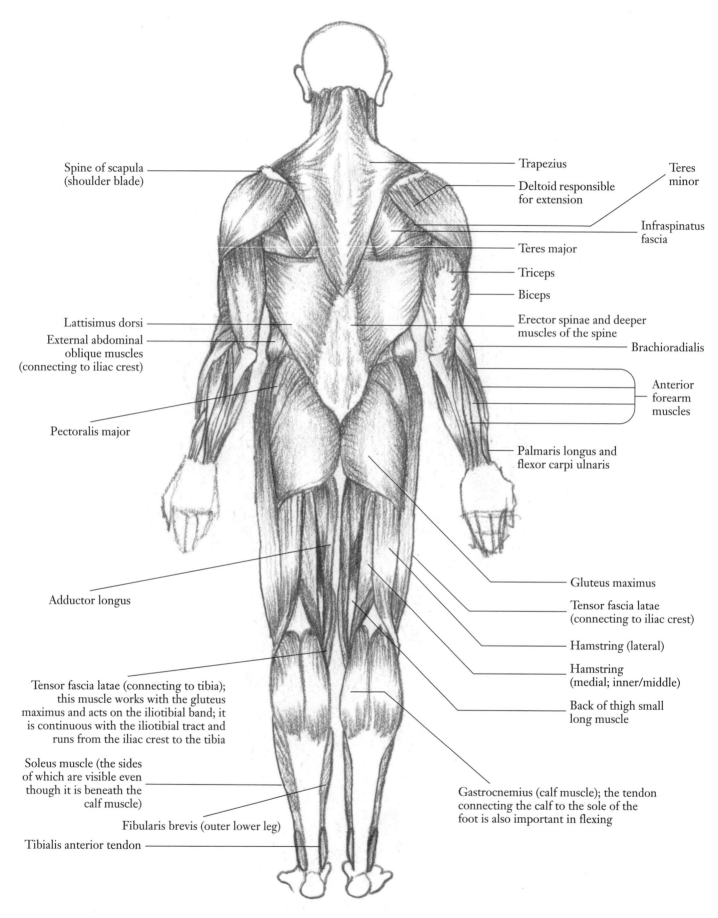

Spine of scapula
(shoulder blade)

Trapezius

Teres
minor

Deltoid responsible
for extension

Infraspinatus
fascia

Teres major

Triceps

Biceps

Lattisimus dorsi

Erector spinae and deeper
muscles of the spine

External abdominal
oblique muscles
(connecting to iliac crest)

Brachioradialis

Anterior
forearm
muscles

Pectoralis major

Palmaris longus and
flexor carpi ulnaris

Adductor longus

Gluteus maximus

Tensor fascia latae
(connecting to iliac crest)

Hamstring (lateral)

Hamstring
(medial; inner/middle)

Back of thigh small
long muscle

Tensor fascia latae (connecting to tibia);
this muscle works with the gluteus
maximus and acts on the iliotibial band; it
is continuous with the iliotibial tract and
runs from the iliac crest to the tibia

Soleus muscle (the sides
of which are visible even
though it is beneath the
calf muscle)

Fibularis brevis (outer lower leg)

Gastrocnemius (calf muscle); the tendon
connecting the calf to the sole of the
foot is also important in flexing

Tibialis anterior tendon

POSTERIOR VIEW OF MUSCLES

QUICK SKETCHES

It is useful to get into the habit of drawing quick sketches of isolated parts of the figure. You can combine them later or recombine them in different ways if you need sketches for character design or if you wish to compose scenes with multiple people. Being aware of the angle of tilt of the shoulders compared to the hips will enable you to create more expressive drawings. Refer back to the chapters about shape and perspective to see more detailed examples of exercises you can carry out to help you practise using simple shapes and forms in order to build up a drawing of the body. More examples of this are included in the chapter on portraiture.

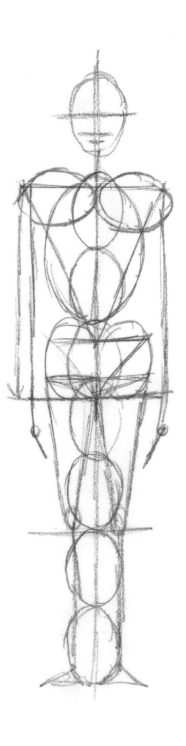

GEOMETRIC SHAPES

Simplifying what you observe is an approach that we have considered in earlier chapters. There is no single way to do this. You might use geometric shapes, line or perspective.

GESTURAL LINES

Looking for gestural lines 'within' the figure can also help you think about how you want to communicate movement or fluidity. Once you have your gestural lines, you can build up shapes to represent the form of your figure. Use your anatomical knowledge to refine your image so that it looks the way you want it to look.

TONE AND DETAIL

These two drawings of a clothed, seated figure in a chair emphasise the creases in the fabric and the shadows created by the different structures of the chair. Refer back to the chapter on tone and shading for guidance on drawing light and shade.

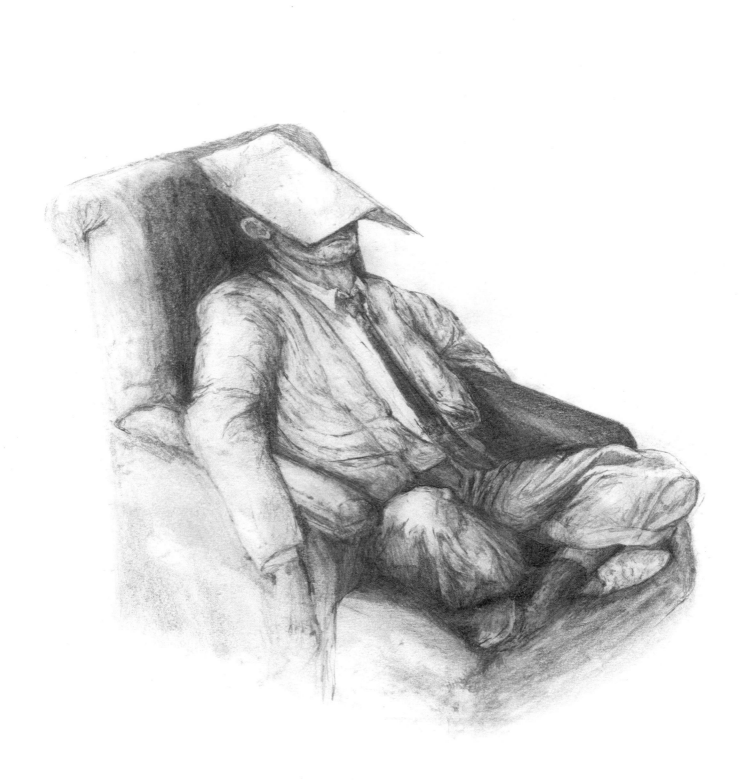

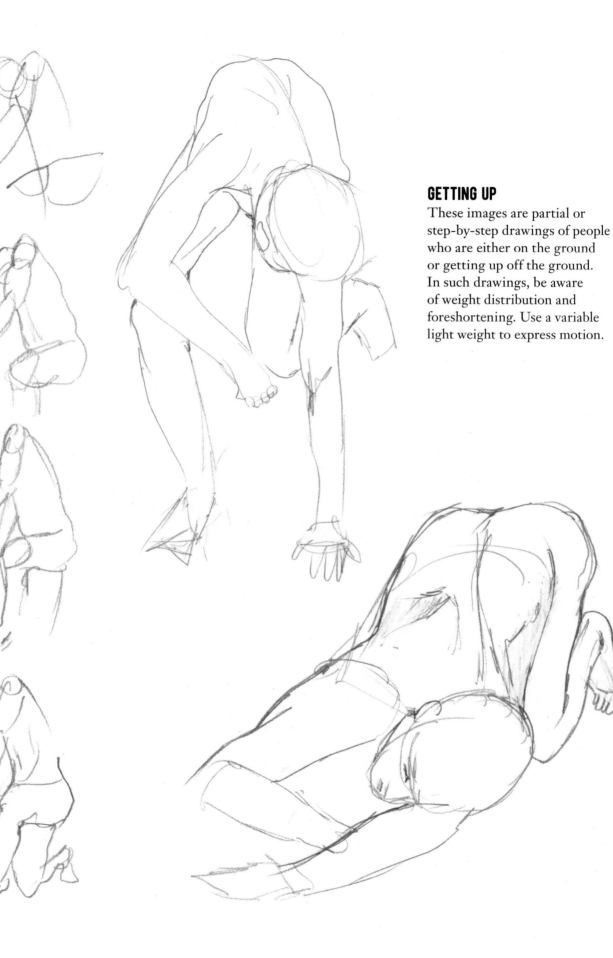

GETTING UP

These images are partial or step-by-step drawings of people who are either on the ground or getting up off the ground. In such drawings, be aware of weight distribution and foreshortening. Use a variable light weight to express motion.

MULTI-POSTURE POSES

In these sketches, we can see an array of poses: one standing, one in a fighting pose, and another seen from below looking up and holding a cat. In the cat drawing, the animal appears very large due to the effect of foreshortening. Notice how the hands and wrists holding the cat are different sizes from each other and larger than the width of the face. You can tell by comparing the hands to the cat's head that this 'giant' cat is a foreshortened image. The cat is leaning forward slightly towards the viewer, so its head is large in comparison to the person's.

TWISTED POSE

This seated nude woman has a twist in her pose. The shoulders are rotated towards the viewer and away from the direction in which the hips are facing. The head is also turned away from the viewer, giving an almost profile view of the face. The legs are crossed and the figure is robed in a piece of fabric. This is quite a complex pose. To capture it, remember the function of the axial skeleton and try to visualise and sketch the direction of the hips relative to the rib cage, shoulders, neck and head.

CROWDS OR GROUPS

When drawing crowds or groups of people, simplicity in your initial sketches can be really helpful. Including a table (or rug, or other similarly simplified piece of furniture) can help to guide any foreshortening or distance. Using the rule of thumb, include the table when you are observing, measuring and sketching. Practise drawing groups of people several times using simple shapes before eventually creating a detailed drawing with individual features. This can help with volume and distance.

16 ANATOMY OF THE FACE AND SKULL

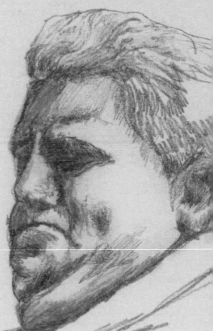

The overall shape of the skull is key to drawing an individual's head and face and conveying its solidity. Although the skull itself has just one moving joint (the jaw), faces are infinitely varied and capable of a diverse range of expressions, thanks to the complex layers of facial muscles. We are programmed to respond to faces – to understand their expressions and remember individual features.

The skull and facial bones form the foundation that supports all the overlying soft tissues of the face. This can be divided into different regions:

◆ Frontal skull (bony forehead)

◆ Orbit and eye socket

◆ Sinonasal cavities

◆ Zygoma (cheek bones)

◆ Maxilla (upper jaw)

◆ Mandible (lower jaw)

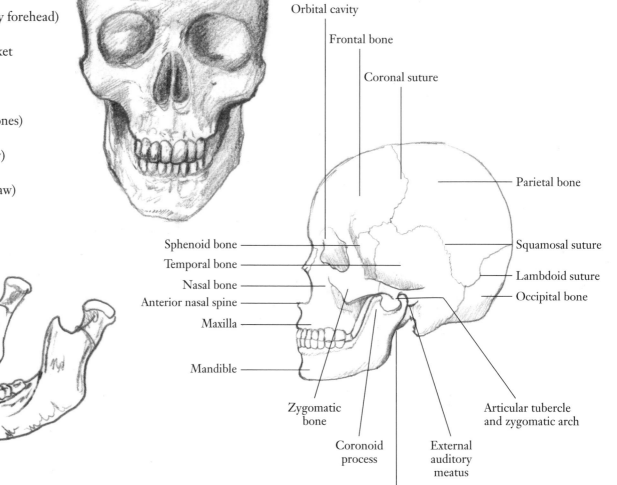

Orbital cavity

Frontal bone

Coronal suture

Parietal bone

Sphenoid bone

Temporal bone

Nasal bone

Anterior nasal spine

Maxilla

Squamosal suture

Lambdoid suture

Occipital bone

Mandible

Zygomatic bone

Articular tubercle and zygomatic arch

Coronoid process

External auditory meatus

Styloid process

FACIAL MUSCLES

Muscles of facial expression tend to be rings or thin flat bands that insert into the skin and move it from beneath, helping us to express or communicate. Of course, the superficial muscles of the jaw and mouth also enable us to chew and swallow food. Just as importantly, they give the face structure. Many of the muscles of the mouth and eye work in a similar way to the drawstring of a bag, while those to the side of the head operate much like a rope drawing a theatrical curtain across, up or down. Facial muscles criss-cross and overlap, creating a very complex arrangement of structures. Some of these connect to parts of the skull or jaw, as well as through layers of fat and other tissue.

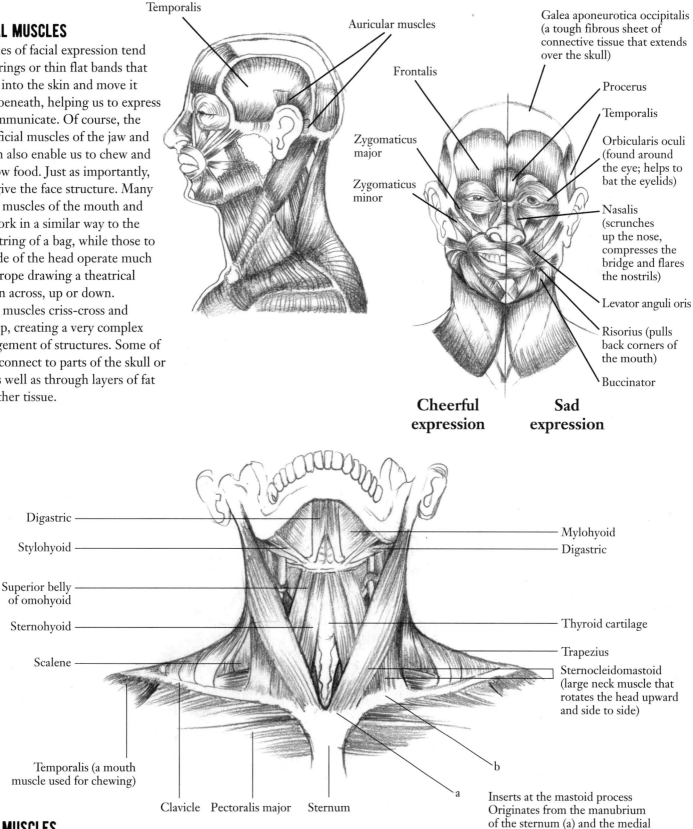

Temporalis

Auricular muscles

Frontalis

Zygomaticus major

Zygomaticus minor

Galea aponeurotica occipitalis (a tough fibrous sheet of connective tissue that extends over the skull)

Procerus

Temporalis

Orbicularis oculi (found around the eye; helps to bat the eyelids)

Nasalis (scrunches up the nose, compresses the bridge and flares the nostrils)

Levator anguli oris

Risorius (pulls back corners of the mouth)

Buccinator

Cheerful expression **Sad expression**

Digastric

Stylohyoid

Superior belly of omohyoid

Sternohyoid

Scalene

Temporalis (a mouth muscle used for chewing)

Clavicle Pectoralis major Sternum

Mylohyoid

Digastric

Thyroid cartilage

Trapezius

Sternocleidomastoid (large neck muscle that rotates the head upward and side to side)

b

a

Inserts at the mastoid process
Originates from the manubrium of the sternum (a) and the medial clavicle (b).

NECK MUSCLES

The neck holds up the head, and the muscles of the neck affect how the head is positioned. For the purposes of understanding portraiture, it is helpful to be able to visualise how different neck muscles affect the tilt of the head, and how the emphasis of muscles such as the sternocleidomastoid in a drawing can help communicate a pose or movement in more detail.

FAT COMPARTMENTS OF THE FACE

Fat is stored below the skin and above the muscle layer, and there are also a few muscles interspersed between the skin and fat. Facial fat protects the organs and functions of the head, and affects the appearance of the face. It occupies areas of the face in different ways; it does not cover the face in an even layer. This is unique to each person and changes as we age.

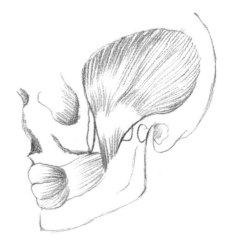

Fat cells can be found in the following areas of the face:

◆ Temple

◆ Orbital

◆ Upper cheek

◆ Medial cheek

◆ Lateral cheek

◆ Inferior cheek

◆ Mouth and chin

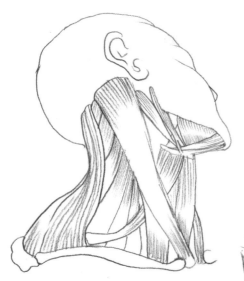

SIDE OF THE SKULL AND NECK MUSCLES

Muscles on the side of the skull enable movement of the jaw and are illustrated here. The neck moves and supports the head, and is important to consider when drawing portraits. The chapter on portraiture goes into detail about this. See the previous page for the labels to the muscles in these illustrations.

ANATOMY OF FACIAL EXPRESSION

The muscles of the face enable a wide range of movements. Some of these muscles are large, but the cheeks have many smaller muscles that control what our faces do when we eat, smile, laugh, cough or cry.

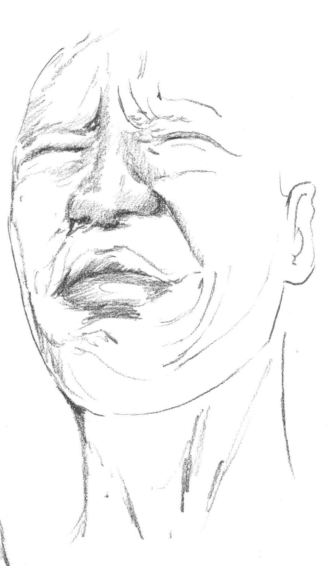

The main muscles of facial expression are:

◆ Frontalis

◆ Corrugator supercilii

◆ Orbicularis oris

◆ Depressor labii inferioris

◆ Mentalis

PROPORTIONS OF THE HEAD: A GUIDE

Many faces are more or less vertically symmetrical (you might know this as mirror symmetry or bilateral symmetry). You can draw the shape of a head using an overlapping ball (circle) and egg shape (oval that is slightly pointed or squared at one end), as shown on this page. This technique is sometimes called the ball and egg technique. The egg shape represents the face area and the ball represents the skull in which the brain is housed. You can draw a vertical line on the egg shape to help guide the drawing of a more or less bilaterally symmetrical shape.

USING THE EYE LINE AND EYE WIDTH AS SCAFFOLDING FOR A DRAWING

◆ The eyes are more or less halfway down the length of the oval.

◆ Sometimes (if the head is at an angle) you might draw this line as a curved line (see examples of ellipses in earlier chapters and on the next page).

◆ The use of the eye line can also help you position the pupils and iris in accordance with what you see in your model. Not everyone is the same, but many people's pupils look in the same direction. You can use the eye line to place the circles that will form the pupils and iris (a bit like scaffolding) so that they are level, but of course you would still use the eye line to draw strabismus (misaligned) eyes. The technique and principles of drawing are the same, no matter who you draw.

◆ Along the eye line, you can fit more or less five 'eye widths' from the edge of the head (near the temples).

◆ You can also fit about one 'eye width' between the eyes and in helping to map out the nostrils and corners of the mouth. There is of course variation between individuals, but it's useful to use this principle alongside the rule of thumb for drawing the head and preparing a portrait drawing.

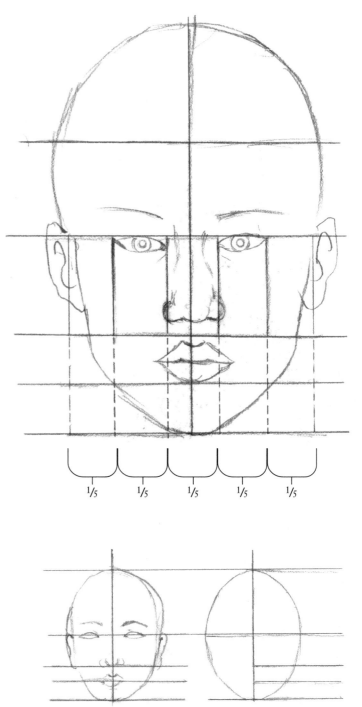

$^1\!/_5$ $^1\!/_5$ $^1\!/_5$ $^1\!/_5$ $^1\!/_5$

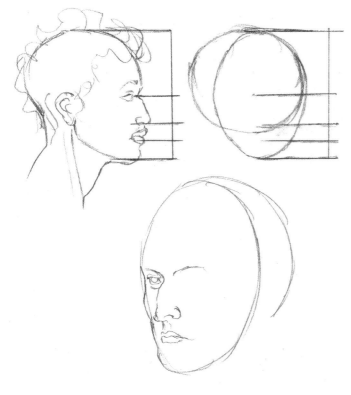

MAPPING THE LOWER HALF OF THE HEAD

◆ From below the eye line (the lower half of the oval), you can divide this space in half and use the rule of thumb to figure out how far down the nose ends and the mouth begins.

◆ Divide the lower half in half to make two quarters; the upper quarter (just below the eye line) is where the nose tends to be.

◆ The lower quarter is where you will find the mouth. The lower quarter can be divided in half again to make eighths. This will help you to place the mouth and chin. In the upper eighth you tend to find the mouth, and in the lower eighth you tend to find the chin.

◆ The way you divide up the face and create scaffolding to help guide your drawing depends on how open the mouth is, and it can help with drawing facial hair too.

TILT OF THE HEAD AND SCAFFOLDING LINES

The lines you draw with your egg and ball will help structure your drawings (eye line and line of bilateral symmetry). These lines need to be sketched out as more curved the more you move away (above or below) eye level – just like ellipses.

Eyes halfway

Mouth lower quarter

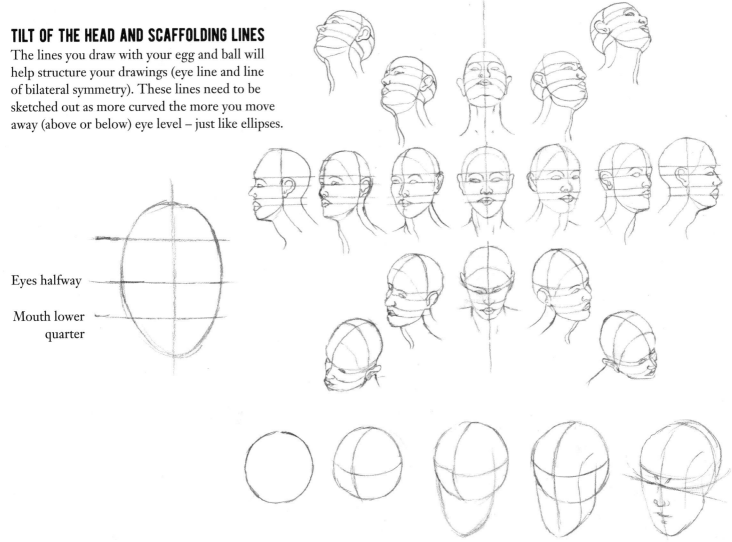

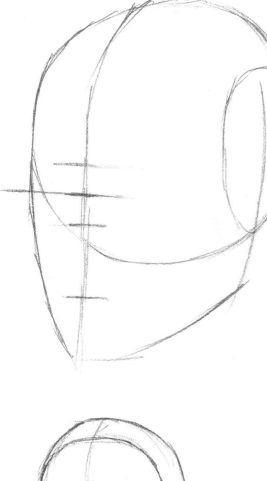

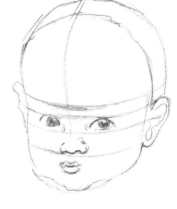

EGG AND BALL TECHNIQUE

The egg and ball technique is helpful in capturing the volume of the skull and positioning the facial features. These images show three-quarter profiles looking in different directions. You can use lines to mark the eyebrows, eyes, nostrils, end of the nose, mouth and chin. These lines can be modified to lightly draw ellipses, which will help to place features that are viewed at an angle, such as when looking up or down.

DRAWING A SIDE PROFILE

The egg and ball technique can also be used in drawing side profiles. Always place your egg and ball lightly with pencil first.

STEP 1

Draw an egg shape and then add some short lines to help guide your drawing. First, add a line halfway down for the eye line. Place another line halfway between the eye line and the chin. This will help you to position the end of the nose and nostrils, which may be at different heights.

STEP 2

Add a circle or oval shape to mark out the eye socket. The eye line should be roughly in the middle of this curve. Use a line to estimate the angle of the bridge of the nose away from the forehead. Add circles for the tip of the nose and nostrils. Use C-shaped lines and marks to sketch out the lips, and a more fluid line to sketch the ear.

STEP 3

Use a putty eraser to remove your construction marks when you don't need them anymore. Add detail to the eyebrow, eye, nostril and bony structures such as cheekbones. To draw glasses, use a straight line and ovals. Remember that the arms of the glasses hold the lens in front of the eye by resting on the ear.

STEP 4

Add details, all the while gently moving back and forth using the putty eraser and pencil marks. Add shadow, hairs and thickness or volume to accessories such as glasses. Modify the outline of your egg and ball shape as well as the forehead in order to capture some of the subtle nuances and bumps you see on your model.

STEP 1

For a seated figure where a little more of the torso is visible, you can use the same egg and ball technique for the face and volume of the skull. If the model is almost looking at you, this will help with the placement of the ear and shadows later on. Use curved lines, rectangles and ovals to capture the positions of the arms and body.

STEP 2

Add construction lines and circles for the eye sockets, with eyebrows to inform where you place these. Then add construction lines to other facial features. Include a more defined line of bilateral symmetry – in this example, the line of bilateral symmetry folds over the shape of the forehead, bridge of the nose, lips and chin. Refine the structure of the hands or other features with geometric shapes such as long, tapered oval shapes that more closely resemble what you see. Use your putty eraser and imagine that you are actually 'sculpting' the shape 'into and out of' the page.

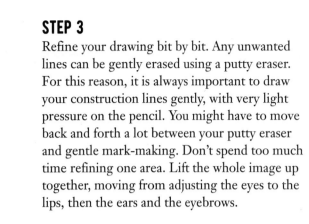

STEP 3

Refine your drawing bit by bit. Any unwanted lines can be gently erased using a putty eraser. For this reason, it is always important to draw your construction lines gently, with very light pressure on the pencil. You might have to move back and forth a lot between your putty eraser and gentle mark-making. Don't spend too much time refining one area. Lift the whole image up together, moving from adjusting the eyes to the lips, then the ears and the eyebrows.

STEP 4

Continue to refine your image, and only start to bring in shading when you are happy with the placement of all your features.

FORESHORTENING

You can adapt your elliptical eye line of the figure depending on the tilt of the head. Remember to apply ellipses when foreshortening.

FACIAL EXPRESSIONS

These facial expression drawings show variation in the movements of the orbicularis oculi, orbicularis oris and frontalis muscles. The two drawings at the top of the page show the muscles and the directions in which they can be moved (indicated with arrows).

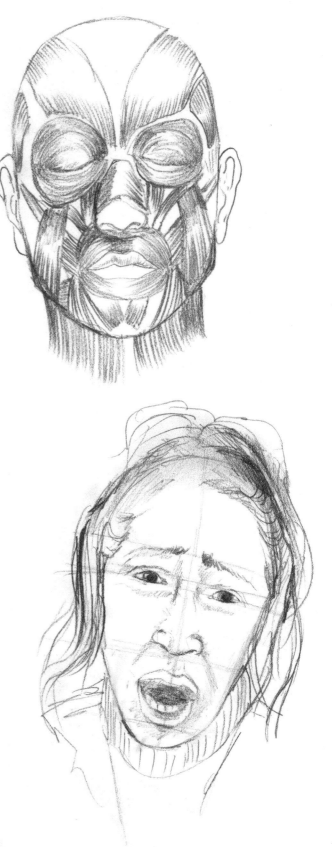

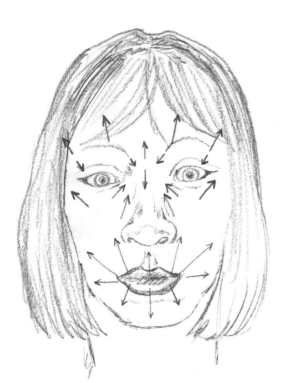

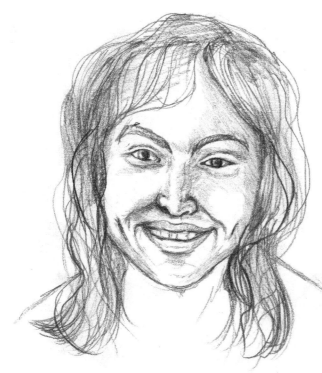

17 THE MUSCULATURE OF THE MOUTH

The flexibility and wide range of movements made possible by the muscles of the mouth are what make it so expressive. The muscles that control the lips and mouth are complex and interconnected like a web, so if you try to wiggle your nose, you will undoubtedly wiggle your upper lip too. These muscles weave over and under each other, connected by fibrous tissue.

FRONT MUSCLES OF THE FACE

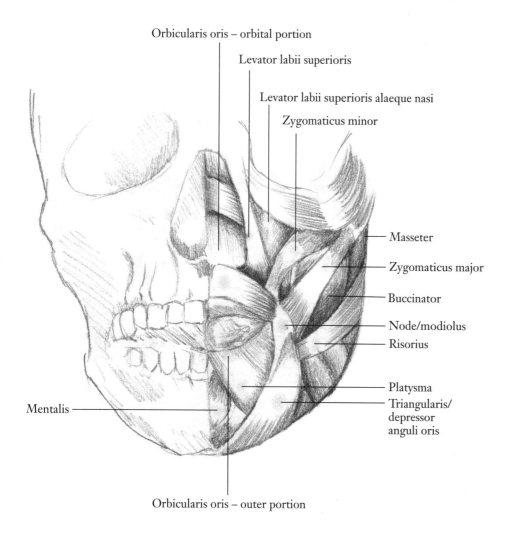

Orbicularis oris – orbital portion

Levator labii superioris

Levator labii superioris alaeque nasi

Zygomaticus minor

Masseter

Zygomaticus major

Buccinator

Node/modiolus

Risorius

Platysma

Triangularis/ depressor anguli oris

Mentalis

Orbicularis oris – outer portion

ANATOMY OF THE MOUTH

The orbicularis oris is a complex of muscles of the mouth. Made from layers of muscle fibre extending from the base of the nose around to the top of the chin, these muscles open and close the mouth, forming and controlling this orifice. The buccinator starts at the jawbone (mandible) and the side of the face, and draws the mouth open and closed. It stretches the circular fibres of the orbicularis oris around the mouth so that they open and close around the opening of the mouth. If the buccinator is compressed, it pushes the lips into the teeth. The modiolus anchors many of the muscles on either side of the face. The masseter opens and closes the mandible. It is connected at the temporal process of the zygomatic bone and the anterior two-thirds of the inferior border of the zygomatic arch to the mandible.

MOUTH ANATOMY AS SEEN FROM THE SURFACE OF THE SKIN

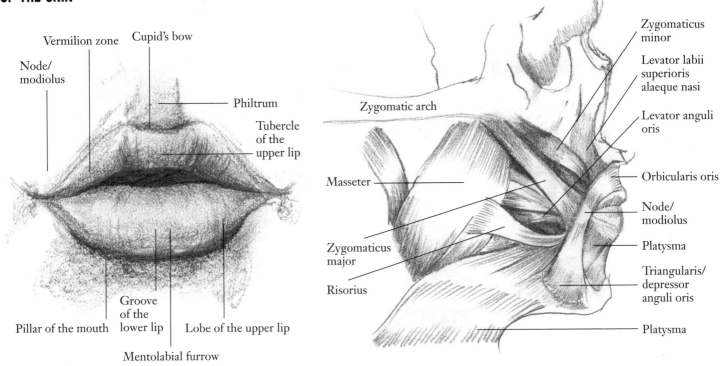

Node/modiolus
Vermilion zone
Cupid's bow
Philtrum
Tubercle of the upper lip
Pillar of the mouth
Groove of the lower lip
Mentolabial furrow
Lobe of the upper lip

Zygomatic arch
Masseter
Zygomaticus major
Risorius
Zygomaticus minor
Levator labii superioris alaeque nasi
Levator anguli oris
Orbicularis oris
Node/modiolus
Platysma
Triangularis/depressor anguli oris
Platysma

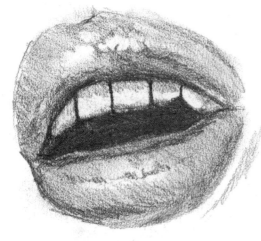

ORBICULARIS ORIS IN ACTION

As well as opening the mouth, the orbicularis oris can tighten into a pucker. The lips can be pushed outwards, and if we combine this with suction from within the cheeks, we can exaggerate this movement as seen in the drawing below. This makes for a fun pose – but it's hard to hold for a long time, so you might want to work from a photograph!

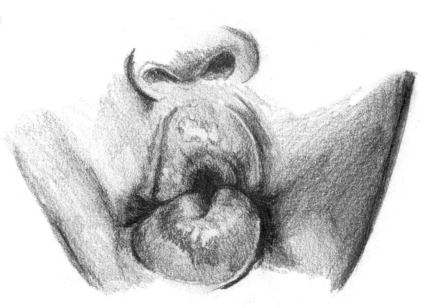

OVERLAPPING OVALS: THREE-QUARTER VIEW OF LIPS

There are many methods for drawing lips using circles. This method is quite useful if you are drawing lips at a three-quarter view. You could use the same principle for a front-facing view or even with a tilt of the head looking up or down.

STEP 1

Begin with a vertical line of bilateral symmetry, then add a horizontal line that crosses this line at 90 degrees (crossing at a point past the halfway point, up to three-quarters of the way along the line where the lips meet). Some way up the vertical line (using your rule of thumb), draw a shallow C-shape on the top half of the vertical line; this will be the Cupid's bow. Some way across the horizontal line, draw dots for the corners of the mouth.

STEP 2

Draw overlapping oval-like shapes to create the main form of the mouth.

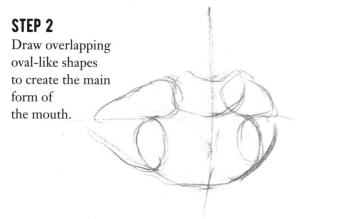

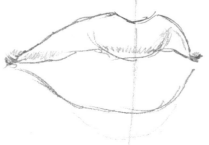

STEP 3

Define the outline of the lips and the centre line. Once you are happy with the overall shape you can erase your guidelines.

STEP 4

Add some initial shading – and you could stop here if you wanted to.

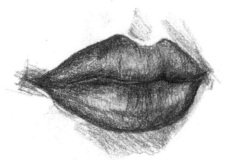

STEP 5

If you want to add more detail, draw full-cover shading.

STEP 6

For more even detail, add deep shading and texture.

DIFFERENT POSITIONS

The mouth can be held in many different positions. Remember to pay close attention to any reflections and shadows that go back into the mouth, on the lips and beneath the mouth.

VARIATIONS IN FACIAL EXPRESSION

In the same way that some people can roll their tongue while others can't, there is great variation in some of the smaller muscles of facial expression. This is a drawing based on Peter Paul Rubens' portrait of his daughter Clara Serena Rubens, circa 1616. The girl is pursing her lips, but some people cannot do this. Such anatomical variation and diversity is very typical – the facial muscles around the mouth can vary enormously from one person to another. The angle of the levator anguli oris, zygomaticus major, risorius, buccinator and depressor anguli oris vary in their arrangement in relation to the angle of the mouth. The same can be said of the mid-facial region, the levator alaeque nasi, levator labii superioris, zygomaticus minor, risorius and zygomaticus major (which can be both single and bifid), and the nasolabial crease varies a lot – it can be concave, convex or straight.

RESTING MOUTH AND PULLING FACES

While the pensive expression above shows the mouth in repose, the drawing below captures a fleeting moment of exuberance. It might help to draw from photographs to capture this kind of facial expression, as it would be very awkward for a model to hold for a long time.

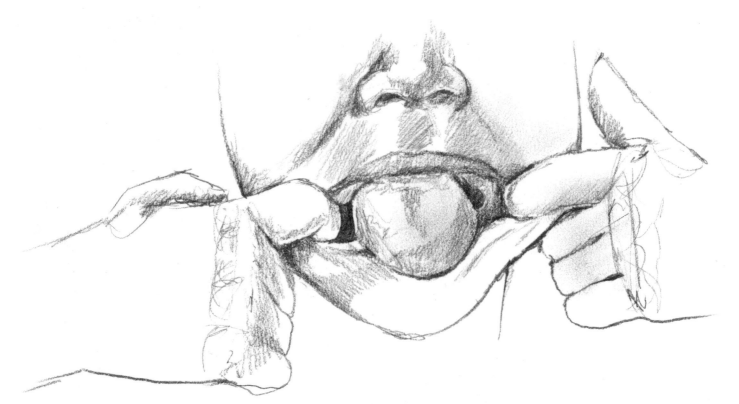

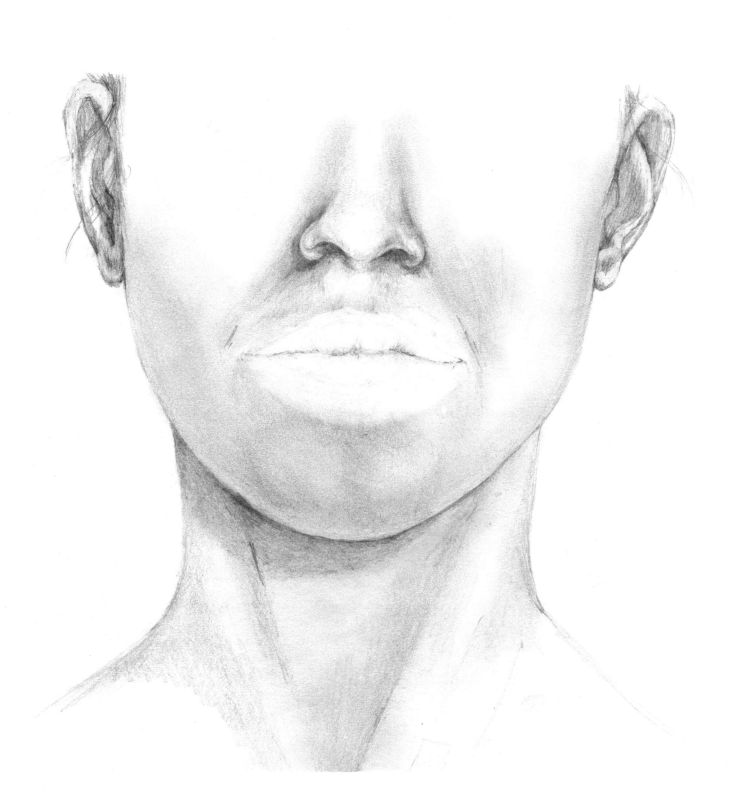

ADDING DETAIL TO THE LIPS

The lips have not yet been finished in this image, but
initial construction lines and a more detailed/accurate
line has been added to denote where the two lips meet.
This is not always a straight or perfectly curved line.

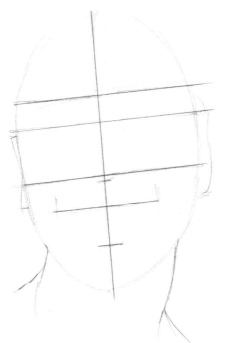

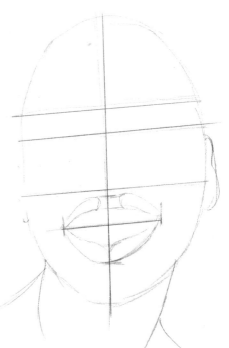

STEP 1

Begin with construction lines. You can use a ruler if you wish, but this is not always necessary. The proportions will be different for an open mouth, but the principle of proportions is always quite similar.

STEP 2

For an open mouth, be sure to include construction lines to show its width. The mouth might not be perfectly symmetrical, but this is totally fine and to be expected.

STEP 3

Use curved shapes to accentuate the lower and upper lips. Do this in four sections as shown in this image: top left, top right, bottom left and bottom right.

STEP 4

Start refining your drawing. Add shadow as if you are sculpting in and out of the page.

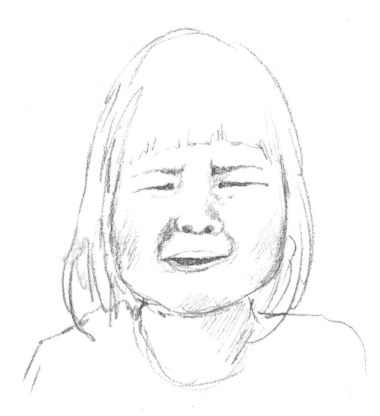

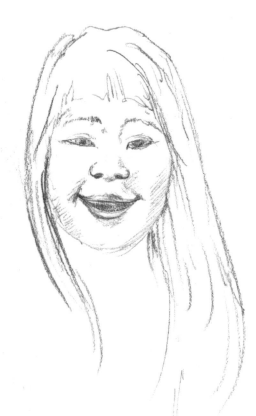

CRYING AND FROWNING

The main facial muscles used in crying are the frontalis, corrugator and orbicularis oculi. The brow tends to be compressed in a frown, the corners of the mouth drop and there tends to be a downward pulling of the lower lip into a pout.

SMILING

When observing smiles, what we notice is that the corners of the mouth are raised – five pairs of muscles are needed in this movement alone. Sometimes the teeth are partially visible.

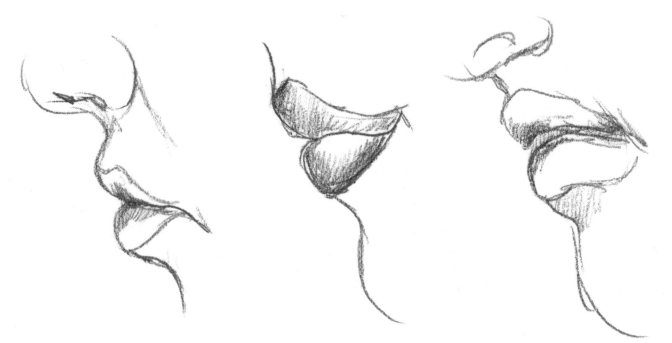

THREE CLOSE-UPS OF THE MOUTH

When drawing the mouth and lips up close, think back to ellipses. Is the curve where the lips meet at your eye level exactly, or is it slightly above or below it?

18 THE TEETH AND JAW

Drawings that show teeth can be very difficult to do. We have mentioned teeth in the previous chapter, but will spend more time on them here. Teeth are organic, so drawing them with lines that are not perfectly straight will help to make them look more realistic. The anatomy of the jaw is covered over the next few pages.

MUSCLES IN THE SKULL AND JAW

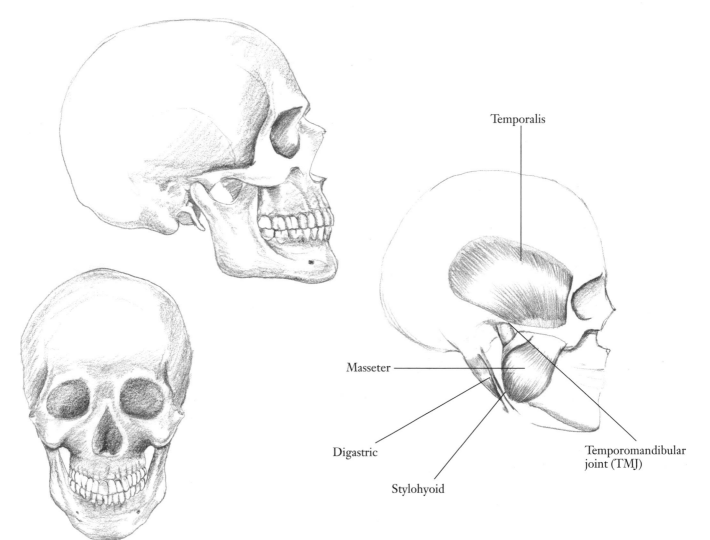

Temporalis

Masseter

Digastric

Stylohyoid

Temporomandibular joint (TMJ)

LATERAL VIEW OF JAW MUSCLES

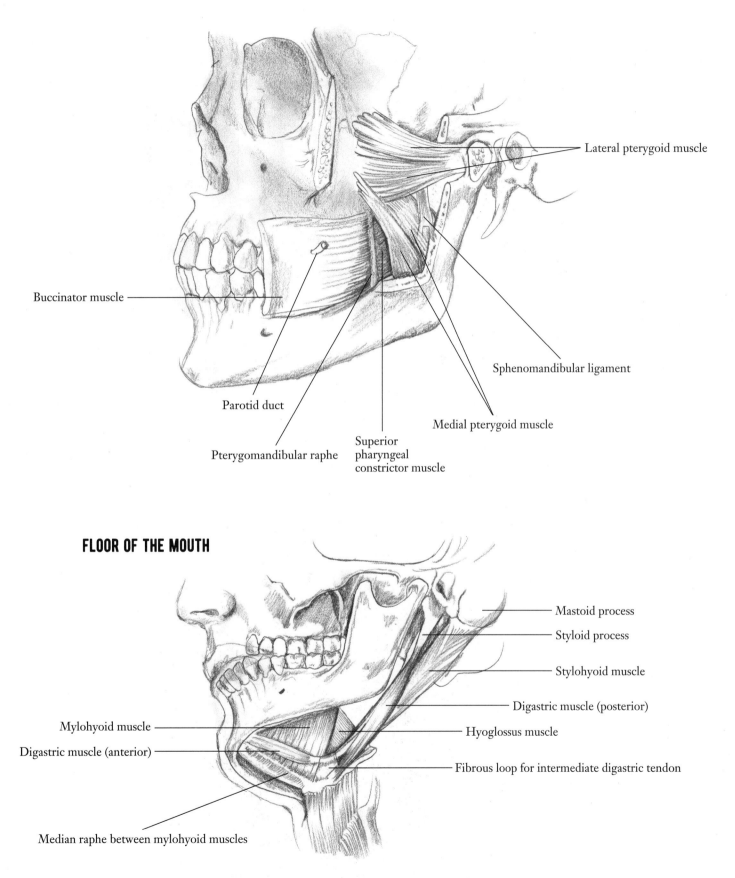

Buccinator muscle

Parotid duct

Pterygomandibular raphe

Superior pharyngeal constrictor muscle

Medial pterygoid muscle

Sphenomandibular ligament

Lateral pterygoid muscle

FLOOR OF THE MOUTH

Mylohyoid muscle

Digastric muscle (anterior)

Median raphe between mylohyoid muscles

Mastoid process

Styloid process

Stylohyoid muscle

Digastric muscle (posterior)

Hyoglossus muscle

Fibrous loop for intermediate digastric tendon

LOWER JAW AND TEETH

LOWER JAW (THREE-QUARTER VIEW)

The lower jaw is called the mandible and is hinged on to the skull at the temporomandibular joint, just beneath the ears. The mental protuberance of the chin can be a notable individual feature, as can the lower jawline. The teeth have curved edges and protrude out slightly from the jaw. They are also wider at the base where they meet the gums, and then taper up to be narrower at their tips.

Alveolar process

Mental foramen

Ramus of the jaw

Mental protuberance of chin

Body of the jaw

TEETH (FRONT VIEW)

Drawing teeth with straight lines does not help to capture an accurate likeness. If that is what you are aiming for, draw teeth that are slightly angled. Most people do not have totally straight teeth.

BRACES

This drawing shows braces behind the teeth of the jaw bone. These are difficult to draw, but you can use squares and lines in a similar way to using an egg and ball to draw a head.

TOOTH ROOTS AND GUMS

The teeth have quite large roots that hold them in place. Don't forget to draw the gums, if you can see them – they are interesting and shiny.

TEETH AND LIPS

Having a lovely gap between teeth or irregularities in teeth alignment are always fascinating. Braces can also be interesting (albeit tricky) to draw. Don't forget to include shading on the teeth – the lips create a shadow over them. Lips and teeth can be hard to combine, so build up tone gently towards the darker tones of the mouth. Never press too hard when sketching out structure. Save the heavy, dark tones for last. This will intensify the shadows and darker areas of your drawing.

19 THE EYE

The eyeball and surrounding muscles that keep it in place and move it around have their own anatomy. Whenever we draw eyes, we need to think about the external anatomy – the skin around the eyes, eyelids, lashes and brows are very important in the way we communicate to each other using facial expressions. Seven muscles move the eyes within the eye socket (orbit). These are responsible for moving the eye up and down and controlling the direction in which we look. We cannot see them, but it helps to understand how they direct the gaze. Frowns, grins and smiles affect how much of the eyeball is visible, and the eyebrows are also important in forming facial expressions.

ANATOMY OF THE EYE

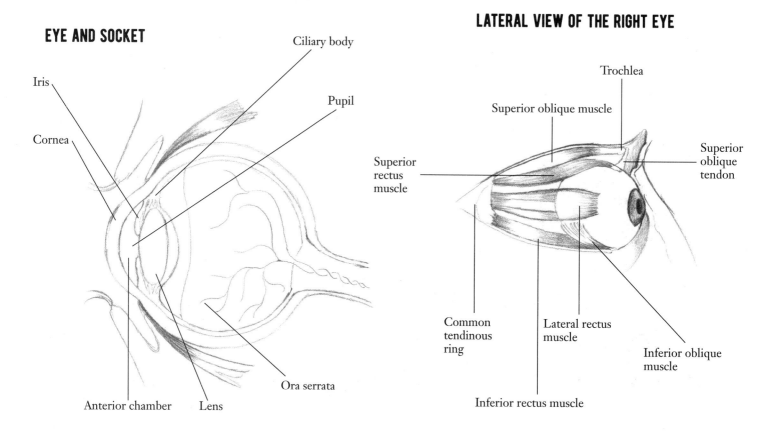

EYE AND SOCKET

Iris

Cornea

Ciliary body

Pupil

Anterior chamber

Lens

Ora serrata

LATERAL VIEW OF THE RIGHT EYE

Trochlea

Superior oblique muscle

Superior rectus muscle

Superior oblique tendon

Common tendinous ring

Lateral rectus muscle

Inferior oblique muscle

Inferior rectus muscle

ANTERIOR VIEW OF THE RIGHT EYE

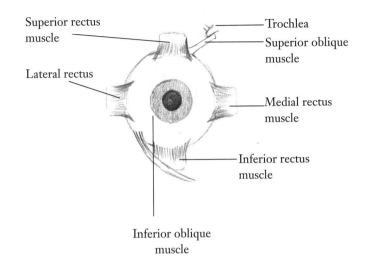

Superior rectus muscle

Lateral rectus

Trochlea

Superior oblique muscle

Medial rectus muscle

Inferior rectus muscle

Inferior oblique muscle

DRAWING EYES

The drawings below show how to draw an eye step by step. We tend to draw eyes much larger than they actually are. It may seem counter-intuitive, but beginning with a circle is a very effective way to make sure your proportions match your observations. Drawing a smaller circle in the middle and yet another smaller circle within this one is a great way to practise. Sketching circles makes you think about the whole structure of the eye and how the eye, iris and pupil are framed and shaded by the eyelid and lashes. Remember that the eyeball is held within the eye socket of the skull, and always has some shadow within it.

We tend to want to draw brilliant bright white eyes. But even though shading with pencil or greys or yellow can feel a little bit strange, it yields some good results. Remember that the eye is also a sphere – not actually a circle – so it will always have some kind of shadow.

Depending on the angle at which the head is tilted and where the eye is looking, the eyelid will cover part of the iris and even part of the pupil. In Step 6 below, a slight shadow is added. To develop this image further, I would add more shade and then use a putty eraser to create bright reflective marks that represent the wateriness of the eye's surface.

STEP 1
Draw a faint circle. Take your time to get it as accurate as possible.

STEP 2
Now add another, smaller circle in the centre, which will form the outside edge of the iris.

STEP 3
Add a third small circle in the centre to denote the pupil.

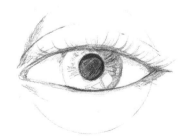

STEP 4
Draw an oval shape, pointed at each end, overlapping your middle circle (the iris) at the top and the bottom.

STEP 5
Lightly shade the pupil and add some definition to the shape of the tear duct.

STEP 6
Adding some eyelashes and shading around the eyelids, iris and pupil will transform your drawing from a diagram into a realistic picture of an eye.

ATTENTION TO DETAIL

Sometimes the subtlest things can be missed, but to make a drawing really sensitive, don't be afraid to include lines and creases and use curved lines for the lashes. Some lashes might even seem to curve into the eye when you draw them, but this makes them seem more three-dimensional. Experiment by practising to draw the eye while your model gazes in different directions.

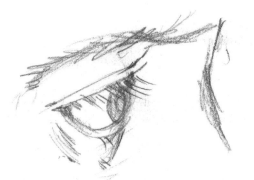

QUICK SKETCH

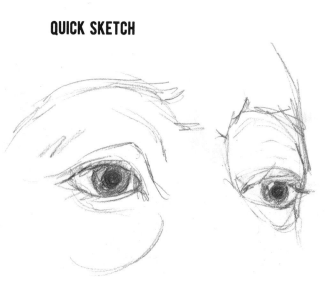

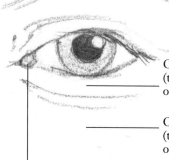

Orbital portion of the lower lid (the orbital portion of the upper or lower lid sits on the eye socket)

Ocular portion of the lower lid (the ocular portion of the upper or lower lid sits on the eyeball)

Lacrimal caruncle

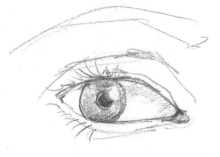

LASHES AND LIDS

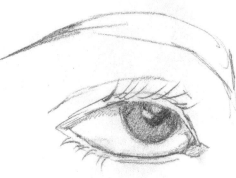

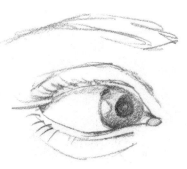

TECHNIQUE: CROSS AND BULLSEYE AND THE RULE OF THIRDS

When you draw an eye, it is important to keep the proportions of the circle that represents the eyeball, the circle that represents the iris, and the circle that represents the pupil. The diameter of the eyeball circle needs to be divided into thirds, and the middle third is the iris. Within the iris circle, the middle third of this circle is the pupil.

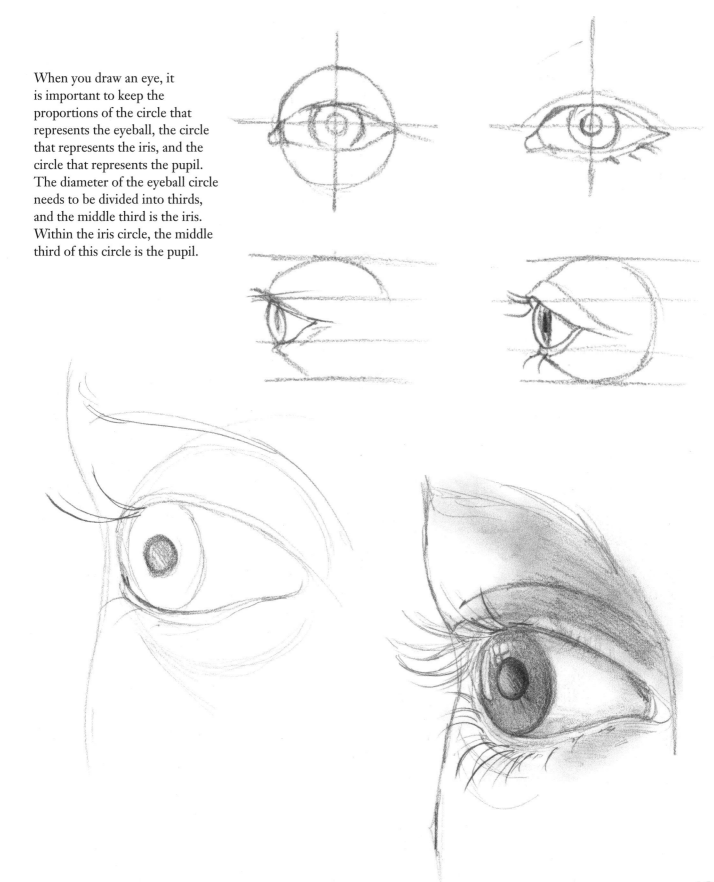

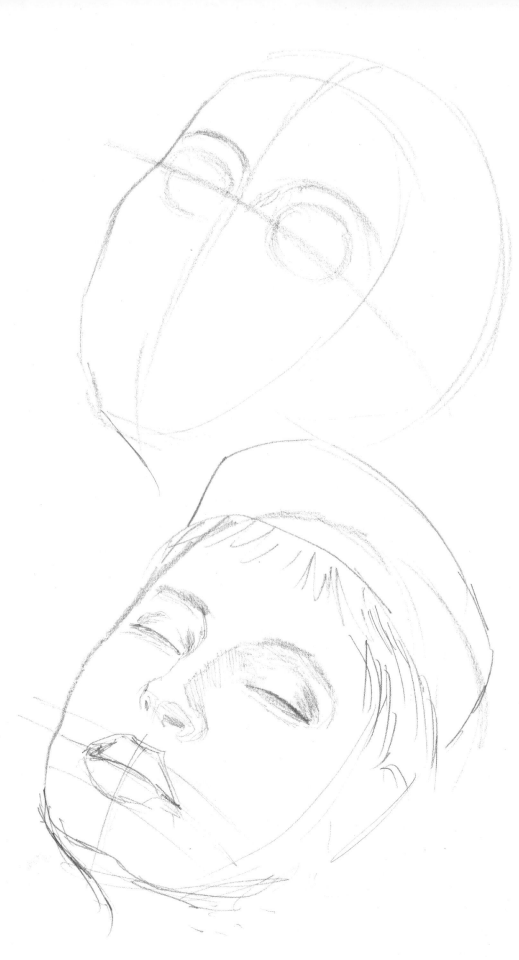

CONSTRUCTION LINES

When positioning the eyes, use construction lines and ellipses. Also be aware of where the head is facing, so that lines of bilateral symmetry can be placed and measured against.

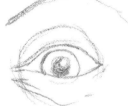

DIFFERENT VIEWS

Here is a page of different eyes looking in different directions and with different expressions. Line drawings can be very effective, but if you wish to use tone and shade, make sure you layer your pencil tone carefully. Also be mindful of the fact that the eyeball itself is in a socket so it will not be a brilliant white colour – it may have some shadows over it.

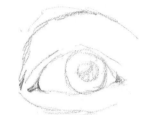
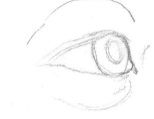

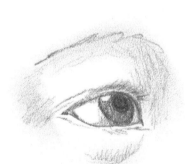
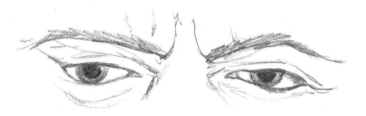
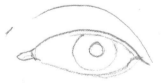
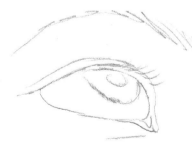
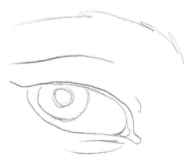

DRAWING SPECTACLES

When drawing spectacles on a person, be careful to use a straight line to be the 'legs' of the spectacles frame. This straight line will go from near the centre of the shape you draw for the lens (an ellipse in these examples), and will rest on the point where the ear meets the skull. Draw a simple line drawing first, then add depth and volume as your work progresses.

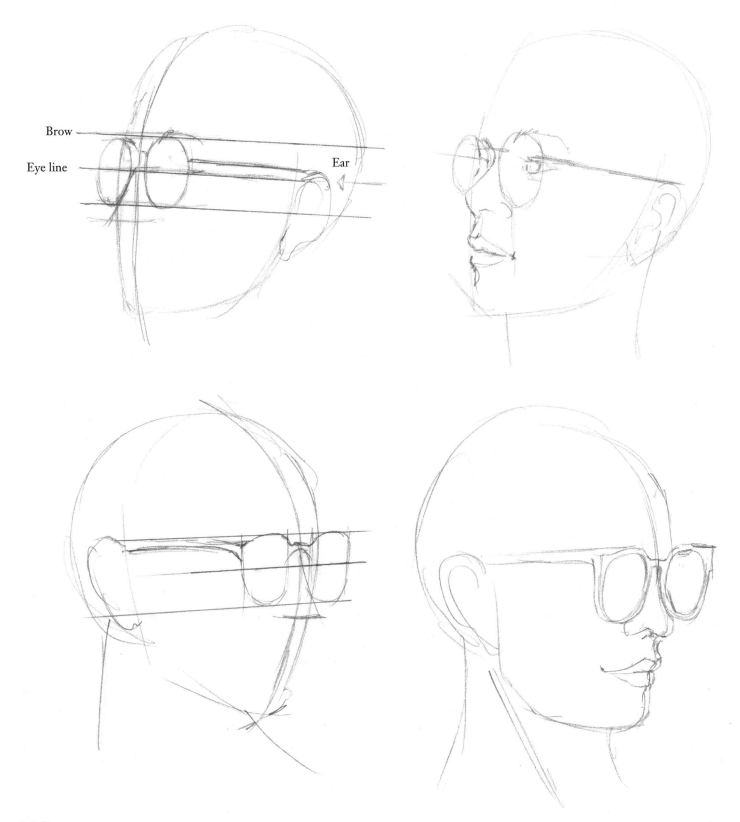

INK AND WASH FINISH

These two examples have made use of ink and water to create an ink wash effect to complete the image. More detail would be possible with a thinner medium such as a mechanical pencil, however this might not always be desired or what you have time for.

20 THE EAR

The external part of the ear (the outer ear) is a complex structure that comes in many different shapes and sizes. It is made of cartilage and skin, and its unique structure gives each of us our unique appearance. The medical/anatomical term for the outer ear is the auricle or pinna. There are three different parts to the outer ear: the tragus, helix and lobule. Sometimes these can be drawn rapidly using curved lines and shading. As well as studying the size and shape of the ear, notice the angle at which it is connected to the head. Some ears lie flat and close to the head while others protrude to varying degrees.

DRAWING EARS

Ears vary a great deal, and below are some examples of step-by-step drawings showing the ear face on, from the side and from behind. You can see how simple curved lines and then shading are gradually added to give the ear detail.

EXTERNAL EAR ANATOMY

Here are some examples of ear drawings, some labelled with anatomical terms.

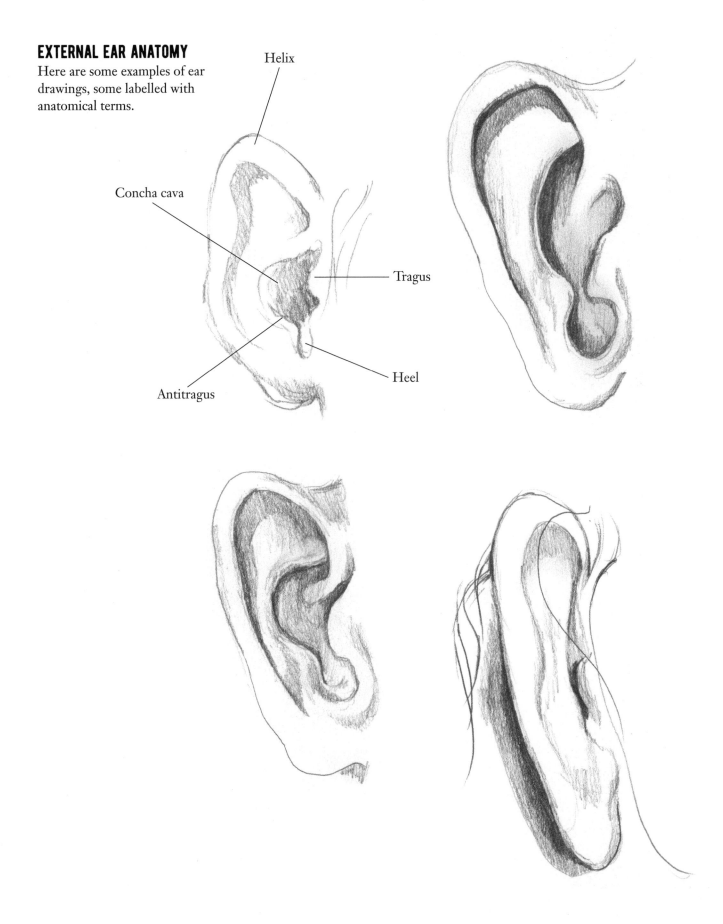

Helix

Concha cava

Tragus

Heel

Antitragus

21 THE NOSE

The nose is roughly pyramidal in shape and is mainly made of cartilage and skin. The nasal bone is located at the base of the nose between the eyes, and sometimes the nasal bridge is small or flat, other times wide or pronounced. The nasal root is continuous with the forehead and contributes to the shape of the face in profile. The nose ends in a rounded tip (apex) which can be curved, slightly squared, flattened or anything in between. The dorsum lies between the root and apex of the nose. The nostrils (nares) are pyriform openings into the nasal cavity and are connected in the middle (medially) by the nasal septum, and on the side (laterally) by the alae nasi (lateral cartilaginous edges of the nose).

ANATOMY OF THE NOSE

The nose as seen from the surface is shaped by the nasal bone, triangular cartilage and alar cartilage.

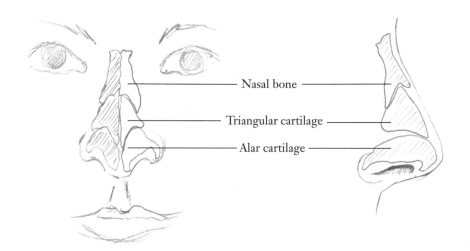

Nasal bone

Triangular cartilage

Alar cartilage

SIDE VIEWS

These images show how circles, curves and lines can be used in drawing differently shaped noses.

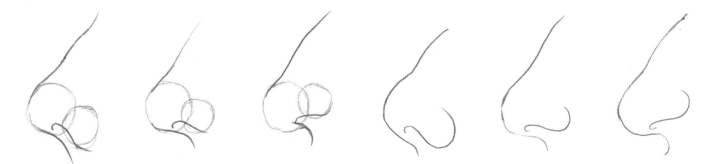

DRAWING A NOSE

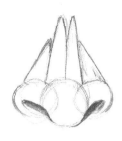

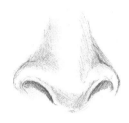

STEP 1
To draw a nose facing frontwards, sketch three overlapping circles. The middle circle represents the apex of the nose and may need to be bigger or smaller than the other two, depending on the angle and size of your model's nostrils. The middle circle may also need to be higher or lower than the other two, depending on the direction in which your model is looking (up or down) and their individual anatomy.

STEP 2
Sketch out triangle shapes to try to capture the shape of the nose. Think of the skin on the nose a bit like a tent, with the nostrils, bridge and nasal bones holding the tent in place. Add curved S-shaped or C-shaped lines for your nostrils, then add shadow.

STEP 3
Remove construction lines, add tone and blend.

OTHER VIEWS

Observe how noses can look quite different when seen at different angles, to the side, from above or below.

22 HAIR

Hair is important! It is not an anatomical structure as such, but it's still something important to consider in a drawing or in portraiture. It can express a great deal of individuality and culture, and it is also fun and satisfying to do. Much like the chapter on line, marks and texture, drawing hair is about layering tone, applying marks and using a putty eraser to create reflections. Sometimes you might need to use a wide hard pencil or piece of graphite to create a base layer. You will then need to draw more defined structures using a softer pencil to create darker tones. Keep your pencil sharpener handy so that you can really capture details – the odd stray hair can really enhance a drawing.

Hair is extremely variable in texture, length and form, and there are innumerable ways to style and colour it. It might not be common to include hair in a book about anatomy since it isn't really an anatomical structure, but it is so important to self-expression, culture and identity that it really does deserve its own section. It can add a lot of character to a drawing, especially if your model expresses part of themselves and/or their culture through different hairstyles.

STRUCTURE AND TEXTURE

BRAIDS

Complex hairstyles such as braids can be drawn using the same method that we have used throughout this book, by breaking elements down into smaller, simpler shapes. Start off by drawing the direction of each braid. For cornrows, the direction and structure of each braid is carefully designed by a hairdresser to create a particular effect, and there are infinite geometric possibilities. Sketch the direction and size of the braid using a curved shape that tapers off where the braid begins and ends. Some braids are wider and fuller, while others are smaller. The next step is to think about the braid pattern, and depending on the plaiting pattern (for example, a three-stranded braid or a fishtail), divide the initial braid outlines into two, three or a zig-zag line to demarcate the direction of each individual braided section of hair that is visible. After this stage, divide each braid into smaller curved shapes using a stretched S-shape to create a wavy seed or leaf shape which also tapers at either end. Finally, add shading, tone and highlights, depending on light source.

LINES AND TEXTURE

Hair can be represented with very simple but carefully placed lines, and this also applies to eyebrows, cascading strands and special hairstyles. These images show various stages of completion. The bottom left drawing shows a rapidly shaded base layer; this needs to be blended and refined with more detail using a softer pencil that is nice and sharp. Lines and structure drawn with a heavier pencil may also need to be blended, depending on the texture and style of the hair you are drawing.

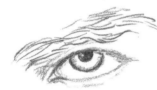

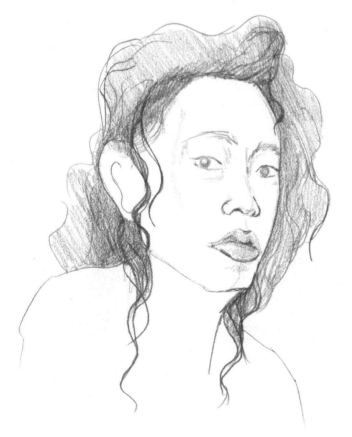

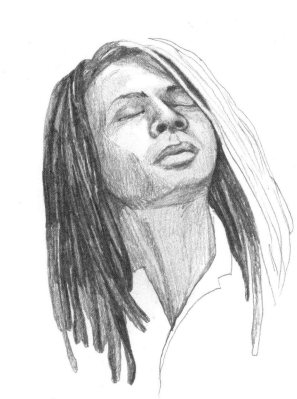

STRUCTURAL DRAWINGS

These images show earlier and later stages of
two drawings. The earlier ones on the left show
structure and construction lines, while the later
ones on the right show the application of more
advanced shading and blending.

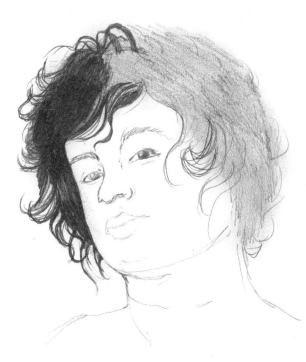

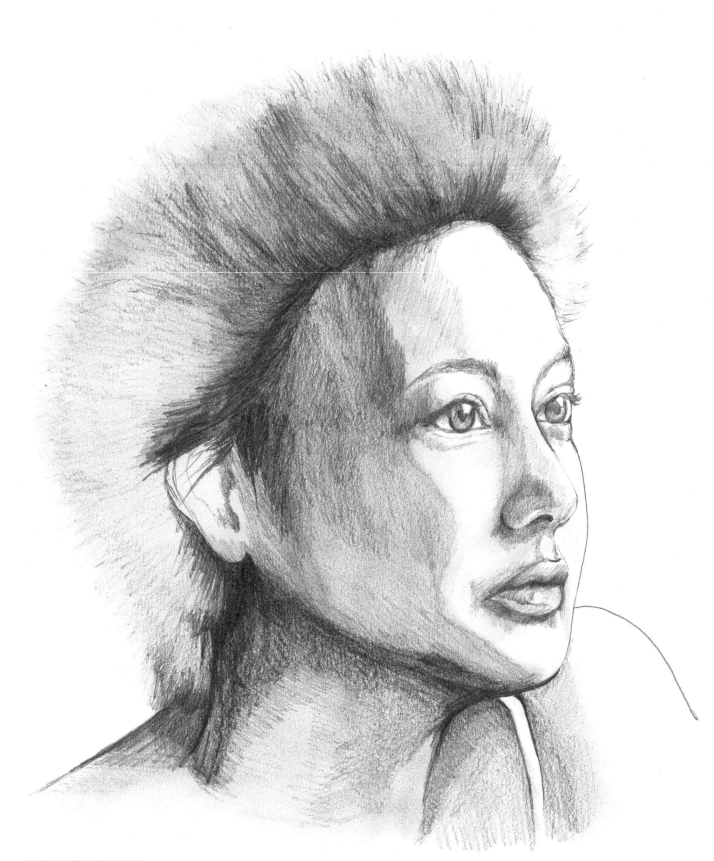

SHADING AND TONE

This hairstyle, in which the hair is sticking up and
has been dyed pink, can be drawn by using shading to
denote the roots and a lighter tone for the colour.

SIMPLE SHAPES

In the same way that you use simple shapes to break down a complex form, you can do the same with hairstyles – in this case, to show the hair tied back.

SHADING AND MARK-MAKING
This image was created using
an HB mechanical pencil and a
combination of tonal shading (light
marks that were blended together)
with marks made using more
pressure to create defined hairs.

FACIAL HAIR

Facial hair might require an even tone be applied to the jaw and face. This will set up the marks that you will make later on to represent the hairs of the beard. Facial hair varies in texture too – it may be thick, soft or stubbly. Be sure to follow the direction of hair growth as carefully as you can.

RAPID SKETCH

You can use a wide variety of pencils, graphite or graphite sticks to create rapid sketches of hair, including facial hair. This image was made using a graphite stick on its side and a sharp, soft pencil to create more definition around the eyes.

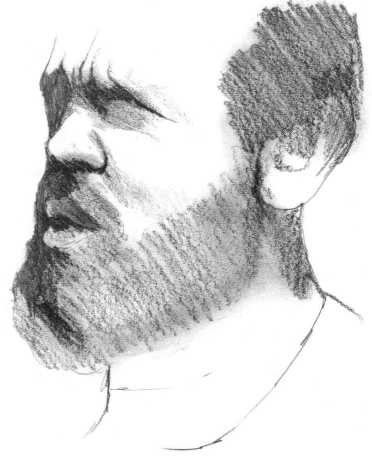

23 MOVEMENT

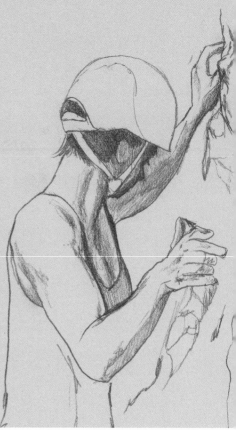

Drawing the body in movement can be difficult. The key is to use exaggerated lines that are slightly darker than the other lines, to trick the viewer into almost perceiving movement. There are other techniques, such as making a series of drawings showing movement in sequence, or using a slightly blurred outline for those parts of the body that are moving. The range of motion you can draw is huge: from dynamic poses seen in gymnastics, dance and other sports, to subtler movements involved in stretching and balancing. Grip, force and holding objects are also quite interesting aspects of movement and articulation.

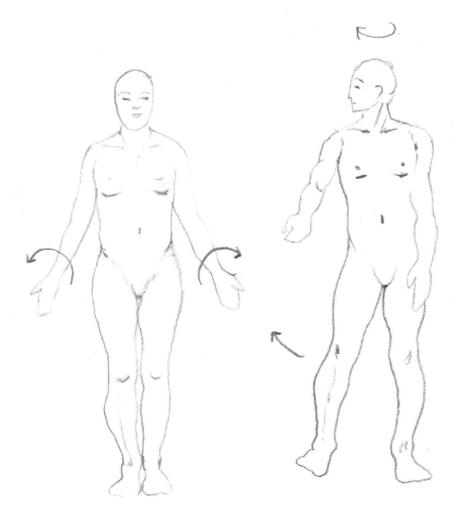

FUNCTIONAL ANATOMY AND TERMS

Muscles have different degrees of movement according to how they move the skeleton and how they are connected to it. Different muscles move the skeleton in the following ways:

- ◆ Extension
- ◆ Flexion
- ◆ Adduction
- ◆ Abduction
- ◆ Circumduction
- ◆ Rotation
- ◆ Supination

- ◆ Pronation
- ◆ Inversion
- ◆ Eversion
- ◆ Dorsiflexion
- ◆ Plantar flexion

APPLYING THE TERMS OF MOVEMENT

Neutral (sitting, standing or lying down)

Shoulder, spine and neck extension

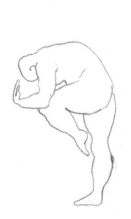

Neck, shoulder, spine, waist, elbow, knee, hip and toe flexion

Finger extension

Wrist flexion

Wrist extension

Finger flexion

Wrist adduction

Plantar flexion

Foot eversion

Foot inversion

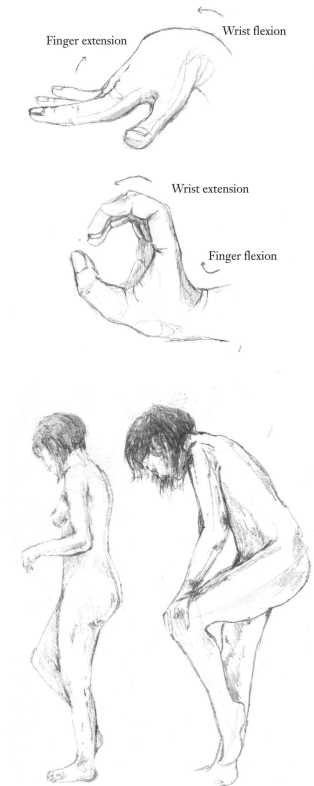

The figures in these two drawings are about to lift their leg and then lifting it off the ground. Having a series of two or more drawings in a sequence can be an interesting way to study movement and balance.

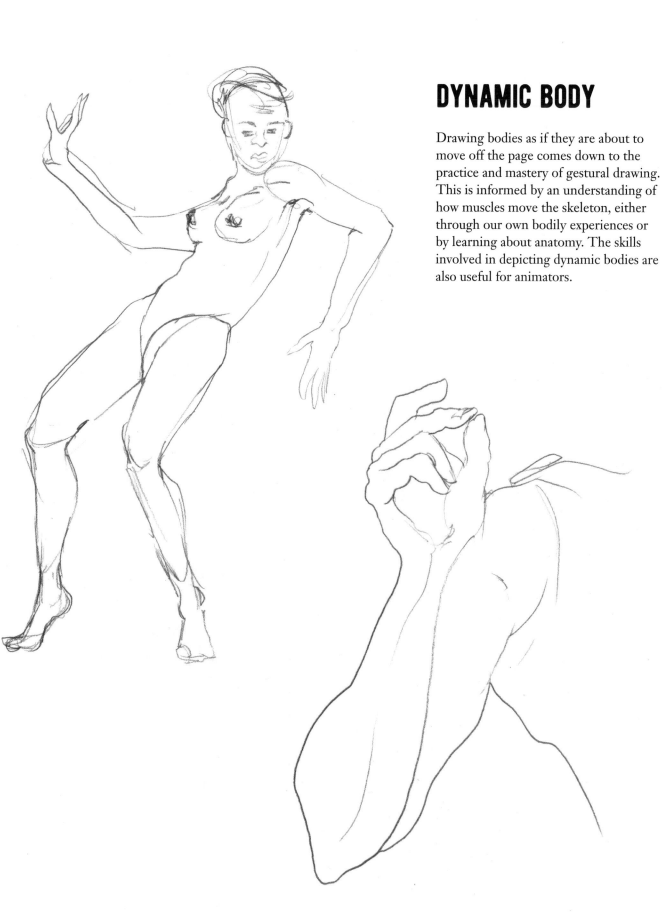

DYNAMIC BODY

Drawing bodies as if they are about to move off the page comes down to the practice and mastery of gestural drawing. This is informed by an understanding of how muscles move the skeleton, either through our own bodily experiences or by learning about anatomy. The skills involved in depicting dynamic bodies are also useful for animators.

CONSTRUCTION LINES AND THE FIGURE IN MOTION

This page shows some examples of how construction lines can be used to depict a figure in motion.

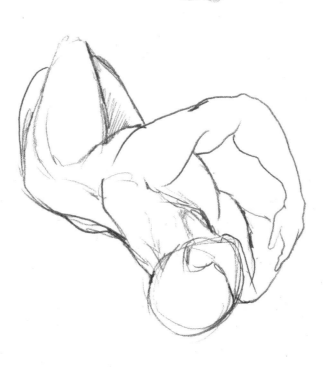

BALANCE AND MOVEMENT

GYMNAST

When a gymnast performs a standing split, the arms are used as a means to balance and distribute the body's centre of gravity.

WHEELCHAIR FIGURES

Similarly, these two images depict bodies in mid-movement, where the model's centre of gravity is shifted from its usual resting position. The top figure is using the hands to move the wheelchair up and across an obstacle. You get a sense of the weight distribution shifting because of the posture of the figure and the way the hands are gripping the wheel.

A wheelchair should be understood as part of the body and interpreted as such, since it enables its own range of movements that are unique to each person. This second figure is just about to throw a basketball. The wheelchair is tilted at an angle as the person pushes their weight behind the ball.

UNUSUAL POSES
Some poses may be fairly atypical, but it can be an interesting study to observe the knees, joints and range of motion.

THIGHS AND MOVEMENT

Sometimes it helps to emphasise certain muscles when you know they are used in a movement. This makes the drawing look more familiar and convincing in terms of what people see and experience. When drawing a squatting pose, emphasise the rectus femoris and vastus medialis with a bit of shading and/or highlight on the outside of the thigh to show that it is being engaged by the body. For the inside of the thigh, a diagonal edge (shaded and/or highlighted) from below the knee to the top of the knee will emphasise the sartorius muscle, and a shaded or highlighted edge emerging at 90 degrees from the knee will emphasise the vastus medialis.

Rectus femoris

Vastus medialis

Iliotibial bands

Rectus femoris

Vastus medialis

Sartorius

LATERAL VIEW

MEDIAL VIEW

UNDERWATER MOVEMENT

In the swimming figure above, the focus is all on the leg muscles. There is some shading to emphasise the underwater movement. In the second drawing, showing the line of the water surface and a couple of bubbles escaping from the swimmer's mouth makes all the difference – the viewer knows that the swimmer is about to surface and is moving upwards. In the drawing on the right, the depiction of the hair, which looks weightless, contributes much to the impression of movement underwater.

Not only does hair move in an interesting way in water, it reflects light differently. Hair appears more matt underwater.

UNIQUENESS OF HANDS

Hands are unique to the person you are drawing. A bit like eyes, we are so used to looking at our own hands that when we look closely at another person's, we suddenly notice how unique they are. This child's chubby fingers are pressing into the base of the bowl, pushing it up towards her face.

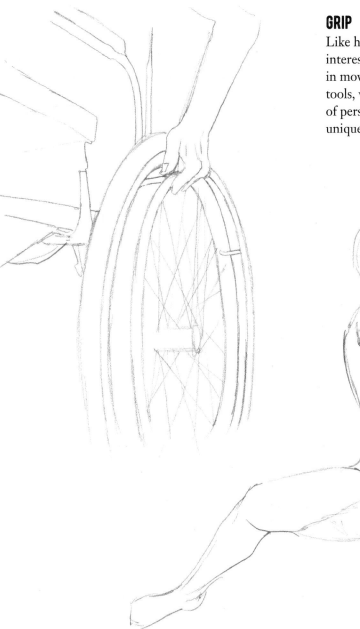

GRIP

Like hands, grip is also very personal and interesting in humans. When grip is used in movement and the manipulation of tools, we can add yet another dimension of personality by aiming to capture the uniqueness of hands together with grip.

If you think about all the unique and wonderful things we can make and do with our hands, it is no surprise that grip should be unique to the person we are drawing. Grip is every bit as unique as handwriting, drawing and manual skills.

CLIMBING

In some cases, the hands can carry weight. In these rock-climbing images, the grip seems quite delicate, but we can tell from the shadow of the brachioradialis that this forearm muscle is bearing some weight and is engaged in a movement or grip.

The shifting of body weight in a drawn figure who appears to be in motion can also be understood through other visual cues, such as the twist in the spine in this image of an upside-down climber. Pay attention to the angle of rotation of the shoulders compared to the angle of rotation in the pelvis. In this drawing, the climber is using their hands and the tops of their feet to support their weight.

MORE CLIMBING POSES

Here are two more climbing poses in which we can notice the relationship between grip and weight distribution.

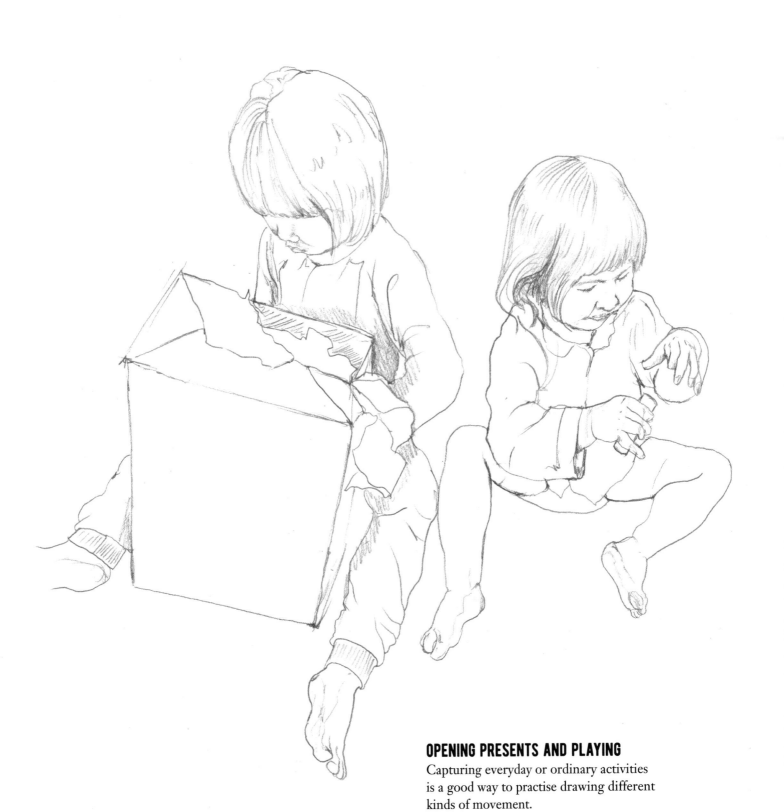

OPENING PRESENTS AND PLAYING

Capturing everyday or ordinary activities
is a good way to practise drawing different
kinds of movement.

SKETCHES OF MOVEMENT

The three drawings on this page capture poses and moments of stillness, yet still convey movement. The standing figure has one heel up (shifting weight to the toes) and the other foot flat on the ground. Both knees are bent and the figure appears to be leaning back towards the viewer somewhat. This combination of static poses gives the impression of movement. The two seated figures are quick sketches in which gestural lines capture the twist and pose of the figure. Some features appear quite odd – the back of the top seated figure, for example, looks unusual due to the scapula protruding on the figure's left shoulder.

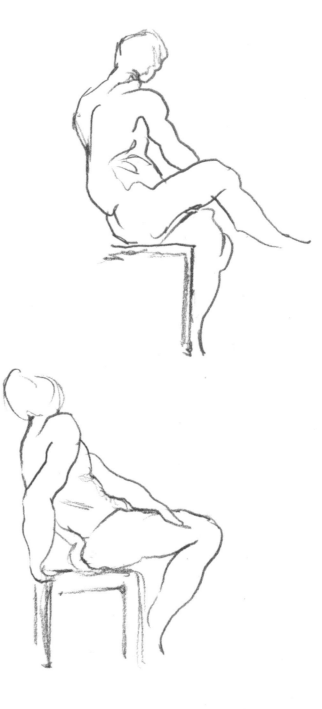

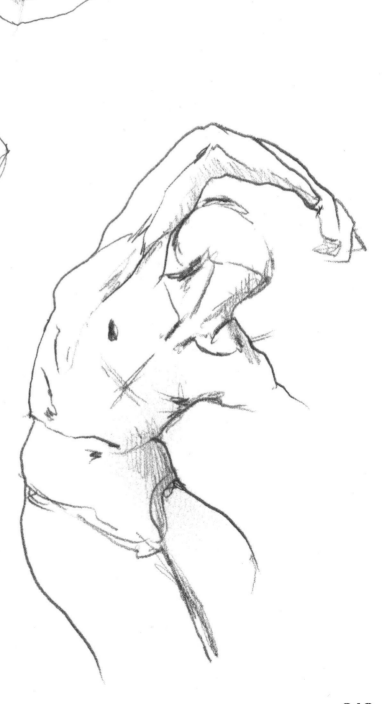

DANCING

Dancing figures are fantastic models for artists studying movement. Dance uses expressive and exaggerated movements that demonstrate the huge range of action the human body is capable of. The figures may also have moving hair or fabric over them, and drawing fabric in mid-movement (even if you have to improvise) can help emphasise movement in a drawing.

24 PORTRAITURE

We have already looked at many aspects of portraiture in this book: the overall structure of the head and placement of the features; how to show wrinkles and fat on the face; the effects of age on the skin; the diverse range of facial expressions; all of the features in detail; and last but not least the hair (or lack of hair), which is so crucial to creating a likeness. The fascinating thing about portraits is how they can combine all of these elements to show a true individual – someone who is absolutely unique – whose image can make an emotional connection with the viewer. In this chapter we shall look at a diverse range of individual portraits using different drawing techniques, as well as double portraits and family groups.

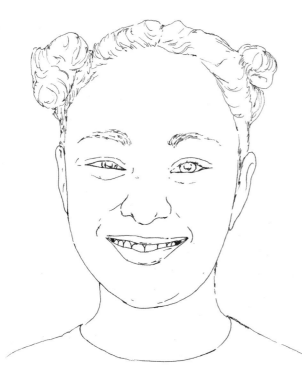

Portraits are often created to capture an individual's or group of individual's character or to capture inter personal relationships and feelings. Some of the portraits in this chapter are done in pencil and include tone while others have been created with line and a fine liner pen. All images drawn with a fine liner pen were initially drawn in pencil very lightly with outlines added in pen. The pencil was rubbed out at a later stage.

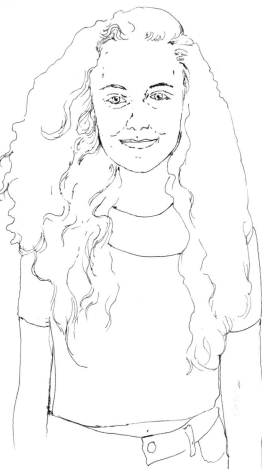

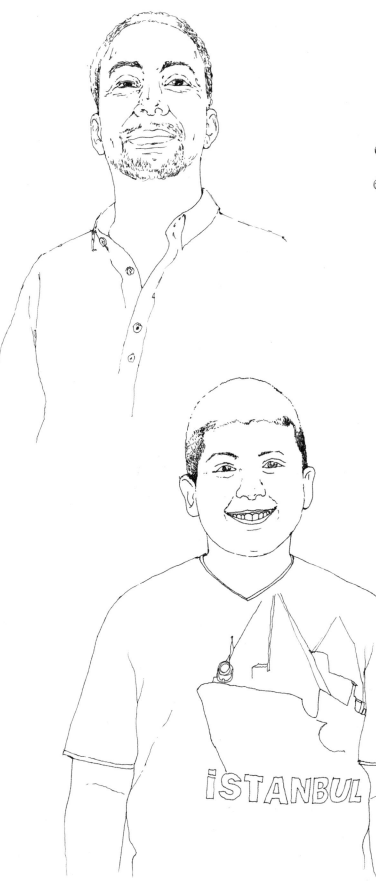

FINE LINER PEN

Using line and mark-making with a fine liner pen can give you new opportunities to explore a more graphic style.

DRAWING A PORTRAIT

The four step-by-step images on the following pages demonstrate the egg and ball technique and construction lines, and show what can be achieved freehand.

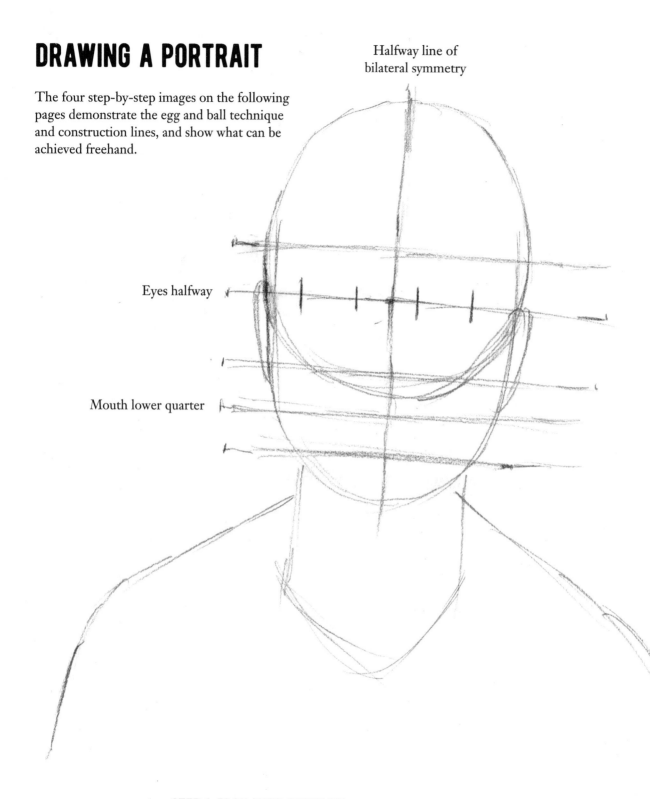

Halfway line of bilateral symmetry

Eyes halfway

Mouth lower quarter

STEP 1: PLAN YOUR PORTRAIT

Draw your egg and ball shapes and sketch in some scaffolding lines. It helps to use a ruler for these, and a sharp HB pencil pressed down with a feather-light touch. Be careful when you draw the shoulders to make sure you capture the diagonal or angled direction of the trapezius muscle. In most instances (depending on the pose and attire of your model), the neck will appear to begin lower down than where the trapezius muscle meets the base of the back of the head. A common mistake is to draw the head and neck at right angles to each other.

STEP 2: MAP OUT THE FEATURES

Following your scaffolding lines, sketch the shapes of the eyeballs, nose, lips and mouth. When you have completed these, erase the scaffolding lines.

STEP 3: REFINE THE FEATURES
Next, you will need to refine the features of the face by adding
eyebrows, eyelids and the skin creases created by facial expressions.
The addition of marks representing bags under the eyes, the Cupid's
bow and details of the mouth will help to move the drawing forward.

STEP 4: ADD DETAILS AND TONE

This final image shows details drawn in fine liner pen to capture the
texture in skin, while the tone is created using a sharp HB pencil.
All construction lines have been removed. The pencil work may
either remain sketchy or be blended to create smoother gradients.

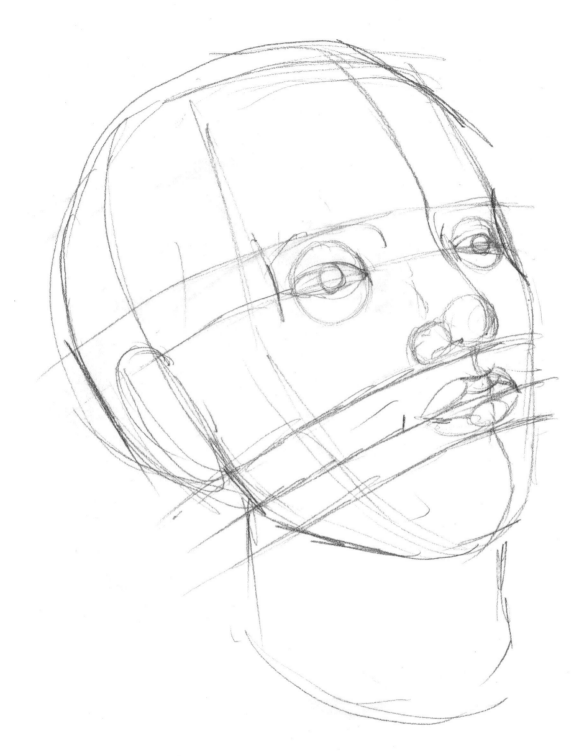

TILTED CONSTRUCTION LINES

Here is an example of the use of construction lines to
plan the drawing of a three-quarter view of a tilted face.

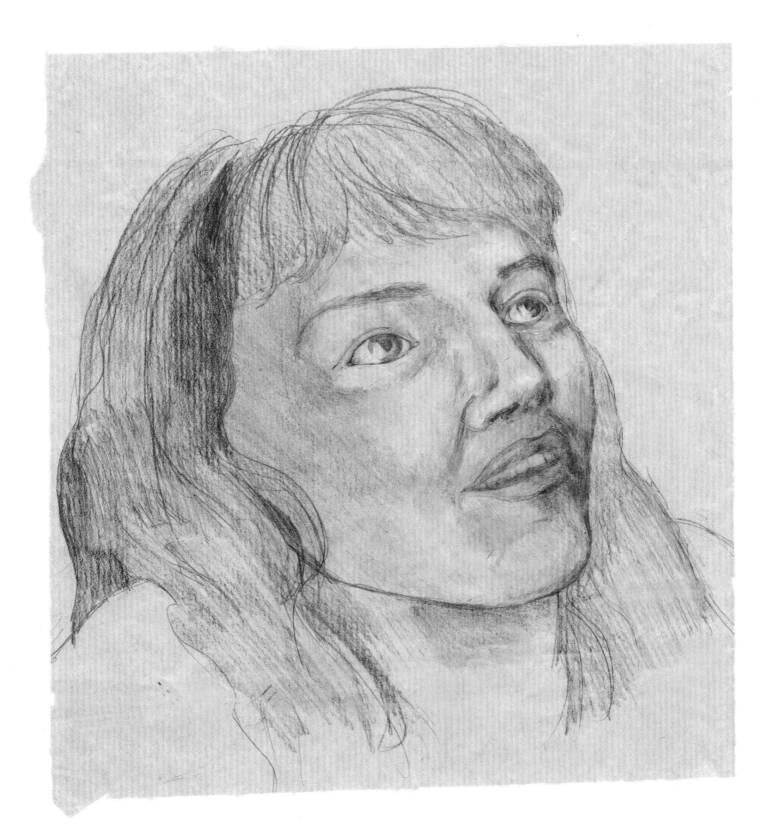

TONE AND TEXTURE

In this drawing on old parcel paper, tone and texture have been used to create 'likeness'. It is fun to experiment drawing on different surfaces. Each surface requires its own unique treatment, so be sure to do some experiments in mark-making, blending, layering and tone before jumping into a drawing on a new kind of surface or a different type of paper.

STATUES

Statues and sculptures can be challenging and fascinating to draw, and even a veiled face can have plenty of personality.

PORTRAIT OF A YOUNG GIRL

The following steps show how to approach a simple portrait of a young girl, from getting the 'bones' of the facial structure in place to filling in the details of her skin, hair and facial expression.

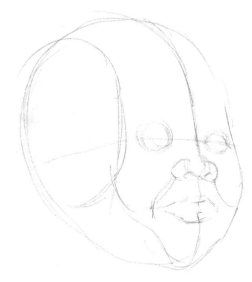

STEP 1

Start with your construction lines: egg and ball, line of bilateral symmetry, circles to sketch out the nose etc. Add a circular disc shape to mark out the side of the head in a three-quarter turn. The ear will ideally be at the centre of this disc. Be careful of foreshortening in such a pose.

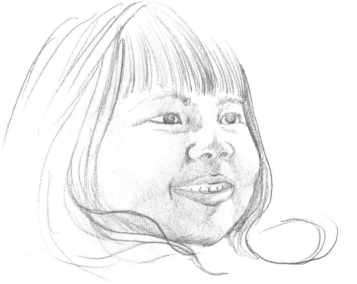

STEP 2

Add more details, removing the construction lines as you go, moving between your putty eraser and pencil.

STEP 3

Refine and add greater contrast in your shadows and highlights. Use a sharp or mechanical pencil for fine detail of the hair and any reflections on the face.

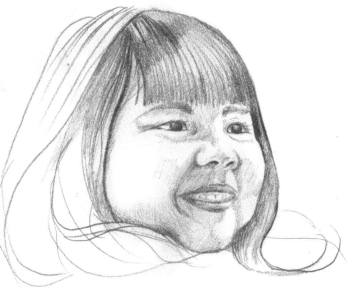

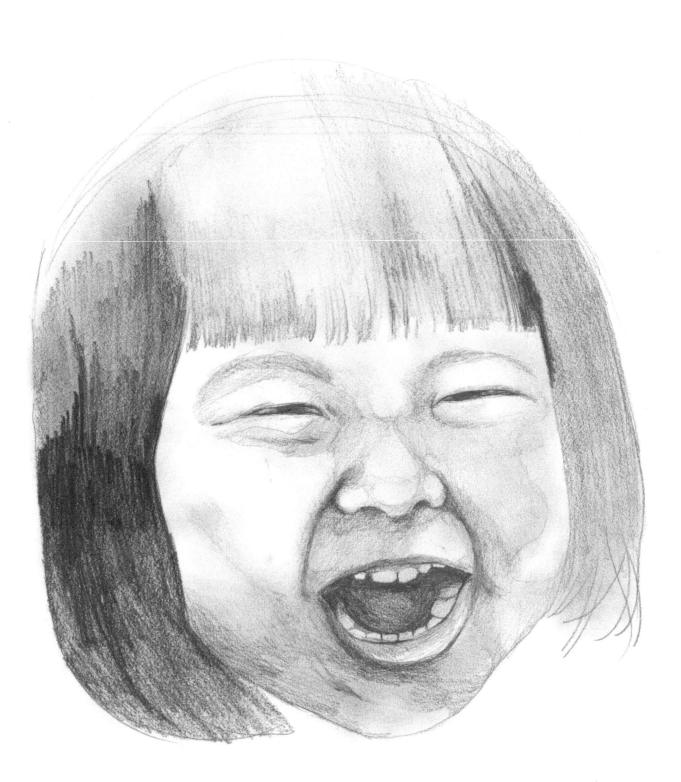

EXPRESSION

As a crucial aspect of communication, expression is something you'll want to try to capture in your portraits.

DIRECT GAZE

The gaze is also important in a portrait drawing. Many humans will look each other in the eye when they communicate, although not always. You can create a powerful impression in a portrait if you draw your model looking directly at you.

ACCESSORIES

Accessories and details such as jewellery can
be important to capture particular moments.
In this drawing, we have a three-quarter pose
with the model's gaze directed at the viewer.
The hat has been drawn just with outline and
not rendered in any more textural detail.

INK AND WASH 1

Using ink and wash might make it difficult to include the
fine details that are possible with a fine liner or pen, but they
give you the opportunity to experiment with blending. In this
example, a water-soluble felt-tip pen has been used with a
square-tipped brush used on its side and dipped in water.

INK AND WASH 2

When using ink and wash, it might also be useful to wet the paper slightly first, as this prevents wrinkling on the page. Brush the paper lightly with water, not so that it is wet, but just damp. Do not wait for it to be totally dry. This will affect how your ink actually spreads across and is absorbed by the paper. Add your water wash on top, as if it were paint or a smudging tool. Do not rub the paper with your brush.

INK AND WASH 3

Here, the natural spreading of the ink has become part of the shadow and tone in the image. The technique of slightly wetting the paper in preparation for watery media can also be used with watercolour painting. Paper can be prepared by lightly soaking the paper in water – either quickly submerge it or dab it with a wet sponge. You could apply ink immediately but it would spread rather rapidly across the surface. If you wait until the paper is dry to the touch but still contains moisture, you can use pencil on the paper and ink will not bleed as much across the surface.

INK AND WASH 4

Using ink and wash can yield surprising and intriguing results. It requires that you give up control of certain variables, as the water and ink can bleed into each other. This is an exciting process because some inks can separate out into different colours, adding an unexpected and new quality to the image.

DOUBLE PORTRAIT

To make a double portrait, begin by using the egg and ball technique, construction lines and other geometric shapes to place the main volume of your drawing. Note that your two figures may be looking in slightly different directions. Compare the difference in the direction of their gaze (and thus your line of bilateral symmetry in each face), and also observe the angle of rotation in the shoulders. In this image, the shoulders are facing different directions. Add more construction lines wherever necessary, to guide your analysis of the figures.

CONSTRUCTION LINES FOR A SIDE PORTRAIT

Side profiles can capture aspects of personality just as effectively as forward-facing portraits. Practise them using the egg and ball technique. Use curved lines when you mark out the shape of the nose, and visualise your drawing as an act of three-dimensional carving or sculpting.

PORTRAIT OF JACQUELINE

Whenever you draw a portrait, you always need to analyse your model's pose. This image is of an almost three-quarter view of the face (slightly more forward-facing), while the gaze is looking directly towards the viewer. The head is tilted gently backwards and the shoulders are at a slight angle away from the viewer.

PORTRAIT OF BAM

In this pose, the model's gaze is towards the viewer, the head is slightly tilted to one side, and the shoulders are slightly tilted down and towards the viewer. You can see from the sternocleidomastoid muscle that the head is ever so slightly tilted back. Use your awareness of anatomy to help communicate subtleties such as these.

ALPHA WITH SUNGLASSES

Portraits may sometimes face away from the viewer and even have their eyes concealed or hidden by hair, hands, sunglasses or other items. In this pose, the tilt of the head tells us that the model is looking upwards. The hands are on the hips, and the hips and shoulders are more or less facing the same direction but angled slightly away from the viewer. As the head is tilted back slightly, we can see shadows and reflection under the jawline.

JACQUI LEANING

A standing figure can make for an excellent portrait. This model is adopting a leaning pose, with the shoulders angled at a three-quarter angle away from the viewer and the head almost facing the viewer. Pay attention to the sternocleidomastoid muscle in such poses. Sketches like these can be used to develop paintings and all kinds of other images. Many portrait artists do quick preparatory sketches of their model in order to analyse and understand their pose, posture and facial expressions.

CLOSE-UP OF JACQUI

A close-up drawing of the same pose can enable you to study it in more detail – in this case, focusing on the slight tilt in Jacqui's head towards the right shoulder. The leaning posture of the figure can be seen differently in this version: more attention has been given to the details of the hand, which is at rest.

A DIFFERENT GAZE

It is important to be sensitive to any variations that your models may have in their gaze. While for most people both eyes face the same direction, this isn't the case for everyone. In strabismus (where the eyes look in different directions) or amblyopia (which can occur in one or both eyes), we experience an expressive gaze that might not be what we are used to seeing. In some models, the eyelids may droop asymmetrically. Attending to and respecting variations in people's gaze is necessary in all portraits.

GUS WITH GLASSES

Drawing spectacles takes a lot of practice. Here, we start with an egg-and-ball drawing with construction lines. In the finished tonal drawing, you can see how the sketched lines have been developed into the glasses.

JENNIFER AT CHRISTMAS

A tilted head can make for a very expressive portrait. You may choose to draw the tilt of the head so that the jawline is visible. In this image, the cheekbones and jawline are quite pronounced.

SCALE AND FOCUS

These three portraits show various scales (the size of an object, or in this case a person, in relation to another) and focus on slightly different aspects of the person. The boxing figure includes a torso, for instance, while the other two focus on details of the hair.

LINE-DRAWING PORTRAIT

Line is a useful starting point in some portraits. The fabric of the scarf in this image is slightly more detailed compared to various other examples included in this book.

FAMILY GROUP: MUHAMMED, FAWZIA AND AHMED

For portraits of groups, be careful with foreshortening of figures in the foreground and background. Start your drawing with geometric forms. The clothing here is rendered with simple folds in the fabric, and these have been shown by using mark-making.

YARA AND HAMZA

These are two separate drawings that have been brought
together. You may want to combine drawings that you have
done individually to create a group. You can make use of your
knowledge of foreshortening to place your figures in a way that is
convincing. In this image, Yara (left) needs to appear to be in front
of Hamza (right) – the drawing of her is proportionally bigger, so
she needs to be in the foreground. Her arm, however, is not quite
complete. To make this a more convincing image, I could place her
further away from Hamza and move her slightly further down.

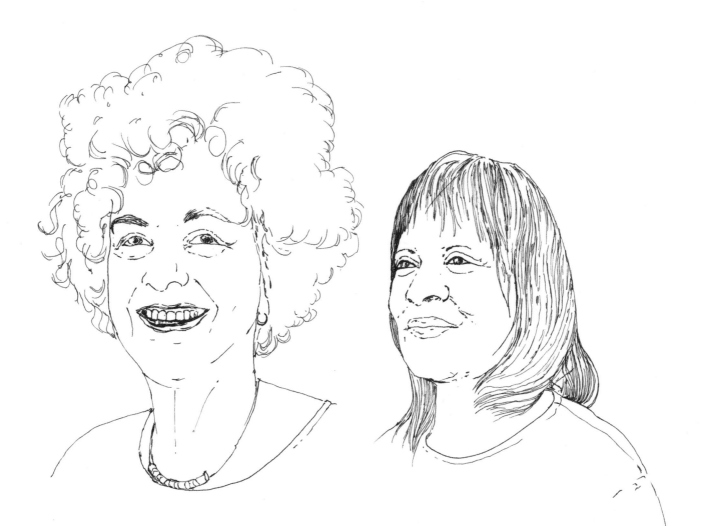

RITA AND HILARY

If you are combining images drawn at different times and
want to create a group portrait, think about how scale and
position relate to each other. For example, in the image on
this page Rita (left) is larger in scale compared to Hilary
(right). Positioning the image of Rita so that she appears to
be in front of Hilary helps the image make more sense.

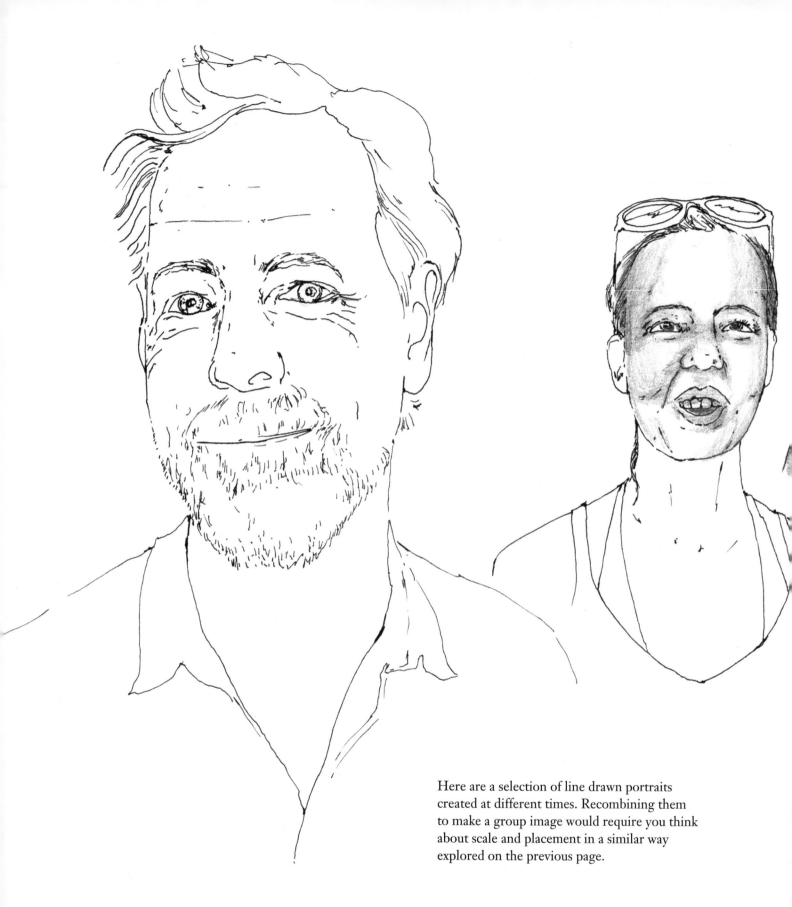

Here are a selection of line drawn portraits created at different times. Recombining them to make a group image would require you think about scale and placement in a similar way explored on the previous page.

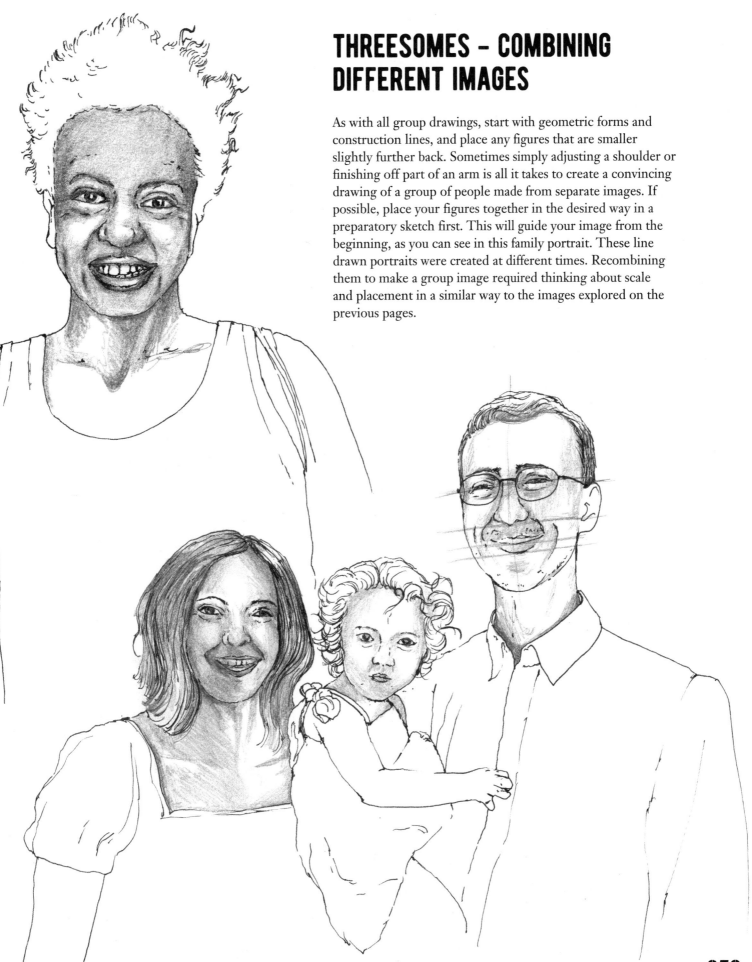

THREESOMES – COMBINING DIFFERENT IMAGES

As with all group drawings, start with geometric forms and construction lines, and place any figures that are smaller slightly further back. Sometimes simply adjusting a shoulder or finishing off part of an arm is all it takes to create a convincing drawing of a group of people made from separate images. If possible, place your figures together in the desired way in a preparatory sketch first. This will guide your image from the beginning, as you can see in this family portrait. These line drawn portraits were created at different times. Recombining them to make a group image required thinking about scale and placement in a similar way to the images explored on the previous pages.

INDEX

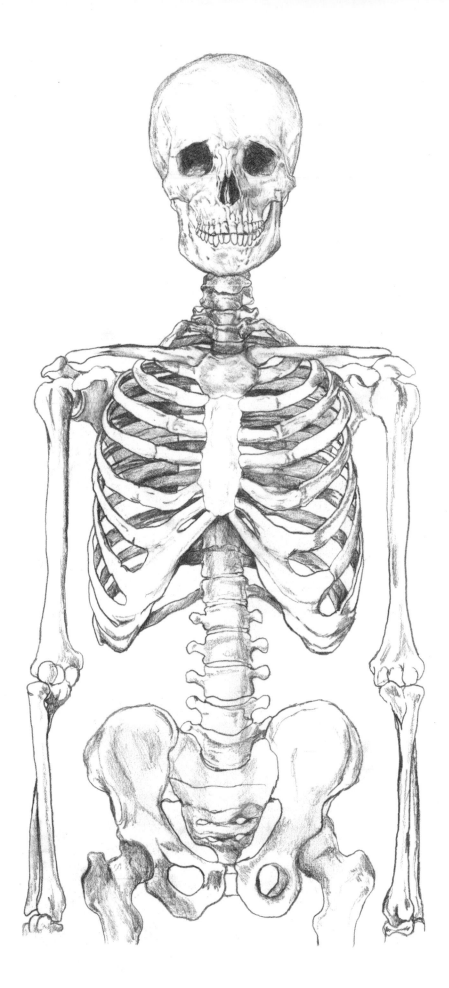